Teaching Children to Draw

A Guide for Teachers and Parents

Marjorie Wilson

Brent Wilson

Davis Publications, Inc.
Worcester, Massachusetts

Front cover: Amie drawing on the driveway.
Back cover: Amie, age 3, "Springy Tigger," 2008. Courtesy of the artist and her mother.

Publisher: Wyatt Wade
Acquisitions Editor: Jane McKeag
Production and Manufacturing: Reba Libby
Design: Janis Owens, Books By Design, Inc.
Production Assistance: Victoria Hughes-Waters, Jo Ann Nelson, Claire Mowbray Golding

To Amie who brought us into the twenty-first century;

to Andy B. and Andy S.,

Anthony and Becky and Bobby G.,

Dane and the Space Horse that shoots fire,

and David, and Dirk and his Change Bugs,

Holly and Lindsay and the house that grew,

Jeff and the Zargonians,

and Jonathan and his bats,

Kelly and her wondrous worlds,

Lana and Leif,

The Larsen kids: Dane, Jens, Teal and Kess,

Michael L.,

Oak and Philip,

Sam and Brent R.,

Steven and Michael B.,

Summer and manga,

Tony and Tami,

and all the rest who allowed us

to share in their

special graphic worlds, and

those who were eager

to draw with us and for us,

and who changed our lives,

and without whom this book

would not have been possible.

Printed in the United States of America
ISBN: 978-1-61528-005-6

10 9 8 7 6 5 4 3 2

Contents

See page 6

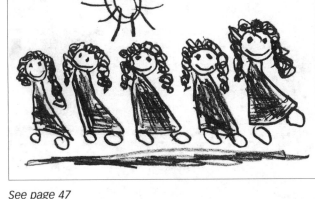

See page 47

See page 126

Introduction to the Second Edition

Drawing in a Digital Age

This twenty-first-century edition of our late twentieth-century book about drawing with kids begins with a twenty-first-century child.

Over thirty years have passed since we began collecting drawings for the first edition of this book. During the intervening time the world has changed in many incredible ways for the late twentieth-century children that it portrays. They could not have imagined that their dozen or so television stations would multiply to hundreds, that the CB radios through which their heroes communicated would become ubiquitous cell phones, that many of the fantastic things they only imagined would become reality. If images from the media are the raw material from which children form their own visions and versions of the world, imagine the vastly greater number of images they encounter today than they did three decades ago. Not only television, film and the internet, but wonderfully complex video games provide them with characters, settings, actions, and challenges that overshadow many of the simpler narratives of the earlier publication.

And what of drawing? Do twenty-first century children still need the old-fashioned graphic means of recording the worlds they actually live in, imagining the worlds they might live in, and graphically fantasizing the worlds they could never live in? Has the old-fashioned process of marking directly on paper outlived its usefulness? With the advent of digital media that make it possible for children to photograph, scan, manipulate, and print images, and computer programs that make it possible to put into perspective view virtually any image or to plot human figures in almost any position and from any angle, it might seem as though we have entered a time when traditional drawing—where pencil and crayon are put to paper—is no longer as useful to children as it once was.

As we return to the issues we first raised three decades ago we believe that, if anything, drawing is more important to young people today than it was when this book was first published. Since the time of the first edition we have come to understand more fully the cultural, narrative, and playful foundations of children's drawings. Our insights into the many ways that adults might interact with children as they draw have become both more expansive and more subtle. We also have a greater understanding about the popular media's influence on children's drawings and how, rather than proving a detriment to children's drawing activities, the worlds depicted in the media provide children with a plethora of exciting material from which to build their own creations. Perhaps the most important new understanding, only anticipated in the first edition of this book, is the larger playful narrative context that provides the conditions for children's marvelous life-shaping drawings.

Three Major Drawing Sites

If creating realities/world-making-through-drawing was the central theme of *Teaching Children to Draw*, the alternate theme of adult/child interaction was and continues to be of equal importance. We pointed to the myriad ways parents, teachers, other interested adults and other kids shape the course of drawing development and its accompanying narrative competence—depending upon when and how they interact (or fail to interact) with kids as they draw and when and how they talk with kids about their drawings. We have come to view children's drawings and drawing activities as a vast and varied landscape. Within this terrain that we have observed for so many years we will point to three important drawing sites. The designation of these three sites has helped us to clarify many of the ideas presented in the first edition.

The three drawing sites are not merely places, but most importantly, they encompass such things as the motives and interactions that inform them. Contrast the conditions and motives when the child decides to make a drawing for her own satisfaction with the situation in which a teacher asks a classroom of students to make drawings of an assigned topic. One drawing episode is initiated by a child to please herself or himself; the second is initiated by an adult to meet an educational objective deemed important by the adult—but not necessarily by the students. When children initiate their own drawing activity for their own purposes, we call it the *first drawing site*. When adults assign children to draw, in schools or museums, we term it the *second drawing site*. When a child and an adult, for a period of time, set aside the status and authority that generally separate the realms of adulthood and childhood, when they become near equals and colleagues, and make joint contributions to a drawing we call it the *third drawing site*.

Amie Begins to Draw in the Third Site

As we further delineate these three drawing sites and the important distinctions among them, we will begin with Amie, her mother, and the technological and media worlds in which they live. When we wrote *Teaching Children to Draw* in the early 1980s, written text and images of children's drawing provided us, and

others who wrote about children and their art, with the principal way to communicate our ideas. The computer had not yet become a fully-realized instrument for us and it was inconceivable that, in our lifetime, through something called the internet, we would not only communicate with someone or several someones on the other side of the world in an instant, but that ordinary people would be broadcasting their ideas and their lives to the world through blogs and a phenomenon called YouTube.

As we have said, this twenty-first-century edition of our late twentieth-century book about drawing with kids begins with a twenty-first-century child. Unlike the children in the original book, most of whom we met, interviewed, and with whom we often drew, we encountered Amie on the internet in a YouTube video. A blogger calling herself BrooklineMama had posted the video of her 2½-year-old daughter drawing a typical tadpole figure. What was most exciting was Amie's interaction with her mother and father, their questions, and Amie's drawing responses. (It was interesting to see that Amie's parents were interacting with her in ways similar to the ones we suggest in Chapter 3 of this book.)

Amie begins by drawing a somewhat circular shape and, off camera, her father asks, What is that? Amie decides that it is a head and accentuates the idea by strenuously adding two dots for eyes. Then she adds a tentative swirl beneath the "head" and having finished the drawing to her satisfaction, she begins to

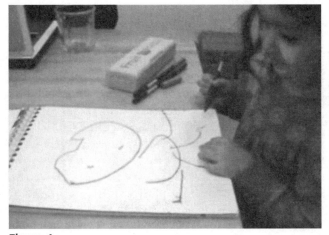

Figure 1

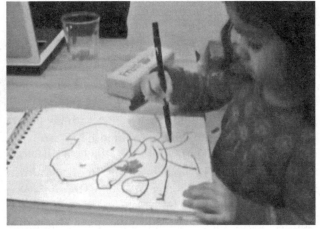

Figure 2

Frames from the YouTube video of Amie at age 2 years, 7 months drawing *Figure with three heads*.

turn the page. Her mother, however, suggests that she "finish" the drawing before turning the page and asks, "What is that? the body?" Amie is agreeable and on request adds legs and arms, but balks at the feet for a few beats. Perhaps, as we describe in chapter three, according to the "territorial imperative" the 2½-year-old believes that there isn't enough space for feet at the bottom.

When asked to draw the mouth, however, Amie adds the mouth to the part designated by her parents as the body. So she is confused when the ever-logical parents wonder why she has put the mouth in the body and when the questioning continues in a quest for the head, Amie obligingly adds another circle, and declares it to be the head.

We think that the drawing-based interactions between Amie and her parents are prime examples of *third-site* drawing activity. In fact, this episode was preceded by dozens of other *third-site* encounters between Amie and her parents. Here are just a few of them.

At 17 months Amie observed her mother writing in her journal and asked if she could write too. Her mother allowed her to scribble on pages of her journal—implicitly acknowledging to Amie that her marking and her marks were as important as her mother's writing. From this point onward Amie's parents supplied her with pads of drawing paper, markers, pencils, and crayons. Until Amie turned three, nearly all of her drawing activities were encouraged by her parents and enthusiastically welcomed by Amie. Her motor control, which is quite exceptional, was facilitated even more by an interactive connect-the-dot game playfully engaged in by Amie and her father. Amie's father drew two dots and when she connected them, her parents cheered, and her father drew more dots. When Amie was 27-months-old her mother wrote in her blog "when she draws or paints she asks me to draw something too, I always respectfully decline for several reasons. I don't want to influence her lines with my perception of things, I don't want to impose my sense of realism on her, and in the end I like to have a drawing that is wholly hers. But then how will she see a drawing being made?" Her mother created a "Drawing Book for and with Amie" in which Amie's drawings of tadpole figures rest comfortably alongside her mother's colorful drawings of characters from some of Amie's children's books—and sometimes even superimposed

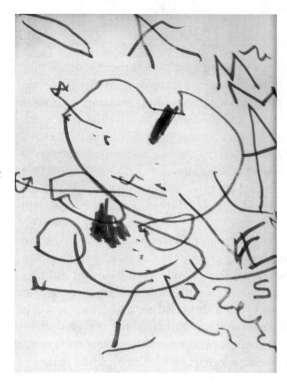

Figure 3
Amie, age 2 yrs., 7 mos. This drawing, a frame from the YouTube video, is a prime example of a *third-site* drawing activity.

Figure 4
Amie, age 17 mos. Amie's mother wrote in her blog, "This is her very first drawing, with a black roller pen in my Moleskine journal." Because her mother's journal-writing was a constant presence, Amie's "writing" was acknowledged as important in this third site.

themselves atop her mother's drawings. Nevertheless, as various *third-site* graphic activities were unfolding, Amie's mother thought it was inappropriate for her to draw on Amie's drawings. Much of this book is devoted to addressing this issue of adult influence on children's drawing. Should adults influence children's drawing, and if so, when and how, and how much?

In Chapter 3, "Learning to Draw: Nurturing the Natural" we address this issue head on. Art teaching practices inspired by the modernist belief that children are natural artists and that they must be permitted to unfold naturally—that they must be protected from cultural influences have been the dominant pedagogy for a century. The nature/nurture debate still rages in art education and within society. In this book we come down squarely in the middle. Of course children are "hard-wired" to keep their drawings as simple as possible (while still achieving their graphic goals), to organize lines and shapes at right angles, to avoid overlapping, to conserve and reuse configurations they have mastered—we outline seven of these principles in Chapter 3. We also claim that if children don't learn to overcome, or subvert, or learn to take advantage of

these inherited biases, their graphic development will be impeded and eventually stop. How then should adults assist children as they learn to draw?

Each adult who interacts with children as they draw must decide how much or how little to influence the child's drawing development. This is the very issue that concerns Amie's mother. We believe that any attempt to "teach children to draw" requires a knowledge of children's graphic developmental steps. (Note that we write 'steps' not 'stages'! Children progress in their drawing ability by taking hundreds—perhaps thousands—of little steps forward and sometimes backward.) It also requires great sensitivity to what the child herself or himself is trying to achieve. Here Vygotsky's zone of proximal development— the difference between what Amie can achieve by herself and what she can do with her parents' and teachers' assistance—certainly applies. It is unwise to try to move a child to a level beyond his or her proximal zone.

On the other hand, to use one of Vygotsky's and Bruner's terms—scaffolding—the helpful interactions between Amie and her mother will enable Amie to do things beyond those she can achieve by herself. The

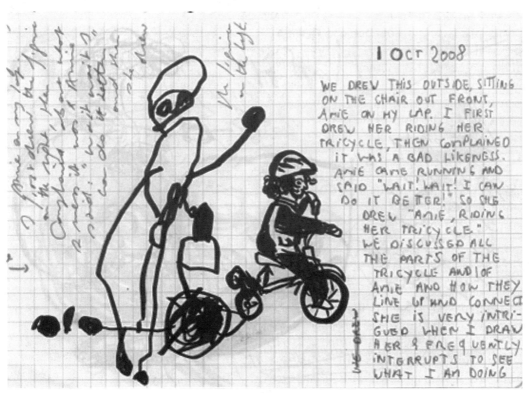

Figure 5

Amie's mother's journal, which describes how Amie started drawing with her. Not only did Amie share her mother's "space," but the ensuing discussion of the drawing of Amie and the tricycle resulted in this cooperative *third-site* drawing, a natural transition from the initial sharing in Figure 4.

term scaffolding refers to any temporary framework of assistance provided to encourage development, to be removed when no longer needed. Chapters 3–8 may be seen as a series of suggestions pertaining to the kinds of scaffolds adults might construct to facilitate children's drawing development. Some adults insist upon limiting their scaffolding to verbal suggestions. Others, among whom we number ourselves, employ the full arsenal—drawing with children, drawing alongside them, and when they are older, not only showing appropriate models but also encouraging kids to search for their own models. We have no qualms about nurturing—guiding in myriad ways—children's natural inclinations to draw. Our rule of thumb is that when the child is ready for something new, something more complex, something more challenging, we find a sensible, sensitive, playful way to present it.

The concept of adults and kids drawing together is one of the most important ideas that we present in this book. In Chapter 8 we talk about adults and kids agreeing to make drawings together—graphic dialogues and conversations—and agreeing, implicitly at least, that the creative collaboration will lead to joint ownership. It is interesting that many adults who are reluctant to draw along with children on the same sheet of paper, do not hesitate to write on their drawings. When Amie made a drawing of a character from one of her favorite series of books—*A Voyage to the Bunny Planet*—as she had seen her mother do, her mother wrote in a corner of the drawing a letter dictated by Amie to the author Rosemary Wells. Amie's mother's writing the words that Amie dictated became a kind of visual verbal collaboration. When, on the family's cement driveway, Amie drew a large "DEAD BUNNY RABBIT," her mother wrote both Amie's caption and her own explanation "NOT A REAL ONE." In the driveway's "shared space" Amie's drawing and her mother's caption had equivalent status.

Amie Makes a *First-site* Drawing

Most children's early art-making activities are instigated by adults—at home or in daycare centers (where it is possible to see first-, second-, and third-site activities). But when does a child move from the second and third sites to the first site? Amie's mother Katrien shared a picture with us that Amie had drawn on her

Figure 6
Amie, age 2 yrs. 11 mos. This self-initiated drawing depicting a hike during which Amie rode on her father's back is a *first-site* drawing, made without adult audience or knowledge. Here Amie differentiates between her father (the simple tadpole figure) and her own body (the definite body with arms in their proper position, on the right).

own, without any audience—a self-initiated product of the *first-drawing site*. Katrien described this picture "of herself and her Baba (dad) on a hike we did last weekend (Baba carried her on his back in a backpack).

Our email response to Amie's mother was, "Do you notice how she has differentiated the figure of her Baba from that of herself? Baba is a typical tadpole figure with no distinguishable body/head separation so that the arms appear to extend from the head. The small figure he carries (Amie), on the other hand has a definite body and the arms are in their 'proper' position. Wow!" It is as if Amie's awareness of her own body had been intensified as she rode on her father's back—so of course it was her body that was drawn as distinct.

The drawings Amie made while interacting with her parents (in the third site) and her entirely self-initiated first-site drawing help us to see the link between these two sites. The fact that her parents provided drawing materials and all sorts of encouragement, continually talking with Amie as she drew, praising, asking questions such as "where are the missing body parts" are examples of scaffolding that, we think, contribute to Amie's developing schemata for the human body. Those schemata were then available for Amie to use when she decided by herself to graphically narrate an actual experience.

If Amie is like most contemporary kids, she will acquire a personal encyclopedia of increasingly complex schemata for drawing humans—discarding old ones when they are no longer satisfying or useful and acquiring new ones that help her to fulfill the (mostly implicit) graphic and narrative objectives that she sets for herself. As Amie continues her graphic development, in one or more of three drawing sites, her parents, teachers, other adults, and kids will interact with her as she draws—playfully challenging her to make her drawings more complex. (These newly acquired graphic skills will permit her to conceive and present increasingly more complex and meaningful ideas through her drawings.) We also hope, if she thinks it's okay, that her parents, other adults, and kids older than Amie will draw with her on the same surface—engaging in the kinds of *third-site* graphic dialogues, conversations, and storytelling that we present in this book—especially in Chapter 8.

Figure 7

Amie, age 3. Amie's self-initiated drawings became more and more intricate and detailed. Her mother wrote in her blog about this "springy Tigger. He's jumping, see, and holding a black balloon, and there's a tree behind him." The most interesting thing about the drawing is how easily we can recognize that this is not a human, a mere three months after the simple tadpole human in Figure 6. Notice his four legs and, of course, stripes.

Drawing from Images of Popular Culture

Regardless of the graphic skills Amie acquires during *third-site* drawing activities, eventually the most fascinating graphic models for humans, animals, and other things she wishes to draw will be those she discovers and adopts by herself in the first drawing site. And if Amie is like other kids, she will find the most useful, the most varied, and the most appealing graphic models in the popular media—in comics, cartoons, video games, and book illustrations. At the very top of the list of appealing graphic models today is *manga*—

Japanese comics. Today it seems that kids all over the world want to draw in the *manga* style. It is a phenomenon whose development we have observed for a quarter century—first in Japan, Taiwan, and Korea and then in America and Europe. In the 1980s we wrote about how differently Japanese kids' drawings looked from the drawings of kids in other countries—and those differences are traceable directly to *manga*.

In the late 1980s when we asked Japanese children to draw stories, more than half the kindergartners drew figures and animals that showed a distinct *manga* influence—things such as humans with heart-shaped faces, large sparkly eyes, and razor-cut hair, and there were, of course, lots of cyborgs, Godzilla-like monsters, and cute animals. About two-thirds of second- and fourth-grade students drew *manga*-influenced characters and three-quarters of sixth-grade students drew *manga*-like characters. (We show some of these *manga*-influenced drawings in chapter three.) They acquire the *manga* style in the first drawing site—by taking the individual initiative to search their favorite media for *manga* models. The Japanese children we studied learned to draw *manga* outside of school classrooms—in the 1980s most Japanese art and classroom teachers discouraged their students from drawing *manga*—and many still do. Consequently, Japanese children learn two distinct graphic languages. One is the Japanese school art style that children acquire in art classrooms—the second drawing site. The other is, of course, the *manga* style that they learn in the first drawing site by borrowing from popular media sources and from other kids.

At this time Japanese *manga* characters have migrated nearly everywhere. American kids and kids in all parts of the world watch Japanese anime, play Japanese video games, and they increasingly read *manga* that have been translated into English and other languages. Models are everywhere; how-to-draw *manga* books have been translated from Japanese to English; kids teach other kids to draw *manga*.

Summer, a young girl living in a suburb outside of New York City, is a good example. We met Summer when she was 12. She says that she "needs" to draw at least two hours each day—including the time she doodles at school. She draws more on weekends and during the summer for a minimum of four hours a day, and this first-site intensity has held for several years. When we asked Summer and her mother why she draws, her mother answered, "It's a part of her being . . . She is compelled, even to the point that it robs her of sleep. I think it's a creative urge that she really has no way of conjuring nor squelching." Summer says, "I wouldn't say the drawings themselves are important to me. I don't know why, but if I don't draw, it really bothers me. It's a kind of OCD [obsessive compulsive disorder] thing. I feel irritable if I don't draw."

When Summer was seven she gained confidence in her expanding drawing skills by reproducing from memory TV characters such as SpongeBob SquarePants. When Summer moved to a new school her drawings, inspired by Pokemon, led to friendship with Emily who loved to draw characters in the style of Korean and Japanese *manga*. Summer took to the *manga* style like a duck to water. Since she began acquiring her new preferred style, she has filled innumerable sketchbooks. A suggestion that Summer use her figures in a sequential narrative, however, was merely met with frustration. Like most American and European kids, she was content to simply develop her *manga*-like characters.

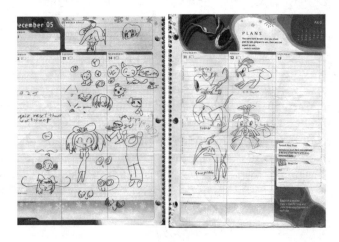

Figure 8

Summer, age 9. For Summer, drawing seems to be a way of continually reminding herself that she exists. Every available surface—school calendar, workbook, sketchbook—provide opportunities for that reminder, and for practicing and perfecting the characters she creates.

Comic Markets as a *Third-site* Drawing Phenomenon

Japanese, Korean, Taiwanese, and Hong Kong teenagers have organized themselves into dojinshi or *manga* clubs since the 1970s. (The Japanese term dojinshi can be translated as group or circle.) The circles, of which there are hundreds of thousands throughout Asia, have as few as two and sometimes as many as a dozen members. Usually without adult supervision, although some high schools and universities have dojinshi clubs supervised by adults, the members decide to create and privately publish their own *manga*. For example, a group of Taiwanese teenagers created a dojinshi *manga* with ten original stories relating to Harry Potter. The dojinshi members typically select an editor/production manager, collectively judge the quality of the stories, layout and design, characters, plots, etc. and so on. This is first-site narrative drawing activity at its most complex. The creation of dojinshi *manga* is a visual cultural phenomenon that appears not to have been replicated in America.

It is instructive to look at the visual cultural context in which Asian kids draw. The dojinshi *manga* phenomenon—and especially the comic markets for amateur makers and consumers of *manga*—illustrates an important relationship between the first and the third drawing sites. In 1975 Yoshihiro Yonezawa—a critic, novelist, and a passionate supporter of popular visual culture decided that teenagers who were drawing and self-publishing their own *manga*-like dojinshi needed a venue in which to show and sell their works. With the assistance of colleagues he organized the first dojinshi COMICMARKET in December, 1975. Thirty-two dojinshi groups and about 600 visitors attended. We see the market as a third-site activity because it is an example in which adults encouraged the production of first-site drawing (and narrating) by assisting young people to display and sell their dojinshi *manga* to fans.

Yonezawa could not have anticipated the phenomenon he was unleashing. That modest third-site beginning has led to an unprecedented increase in the production of dojinshi *manga*. In August, 2008, we visited the three-day semi-annual COMICMARKET in Tokyo—

Figure 9

The inside pages of the Harry Potter dojinshi reveal the skill with which young people in Asia design and draw manga. The pages provide evidence of the kind of careful collaboration and near-professional discipline required to complete such a complex undertaking. Because the prestige of the entire group is at stake, the work of a member may be rejected if it does not meet the standard the group has set for their publication.

along with a *half-million* other visitors. To guide us through the exhibition, we purchased the 1,400-page catalogue in which approximately 1,300 of those pages *each* presented sample postage-size illustrations of 48 different dojinshi *manga* produced by approximately 35,000 dojinshi groups and individuals—a total of more than 56,000 illustrations in a single catalogue. But this is only a part of the story; there are approximately 2,000 other smaller comic markets held in Japan each year—along with countless others in Hong Kong, Korea, and Taiwan. We are convinced that the growth of dojinshi and other forms of anime and fan art are tied directly to the existence of comic markets.

There is one other fascinating point to be made about the influence of the comic markets on narrative drawing activity. Prior to the mid-seventies, most of the young people who participated in the comic markets belonged to high school or university *manga* clubs and most ceased to create dojinshi when they graduated. With the arrival of comic markets, however, these amateur artists had a growing number of options for presenting their dojinshi. Consequently, they continued as members of dojinshi groups after their graduation from high school or university. The markets also provided an opportunity for any young person, whether in college or not, to present his or her dojinshi to an enthusiastic and growing audience of readers. The markets attracted fans, fans encouraged the production of dojinshi, and the number of dojinshi groups outside schools and colleges mushroomed. Now there are dojinshi *manga* artists in their thirties who continue to plot, design, draw, self-publish, and sell their work at comic markets. When we asked a number of them, "how long are you going to keep doing this?" the responses were variations of "as long as I get satisfaction from it." COMICMARKET organizer Yonazawa's third-site encouragement caused an expansion of first-site drawing activity that gives every sign of continuing and expanding into other venues.

From Comic Markets to FanArt Websites

Fan art websites are the predictable extension of Asian dojinshi *manga* comic markets. It is possible to enter websites such as deviantArt.com and Elfwood and

Figure 10
Cover, Tokyo Comic Market catalogue # 74, August, 2008. Over 2000 comic markets are held throughout Japan each year—along with many hundreds more in other Asian countries. In the markets kids and young adult creators of dojinshi manga sell their professional-looking comic books to fans. The semi-annual three-day market has approximately 100,000 young exhibitors and a half-million visitors.

view thousands of images that fans have appropriated from *manga*, anime, and video game characters and styles. These fan art websites are the ultimate third drawing site! With the assistance of website managers, hundreds of thousands of young illustrators, literally from around the world, post an image on a site such as the fanArt site at deviantArt.com. Within a few hours, if the image is attractive, it might be viewed by thousands of admiring fans. For example, in one nine-hour period an image might be viewed more than 7,000 times and downloaded 82 times.

Art educator Marjorie Manfold who has studied the producers of online fan art found that most of the youth who post their images learned to make them through determined copying from genre models. She writes that fanartists, as she calls them, are motivated by things such as producing pleasant images that appeal to others and bringing recognition to their creators. Manfold also found that a third of the fanartists were self-taught and that about the same percentage concluded that taking school art classes did not contribute to the skills they needed to make fan art. Rather, they sought assistance from peers in acquiring the skills needed to make their work acceptable to the online community and to increase their own status within the community. Just as importantly, Manfold describes how fanartists' peers make critical comments, both negative and constructive, regarding skill, imagination, and adherence to the standards of their genre. Manfold says that nearly all the fanartists she studied wanted to develop a unique style, but that about half had no desire to become professional artists—self-satisfaction and recognition within the online community are sufficient rewards.

Art Teachers and FanArt

We wonder how many art teachers are aware of the students in their schools who are fan artists, and if they are, how they respond to these kids who gain much of their sense of self and satisfaction through adding their contributions to a mass form of popular visual culture. We have discussed the many intricate relationships between the first (child-initiated) and third (adult/kid interactive) drawing sites. How do second-site school classroom, youth center/camp, and museum studio drawing programs relate to first- and third-site drawing? We think that school drawing programs will play a more important role in the lives of students when teachers have an increased awareness of the drawings that kids produce outside school. We also believe that teachers, at the margins of school and classroom, should increase their third-site interactions with kids. We became acquainted with many of the kids whose works we present in this book when we met them in classrooms. However, we were often more fascinated with what they were doing on the covers of their notebooks than their artwork relating to school assignments. We would generally ask, "have you got more stuff like that?" And this was sometimes "the beginning of a beautiful friendship."

We are not suggesting that one of the three drawing sites is more important than any other. Rather, we believe that together they provide the whole story of kids' graphic development. Together they give kids three powerful and interrelated means for symbolic world-making and for the exploration of different types of reality. Existing side-by-side and informing one another, the activities in each of the drawing sites can lead to a higher degree of artistic development and knowledge about the self and about the world. It is within the context of the narrative, and world-making, and the dialogue—between child and child, between child and adult, between child and media, between child and works of art—that this important interchange of ideas occurs. Many of the classroom activities that we present in Chapters 5–7 are strongly influenced by what we have learned from studying kids' first-site drawings and from interacting with kids in the third-site. Those of us who are interested in children's drawing need to remind ourselves that there are kids for whom self-initiated activities nearly consume their lives, and that there are others whose drawing experiences depend primarily upon the imagination of a creative and sensitive art teacher.

In this book we have placed a special emphasis on the many relationships between kids' drawings and popular visual culture. Nevertheless, we would also want kids to learn from the so called "high art" generally found in art museums. Indeed, in kids' drawings and in all their artwork we would like to see ongoing dialogues among kids' interests in popular visual culture and images and ideas from the fine arts. This is why we suggest that this book be used alongside *Teaching Drawing from Art*, the book written with Al Hurwitz.

1

Children's **Drawing** Activities

Alex is five months old. All of her boundless energy is concentrated on discovering her world, a world that is totally new—surprising, pleasing, interesting, exciting, amusing, and delightful in part, but also startling, frustrating, confusing, frightening, and utterly overwhelming. How will she learn about her world? How will she come to know the nature of the things and the beings that surround her? For now, most of Alex's knowing is derived through the senses, by direct physical action upon or contact with an object—seeing, feeling, smelling, tasting, listening. When Grandpa sets her in his lap while he draws in his sketchbook, Alex grasps the moving pen, and in doing so, creates marks of her own. She is unaware that her action is in any way related to the marks on the paper, but the marks themselves become the next object of her interest. She touches the lines on the page, surprised to find that they have no substance. None of her turning and wriggling, none of her creeping or her attempts to sit, to crawl, to touch make a mark; only the movement of the pen leaves a permanent record.

It is only later, in her second year, that Alex will be able to employ symbols in order to gain knowledge about her world. This action sets the human child above the kitten, which, as much intrigued by the baby as she is by it, can only know through its five senses. When Alex begins to engage in make-believe play, when the teddy bear that is presently bounced on its head and probed and poked and tasted comes to stand for a friend or a child, to be fed and bathed, to be spanked and scolded and kissed, then she will be using symbols, not only to act upon, but to create a world or worlds of her own. By the time Alex is four or five, her spontaneous activity will have become concentrated on a great variety of playful operations—singing, acting, pretending, storytelling, and drawing. Of all these activities, only the drawing, like the scribbles she helped Grandpa make, will leave a permanent record of her action. She will not only recognize the marks made on the page as her own, but she will also be able to make the lines and circles she draws "stand for" a person, a house, a tree. Because drawing, of all the symbolic activities, is the one that leaves this record, it plays a special role in the child's development.

What are the unique functions that drawing will serve for Alex and other children? When and in what manner might she engage in drawing activity? The functions, of course, relate to the exploration of her world that Alex engages in even now—exploration that we pursue further in Chapter 2. Here we will be looking not so much at the drawings of children as the manner in which children engage in the act of drawing and the circumstances under which they choose to do so. Because all children draw to some extent during some period of their lives, it is useful to note the varieties of those drawing experiences. We will examine some of the ways in which children choose to draw, the sometimes prodigious number of drawings they produce, and some of the places they select in which to produce them.

A Little or a Lot: Days Filled with Drawing

On almost any day, Steven can be found building complex structures with his Lincoln Logs™, drawing, or constructing objects from cut paper. These are the favorite activities of this cheerful, outgoing third-grader, who neither lacks for friends nor misses an opportunity to "throw a football around" with his older brother, Michael.* Given the choice, though, Steven would opt for building, constructing, and drawing over either friends or football. Faced with the possibility of being denied these pleasures, Steven would "faint."

Steven often engages in his creative activities while watching television, although, like most kids in this age of multitasking, the constant sound and action on the set never fully intrude on Steven's concentration. At times the television and the creative activity exist independently of one another as in a collective monologue.[1] At other times, the television action may trigger the construction of a football field complete with football players and goal posts that Steven first draws on a separate piece of paper, then cuts out and tapes to the field in the appropriate positions—Steelers and Rams—as the Super Bowl game unfolds simultaneously on the televised field and on Steven's. Or a rock star, complete with sideburns and guitar, appears in conjunction with a movie depicting the life of Elvis Presley. (1-1)

Steven's creative activity begins at home, before school—usually Lincoln Logs at this time—and continues through the spare moments he has at school. At any opportunity, he will draw for his friends and classmates, who sometimes pay a quarter for the privilege of owning one of his drawings. He tells us that he once received a quarter for two drawings of Kermit (the Muppet frog) and another quarter for two drawings of Snoopy. Steven continues to draw partly because of the encouragement of his teachers—his second-grade teacher praised a book he had drawn as "the best in

*Throughout we have chosen to use the actual names of the children of whom we have written and with whose drawings we have illustrated the book, as we wish them to be known for the individuals they are.

the class." There is also the coveted approval of his brother—he thinks Steven's drawing is "really good"—and there is his need for excitement. But primarily it is his own desire to know or to possess things that keeps Steven drawing. (It has been said of Pablo Picasso that he could possess whatever he wanted "by drawing it."[2]) Steven's mother tells of his desire for a particular Christmas present—a sled. When Santa failed to bring one, Steven built one for himself in miniature out of construction paper. And, too, Steven is moved by the satisfaction of doing something well and by the desire to do even better.

Steven's brother, eleven-year-old Michael, is involved with music and sports but sometimes draws in school to keep from being bored. Although he drew quite a bit when he was younger, Michael's drawing activity never equaled Steven's. Although both brothers were amused by the suggestion that either of them might get ideas from the other, Steven's rock star curiously resembles the figures we found drawn repeatedly on the pages of Michael's notebooks. (1-2) "Steve started watching me do figures," says Michael; and Steven pipes up, "Yes, I tried to do them and I can." While presently Steven's

Figures 1-1 and 1-2

Steven (age 8)
Elvis P. (black ballpoint)
7¾" × 10½"

Michael (age 12)
Rock Singers and Other Characters (black ballpoint)
7¾" × 10½"

Steven drew at any time and in any place that he could, often in front of the television set. He may have received his inspiration for this drawing from a television program and his model from his brother Michael's many studies of the quintessential rock singer.

main preoccupation is with drawing, drawing is only a small part of Michael's world.

Of all the children we have observed, Kelly[3] is probably the one for whom drawing consumed the most working hours, in school as well as outside of school. Like Steven, Kelly had admirers among her friends, but it was not approval that Kelly sought, nor was it an escape from boredom, as it was for Michael. For Kelly drawing served an even more basic need, a need shared with more mature artists—the need for definition of her self and her world. At the age of fourteen, Kelly was creating marvelously elegant fairy-tale worlds. Whether they were idealized miniature replicas of her own world or a series of medieval settings, they were delicately, meticulously, and lovingly drawn. (1-3) The trees in her drawings are like lace, and exquisite little villages nestle between gentle hills. These drawings, and the hundreds more that Kelly produced in the three years that we knew her, attest to the hours spent in her most satisfying occupation. Kelly said that she drew things as she did "to have at least some record. . . . I wanted to get it down so other people could go there too." But then she added, dejectedly, that "nobody ever saw them or got the same feeling [from them as she did]." We wonder how many other children may be creating fantastic worlds to which little or no attention is paid.

Drawing with Others

Some children draw extensively; others draw very little. We know children who will literally fight for a surface to draw on; others draw reluctantly even when they have

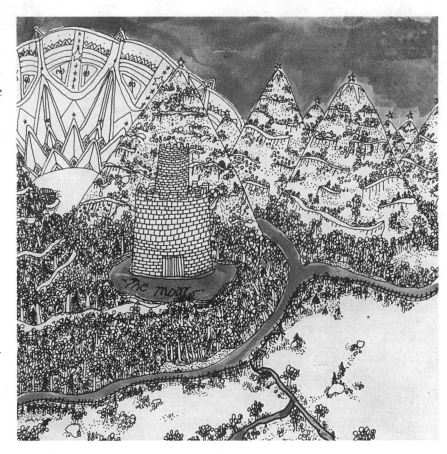

Figure 1-3

Kelly (age 14)
The Moat (Rapidograph and watercolor)
Kelly learned to use the Rapidograph pen from her older sister and spent hours alone, meticulously designing beautifully delicate settings where stories were waiting to happen.

been provided with reams of paper, pencils, and crayons. By describing the intensity of the drawing involvement of a few children, we hope to convey the idea that the drawing activity of all children is tremendously important to them. And of those children who do not draw to the extent of those we describe, how many would enter the fantastic world of spontaneous drawing if given encouragement? Many, we think!

The encouragement to draw comes at times from adults—parents or teachers or both—and at times from involvement with other children. We have often observed the ripple effect of one drawing child on others. Andy B. is a case in point. His older friend Bobby's exciting sixteen-page comic book of the origin of "Goldman" (1-4) became the model for Andy's own fifty-page saga of "The Legend of the Theem and the Red Glob," (1-5) which served in turn as a model for various similar adventures of strange and exotic creatures drawn by several of Andy's classmates. Occasionally, instead of launching adventures of their own, a group of

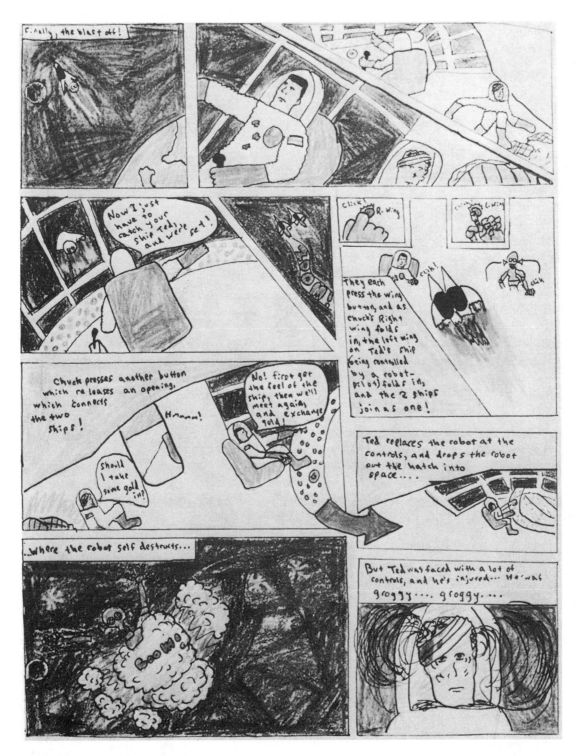

Figure 1-4

Bobby (age 13)
Goldman (colored pencil and marker)
9″ × 12″

The visually exciting and exquisitely colored page of Bobby's 16-page *Goldman* adventure helped to spawn Andy's own 50-page *Theem* and a host of further adventures by Andy and some of his other classmates in the second grade.

children will choose to embark upon a joint venture. This was the case of "Margie and the Boys" in the course of a long-ago Boston summer:

When the streets became too hot for King or kickball or even hide-and-go-seek, we kids sought the relative coolness of the house and there spent the days orchestrating a production that we named Wham Comics. We jointly wrote the stories and the dialogue, delighted in seeing our creations come to life under the pencil of one or another of the members of the group. There, as we crowded around the glass-topped dining room table, the Red Ruby and Lightning and myriad lesser characters were born. Each of us took turns at drawing or writing; someone would be called home for lunch and another artist would take over.

Arthur could draw men that looked particularly virile; Freddie's attempts were not quite as handsome, but the hero of the stories was drawn by first one and then the other as the excitement of getting the hero out of some peril impelled us to complete the adventure. As the only girl in the group, I was assigned to draw all the heroines. It was even better than our Saturday afternoon forays to the mysterious Oriental Theater, where we sat on the edge of those itchy red plush seats, breathlessly waiting to see what would happen next to Dick Tracy or Tom Mix in the weekly serials. In our own serials we could engineer what would happen and what would happen next, and it was ultimately more exciting and more stimulating and more satisfying than anything we could buy for a dime in the corner drugstore. Wham Comics was lovingly and care-

fully transported by me from place to place, from city to city, until years later it somehow sadly disappeared. But the memory of Red Ruby, first Arthur's rendition and then Freddie's, fighting the forces of evil, vividly remains, along with the ice cream man's bell and the front porch swing and Frank Sinatra and the Red Sox of that long-ago summer.[4]

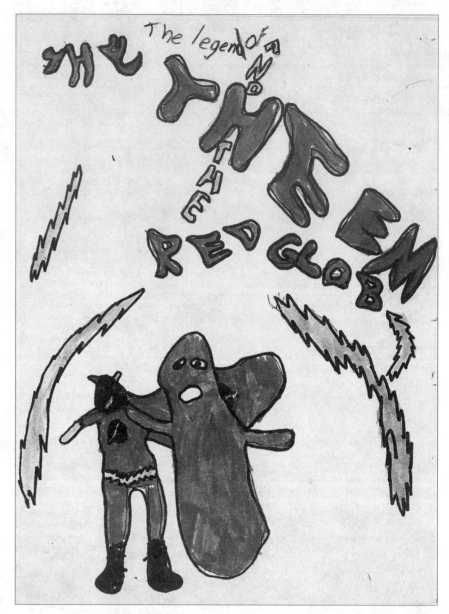

Figure 1-5

Andy (age 7)
Cover for *The Legend of the Theem and the Red Glob* (colored marker)
9" × 12"

Spaces and Places to Draw

Perhaps Steven drew on the living room coffee table because this location allowed him to be with the rest of the family and to listen to TV, while also enabling him to move easily from playing with his Lincoln Logs to constructing and collage activities and to drawing. Other children prefer their privacy, and, like adult artists, they acquire and arrange their own private "studios" to suit their individual needs. C. S. Lewis describes the drawing place that he arranged for himself when he was young:

I soon staked out a claim to one of the attics and made it "my study." Pictures, of my own making or cut from the brightly colored Christmas numbers of magazines, were nailed on the walls. There I kept my pen and inkpot and writing books and paint boxes.[5]

By the age of seven, Michael L., now a professional graphic designer, was drawing complex underground worlds that were mirrored by the place in which he chose to draw. His drawings depicted "complicated little caverns" into which invaders forced their way down one passageway after another, to gain access to underground colonies. Sometimes whole cities appeared "suspended from cavern ceilings by a huge chain," and battles and fires and floods, all created in Michael's own private underground work area—a basement area he established "like a little studio, a little apartment, with fish tanks, books, supplies and

Figure 1-6

Michael L. (circa age 7)
Underground World (pencil)
9" × 12"

Michael L.'s "real" world existed in the basement of the house; his imagined worlds, such as this one, existed further down in the bowels of the earth. In these caverns and passageways and underground colonies all sorts of exciting adventures were born.

my prized possessions." There Michael could shift from drawing underground worlds (1-6) to the production of an eighteenth-century kingdom populated with elegant ladies and handsome gentlemen. (1-7) These marvelous drawings were surely made possible partly because he had a special place to work.

Figure 1-7

Michael (circa age 13)
Eighteenth-Century Characters
(India ink and watercolor)

Michael L. says of these and other characters that he created early in his graphic life "[when I rediscovered them] hiding in a book . . . I had to laugh because that's what I used to do with my time. . . . They form a fantasy world with great mobility—the possibilities for numerous episodes. . . . [It is] interesting to see how someone who wants to maximize fantasy time works."

Establishing Favorable Conditions for Drawing Activities

Spontaneous or self-initiated drawing activities, whether done alone or with others, occur in the lives of some children daily—even hourly— and yet often go virtually unnoticed by parents, teachers, or other adults. But anything that so completely fills the lives of young children is important, both for the pleasure and the excitement it provides and for the effect it has on their acquisition of knowledge—knowledge about the world, themselves, and the future (see Chapter 2).

Kelly's production of drawings was as much an in-school as an out-of-school activity. Other children we talk to and whose drawing activities we observe, draw in school as well. Nine-year-old Sheila draws in school whenever she gets a chance and when the "teacher isn't looking." Although Sheila announces, "She hasn't caught me yet," she is quick to add that she is second to highest in the class; so it is clear that her drawing does not

interfere with her schoolwork. Ten-year-olds Bobby and Sam also tell of "sneaking" drawing. "The best place to draw is in math," Bobby confides. "Any time you get ahead, you just take your math book and put it there [in front of you] and draw." In spite of the prevalent attitudes of teachers described by Sheila, Bobby, and Sam toward drawing in school, we think that the spontaneous drawing activities of children are necessary and important and require more careful examination. It is important, too, that parents and teachers understand the purposes and functions of these activities and encourage children to engage in them.

Display

Encouragement can be as simple as offering approval or acknowledgment of spontaneous work by providing a place to display it. The refrigerator has become the typical

showcase for artwork, but for some work a more dignified spot might be required, such as a separate wall or an honored place in a parent's room. In schools we have seen entire walls and bulletin boards devoted to this spontaneous work, and we know of more than one previously undiscovered "artist" having surfaced because of the opportunity to exhibit spontaneous drawings. (1-8 and 1-9)

Markmakers and Surfaces

A grandfather we know recognized his young granddaughter's need to draw and indulged her by providing an unending supply of good drawing paper. Such a supply of paper may be an unnecessary expense; children who draw in the way we are describing will do so on any suitable surface, from scrap paper to inexpensive newsprint and notebook paper. But certainly making

Figures 1-8 and 1-9

J. C. (age 10)
The Black Canary (black marker)
J. C. (age 10)
Revised version of Superman
(ballpoint and colored crayon)

These drawings of the *Black Canary* and a thirtieth-century Superman were signed by the "Phantom Cartoonist" whose cry to be recognized, "Would you like to see more? . . . Write a note" was answered with a good deal of enthusiasm when it appeared anonymously on a schoolroom tack board. Invitations by adults such as J. C.'s teacher's invitation to display works done at home may afford other aspiring artists the opportunity to be discovered.

supplies available is a good way to encourage drawing activity.

Most children today have a supply of paper and pencils, crayons, and markers with which to draw both at home and at school. It wasn't always so. A hundred years ago the spontaneous drawings of children were as likely to be found on walls, on fences, in the sand, and on school slates and blackboards as on paper. And, as we will see in Chapter 4, children's

drawings were also different then, at least in part because of the materials with which children customarily drew. Materials do make a difference. Here we discuss those materials and their various effects on drawing, and make suggestions for materials that we think ought to be available in every home and classroom.

First, the materials provided should allow children to achieve what they themselves wish to

achieve through their art activities. If a child wishes to depict the intricate workings of an automobile factory, an inch-wide brush and juicy tempera paint hardly suffice. If a child delights in color and pattern, then a ballpoint pen is not a satisfactory tool.

Consider Nadia, a little British girl who by the age of three-and-a-half was producing sophisticated drawings with the facility of an adult artist. Nadia is a special

case—an autistic child who could hardly utter a word but who possessed perhaps the most unusual gift for drawing ever observed and recorded in a child.[6] The first time she was brought to a child development clinic for observation, a psychologist who was unaware of Nadia's drawing ability presented her with a fat yellow wax crayon. As the result of using this unwieldy tool, Nadia produced a formless scribble instead of the exquisite running horses that she was capable of drawing. Her preference was for the ballpoint pen with which she was able to achieve the precision she required. In Nadia's experience there may be a lesson for all children. Fat crayons and other inappropriate tools may inhibit drawing more than enhance it.

Then what kinds of materials should children have available for drawing? Here are some general principles:

- A choice of marking tools and a variety of types and sizes of paper should be available. In general, let children make the choices that best suit what and how they prefer to draw.
- Help children to make reasonable choices. Generally speaking, broad- and medium-tipped markers and large crayons work best with large pieces of paper (12" × 18" or 18" × 24"). On small paper the marks these tools make are too coarse and it is not possible to show detail. On the other hand, small pieces of paper (anything from 3" × 5" index cards and note pads to 8½" × 11" printer or copy paper) seem to call for the accuracy of a ball-point pen, thin-tipped marker, or pencil.
- Occasionally you may want to encourage children to use different marking tools or different sizes and shapes of paper, but don't be concerned if they stick to old favorites. Artists, too, experiment with a variety of media and then sometimes stay with their originally preferred medium for a lifetime.

Markmaking Tools

In our views on the various types of markmaking tools available to children, you may be surprised that we praise the common pencil and question the widespread use of the wax crayon. We will examine each of the markmakers in turn.

The *pencil* is probably the most common drawing tool used by children. We think that it is a good one. Generally, the lead should be soft (#2 or #3 for common pencils, or B or 2B for artists' drawing pencils). Thick-leaded soft pencils are also excellent drawing tools for children of all ages, especially for scribblers; they smudge a bit, but what beautiful, velvety, black lines they make! And, of course, with pencils, a pencil sharpener should be handy. A blunt pencil is not a satisfactory drawing tool.

Ballpoint pens (including more sophisticated fine-point pens) are found in nearly every home and are among the most commonly used tools for spontaneous drawings. Yet they are not often used for school art lessons. They could be, as they are a responsive and precise drawing tool. Some of the most gifted and productive young artists we have studied use ballpoint pens almost exclusively. Ballpoint pens work especially well on index cards and any smooth paper. And remember that these pens come in lots of colors besides black and blue.

Felt- and fiber-tipped markers are a favorite marking tool for children of all ages. They come in a wide range of colors and tip sizes. Our preference is for the fine- and medium-tipped markers. The broad-tipped markers simply don't allow for the detail that most children like to get into their drawings. The primary advantage of markers is the ease with which they make a mark. They require little pressure as they literally glide across paper—especially paper with a slick surface.

When markers begin to dry up, if they can't be revived by letting the tip sit in water for a few minutes, they should be thrown away. There is no more frustrating drawing tool than a nearly dry marker.

Wax crayons were once thought to be just about the only appropriate drawing tool for children. We think they have their place, but they are far more suited to "coloring in" than to making lines. For drawing, their broadness and softness make them quite unresponsive, and if children spend most of their time coloring in, they are not getting as much benefit from their drawings as they might.

Wax crayons are fine for scribblers and for younger children who like to work on larger sheets of paper. But if children choose small sheets of paper and are concerned with depicting lots of detail, they should be encouraged to use markers, pens, or pencils.

Rapidograph® or other *technical pens* are sometimes popular among older children, who are able to handle them and who wish to make highly detailed drawings such as those done by Kelly (see p. 6). They are generally difficult to work with and clog frequently—we recommend them for older children only.

Papers

Papers for drawing come in a few standard sizes, and it is unfortunate that they generally remain that way, when, with the snip of a scissors, or with a paper cutter and tape, they can easily become almost any size and shape. Size and shape have a great effect on both the type and quality of children's drawings. As we talk about papers we consider three things—their size, shape, and type.

Size. For many years adults, and especially art educators, have believed that children should draw only on large sheets of paper. Blithely unaware of this edict, children draw away on small index cards and sometimes on scraps of paper the size of postage stamps. Perhaps they are trying to tell us something.

The art educator's love for large paper stems from the belief that children's art is expressive and that expressiveness is equated mainly with sweeping motions of the hand and arm. Yes, scribblers do sometimes need space to practice their motions, but children in general also need reasonable boundaries to fit the size of their ideas. It does no more damage to a child's spontaneity and creativity to work small

than it does to work large. Children ought to be supplied with paper from about 3- or 4-inches wide, through the regular larger-sized paper, to 6-, 12- or 24-inch-wide paper on a continuous roll such as white wrapping paper. Remember also that if an idea turns out to be too large for the paper on which it is being depicted, then tape and more paper can create a working sheet of almost any size. Some of the drawing dialogues shown in Chapter 8 started out on a single sheet of paper to which five, and sometimes even more, sheets were added.

Shape. Most papers come in standard shapes—a little longer than they are wide. But sometimes it's nice to draw on a square, a long, skinny rectangle, a circular-shaped paper, or even on highly irregular shapes. Children often adapt their drawings to fit the shape as well as the size of their paper. Papers of a variety of sizes may well lead to ideas and inventions that would be less likely to occur on standard shapes of paper. We suggest that adults consult children to learn the shapes and sizes of paper they would like to draw on. Adult artists, too, like to experiment. Frank Stella, for example, invented the "shaped" canvas that allowed paintings to take on a variety of exciting forms.

Although newsprint and printer paper are among the most frequently provided, many other papers have characteristics that make them especially good for drawing. Here we list some of the most commonly available papers. Most can be obtained from variety

stores and office and school suppliers, as well as art supply stores.

Newsprint and manila papers. The best thing one can say about these papers is that they are inexpensive. Actually, newsprint is nice to draw on, whereas manila has a bit too much tooth, or roughness, and it soaks up almost everything put to it. In addition, both papers are impermanent. If you can afford to provide better paper, do.

Printer paper. White paper from note pads and printer and copy paper are reasonably inexpensive and are responsive to pencil, markers, and ballpoint pens. Many children use the small sheets of note-pad paper to make little illustrated books and sequential story drawings. For children's spontaneous drawing we recommend that an ample supply of at least one of these types of paper be available at all times.

White drawing paper. Most white drawing paper, available through school supply houses or in packages and pads from art and variety stores, is satisfactory for children's drawing; in fact, it is better than most of the papers that we have mentioned. When we work with children this is what we like to use. We get it in 9″ ×12″, 12″ × 18″, 14″ × 17″, and 18″ × 24″ sizes and then cut or tape it to the desired size. It works well with all marking tools.

Coated papers. Some papers have a smooth, shiny surface. Actually, the slick surface is a thin coating of polished clay. Sometimes called

finger-paint paper, these papers are excellent for markers, which glide wonderfully across the surface.

We have already mentioned index cards and paper of various widths on rolls. The stiffness of index-card stock makes it especially desirable as a drawing surface for all kinds of drawing tools. A continuous roll of paper can lead to such creations as exciting narrative drawings.

Another word needs to be said about the quality of paper. Artists are often concerned about the grade and type of paper that they use, as they wish their work to be permanent. Children's work, on the other hand, is usually quite "disposable." Drawings are often thrown away within a few days or months of completion. For adults who wish to save children's work, however, we advise against newsprint and manila paper, as they soon become discolored and brittle. As collectors of children's art we sometimes have had to go to great lengths to preserve fragile pieces. We recommend using the best paper affordable; not only is better paper more permanent but it is usually more enjoyable to use.

A Special Place

By necessity, children who draw a lot or who spontaneously create other art generally find or make their own workplaces. In this respect children like the young C. S. Lewis or Michael L. are like adult artists and writers who must have their special places, arranged in their particular and sometimes peculiar ways, in order to work creatively. We have talked about the variety of spaces and places required by drawing children: from elaborately equipped and private places to the communal atmosphere of the dining table. There are also many children who do not actively establish their "creative territory." We believe that adults should assist children in establishing such spaces in homes and schoolrooms—these inviting territories can facilitate drawing and other creative activities. Sometimes it is best to mark off a space in a child's room where things can remain as the child leaves them—ready for another session—and where the valued work is safe from the hands of younger siblings or from exuberant pets. But wherever and whatever the spot set aside for the child's creative activity, it should be designated as such and agreed upon by adult and child.

Keeping a Record

We know adults who have carefully saved and documented all of the substantial output of a child's drawing activity. Recording the child's age, the date, and other pertinent information on the back of a drawing (and, in the cases of younger children, what they said about the picture), will later surprise and delight child and adults alike. This practice provides a record of the child's growth in ways that are often important and sometimes profitable.[7] It allows adults, too, to discuss drawings with children (Chapters 3, 5, 6, 7, and 8 are devoted to *what to say* and *how to say it*).

A Time to Draw

Finally, having supplied the child with the necessary encouragement, materials, and space to work, adults must allow children *time* for drawing as well. Children like Steven and Kelly will make time for drawing under any circumstances. Other children, however, who would benefit equally from these creative acts, are often kept so busy with other activities that there is literally no time to draw. Some adults try determinedly to keep children from being "bored" by providing them with all sorts of lessons and sports activities. Although these outlets are unquestionably valuable, they inhibit the very thing that has often given some of our most renowned artists and scientists the impetus to create: boredom. Maurice Sendak, author and illustrator of such popular children's books as *Where the Wild Things Are*,[8] says, "I was the kind of child who has to live in fantasy as much as he does in reality—probably because I was very easily bored."[9]

Regardless of the role that drawing plays in the lives of children—whether it is a total immersion or merely a wetting of the feet, whether it occupies a lifetime or only a few intense years—that role can be made more important and more exciting through the sensitive encouragement of concerned adults.

Figure 1-10

Ralf (age 11)

The stamps of the Netherlands are color-ful, imaginative, and visually exciting. This page of designs for "World Championship" stamps by soccer fan Ralf—showing one of the stars of the game, Ruud Gullit, and the stadiums in Naples and Palermo as well as the ruins of Rome—was inspired by the games that were taking place in Europe at the time. A careful look at two of the stamps shows soccer balls being kicked out of the stadiums.

Figure 1-11

Lennie (age 9)

Lennie's version of Caravaggio's *Calling of St. Matthew* is not a mere copy, but a young boy's interpretation of that famous work of art. He has added several more figures to the original five seated around the table. Those who look up from their gambling activities—and Lennie has made them drinking as well—to attend to the saintly pointing figure show their amazement through the placement of question marks over their heads. Lennie is as yet unsure of his ability to portray facial expression, but he has shown his understanding of the importance of Caravaggio's use of chiaroscuro—of dark and light. Notice the rays of light shown coming from the window in the background and the addition of shading to the left-hand portion of the picture.

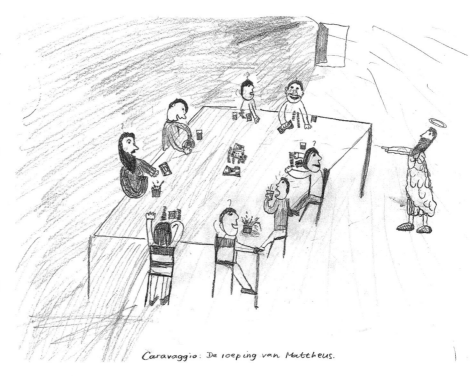

Caravaggio: De roeping van Mattheus.

Encouragement and Opportunity

A wonderful example of the way parents and teachers can collaborate to encourage children's drawings is represented by Ralf and Lennie's adventure. For the space of an entire year, two young boys from the Netherlands, with whom we had often drawn on our visits to that country, lived in the southern part of Italy. Their mother is an art historian and their father, who is a sociologist and a journalist, was studying the culture of the people of a small village. Since the boys—Ralf who was eleven at the time, and Lennie who was nine—could not attend school, they were given materials by their school in the Netherlands for the year's lessons so that they could keep up with their schoolmates. In addition, they kept in touch with their teachers and friends at school through a series of handmade newsletters, drawn by first one and then the other, chronicling their trip—the places they visited, (1-10) the works of art they saw, (1-11) the things they did, (1-12),and the things they learned. (1-13) While Ralf seemed to be more intrigued with Italian architecture and ruins, and with the happenings of everyday life, such as fishermen along the Tiber River in Rome. (1-8) Lennie was interested in interpreting works of art such as his "Picture of Giuliano de Medici with Day and Night by Michelangelo." (1-9)

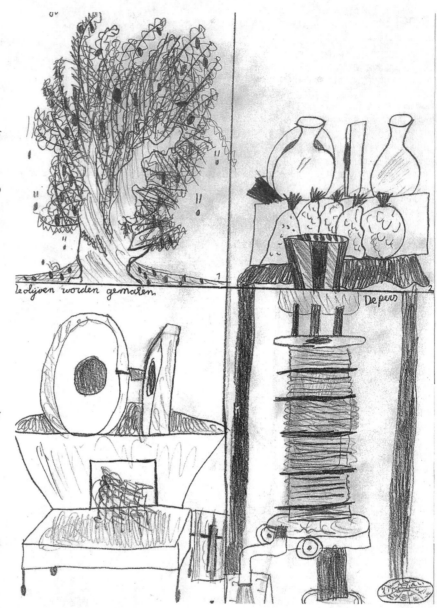

Figure 1-12

Lennie (age 9)

Like many young boys and girls who are fascinated by and wish to understand the way things work, in this series of four frames, Lennie shows the process of making olive oil beginning with the olives growing on the tree to their final destination, the press.

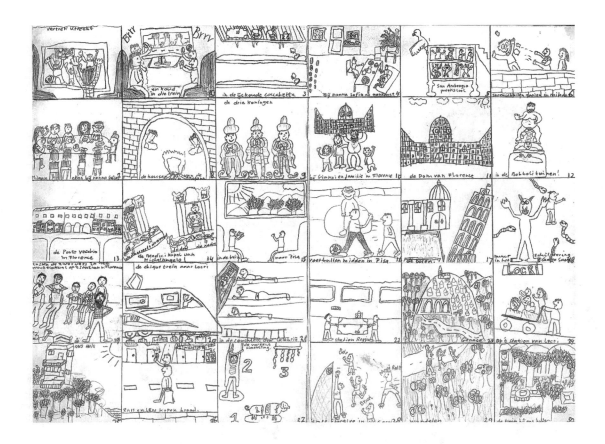

Figure 1-13

Ralf (age 11) and Lennie (age 9)

In this very complex series of drawings sent to a friend as a birthday gift, Ralf and Lennie together recounted their journey and arrival at their Italian village home. It starts with the train at Utrecht in the Netherlands. The winter departure is evidenced in the sixth frame by snowballs with which they pelt their father, but the sun shines brightly in Florence and Pisa and they arrive at their house in the village of Locri amid sunshine and blooming trees. Although the narrative journey recounts such village customs as the butchering of a pig, even in this tiny village soccer is an ever-present passion for Ralf and Lennie.

2

Why Children
Draw

Of all the drawings produced during the months of September and October when Dirk was eight, only 114 survive: six about "Mr. And and his Change Bugs,"[1] (2-1–2-6) in the course of which a giant cyclopean monster named "the Dubser" was born; the Dubser's own series of forty-seven sequential drawings; a coinciding nonsequential set of forty sheets, some containing as many as thirty drawings of "weird people"; (2-7) three drawings of imaginary cities; (2-8) three large panoramic depictions of the battles of the Dubser; (2-9) an eight-drawing sequence of the adventures of an anthropomorphic jet plane; and seven illustrations of riddles and tales. (2-10)

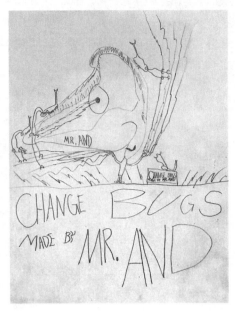

Figure 2-1

Dirk (age 8)
Change Bugs Made by Mr. And—1 (pencil)
10″ × 13″

The character with the exaggerated head is identified by Dirk as Mr. And, who is sending shock waves from his hands and eyes to the Change Bugs on his nose and head. "The Change Bugs have been invented by Mr. And. He finds they have certain powers that can make things change. Mr. And is bad—a sort of crook. He is trying to rob banks to get more money to rule the world."

Figure 2-2

Dirk (age 8)
Change Bugs—2 (pencil)
10″ × 13″

From the left of the drawing, Mr. And looks on as the king of the Change Bugs does his evil work. "Mr. And," Dirk said, "directs his Change Bugs to change people into weird things so that they are almost helpless."

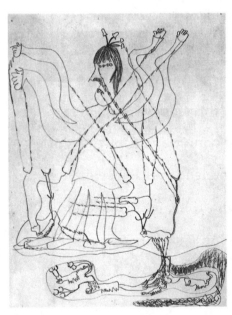

Figure 2-3

Dirk (age 8)
Change Bugs—3 (pencil) 10″ × 13″

"Mr. And has directed the Change Bugs to dig a hole and anyone who passes over will be changed. Part of the changing is getting more arms and legs, but not always."

Figure 2-4

Dirk (age 8)
Change Bugs—4 (pencil) 10″ × 13″

"King Change Bug is changing a woman into something that will squish all things or people that get into her way or under her feet."

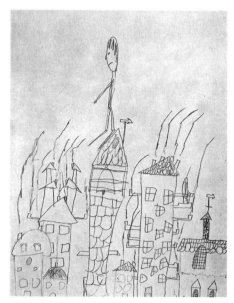

Figure 2-5

Dirk (age 8)
Change Bugs—5 (pencil) 10″ × 13″
In this picture the Dubser is born from the nose of a "changed person." The little figure (above) is a changed lady. The Dubser now has a tail but he will lose it. The Dubser down below is the adult Dubser and he is hanging on to "the change power."

Figure 2-6

Dirk (age 8)
Change Bugs—6 (pencil) 10″ × 13″
In this last drawing, Dirk says, "The new series is born—the weird people series. The Change Bugs have accidentally changed people into futuremen."

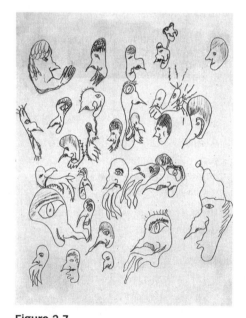

Figure 2-7

Dirk (age 8)
Weird People (pencil)
10″ × 13″

Dirk has followed the lead of Mr. And and created this rogue's gallery of characters who appear to have been fashioned of Silly Putty®. They sprout multiple chins, eyes, and sometimes heads; heads twist and turn and contort grotesquely; noses meander. Some characters appear sinister, some meek, and others simply bemused—a sort of play with characters and characteristics both.

Figure 2-8

Dirk (age 8)
Imaginary City (pencil)
10″ × 13″

This drawing combines Dirk's vivid imaginary *prophetic reality*—in one's everyday life it is difficult to stride from the top of one building to another; in drawing it is easy—and the *common reality* of the tall apartment buildings he had seen on a trip to Scotland and Germany.

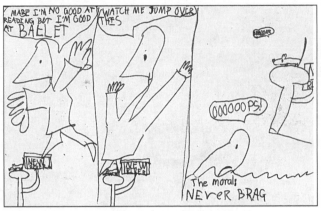

Figure 2-10

Dirk (age 8)
The Bragger (ballpoint)
5″ × 8″

To brag or not to brag: that is the question that Dirk seems to be confronting in this playful drawing. Bingo! A full card for the *normative reality*.

Figure 2-9

Dirk (age 8)
The Dubser Under Attack (colored marker)
18″ × 24″

The giant cyclopsian Dubser is being attacked by formations of airplanes, guns, rockets, helicopters, parachutists, and barrages of assorted missiles. The sense of destruction is heightened by the scribbled smoke emanating from the nostrils of the Dubser and from the points of impact of the missiles upon his body. The Dubser is "bloodied but unbowed."

Children draw, we have said, in order to symbolically explore their worlds. But surely the world is not one of Change Bugs and monsters and weird people. What, then, do these things symbolize? What role do these fantasies play in Dirk's intellectual development? How do they relate to his sense of self, and of pleasure, to his dreams and desires, and to his understanding of such concepts as good and evil?

Let us explore these and other questions as we examine the drawings of Dirk and other children like him. It is the exceptional and varied nature of Dirk's somewhat unusual production that will enable us to answer these questions

and to understand some of the complex and important reasons why children draw.

We believe that our original premise of coming to know the world is the key to understanding the nature of drawing activity. To know ourselves, we must also know the world and understand ourselves in relation to that world. For Dirk, at eight, the world is still full of unknown terrors and pleasures about which he seeks to learn. Similarly, adult adventurers before him have sought the unknown, leading them to explore foreign lands, the depths of the ocean, the mysteries of outer space, the layers of human consciousness, the microscopic

worlds of biology, the theoretical realms of nuclear physics, the possible and the impossible.

And yet only a few can know these realms at first hand. A great deal of our "knowing" about the universe is disclosed to us in the form of literature, of science, and art. It was Jules Verne who first took us "20,000 leagues under the sea," "around the world in eighty days," on a "journey to the center of the earth," and from "earth to the moon." In the Sistine Chapel frescoes, Michelangelo depicted the entire biblical panorama from the Creation to the Last Judgment; Einstein gave us a relative universe; and these are only a few examples

that can be derived from stories, novels, paintings, illustrations, scientific theories, films, photographs, and maps. The presentation by writers, scientists, and artists of the inaccessible, unknown, and otherwise unknowable realities is invaluable, even essential to the "coming to know" of each individual. But what of the special plight of children, who have the most knowledge to acquire and the fewest means of acquiring it? Firsthand exploration is furthest from their grasp—imagine going to India when you aren't allowed to cross the street alone—and symbolic exploration of realities through the arts and other media is still out of reach because children have not yet attained the skill of "reading" books, maps, formulas, and dia-

grams as adults easily do. There is one notable exception, however: media that are primarily visual and correspond in at least some ways to the child's firsthand experiences of the world—television, the internet, films, drawings, and paintings. These visual symbols require "reading" as much as word symbols do, but the media-saturated child of our society acquires the skill early. The process of reading visual symbols begins almost at birth with the continuous bombardment of visual stimuli that display actors, actions, objects, and places. These visual symbols—pictures—provide children with their primary symbolic means for understanding reality. The apple in the alphabet book is not edible—but it is a symbol for *apple* that the child understands.

By the age of three or four most children are able to master the necessary rudimentary means for presenting their own ideas and experiments about reality in observable symbolic form. Years before they can set down their original ideas in writing and numbers, children are able to record their ideas, feelings, and experiences through their drawings, as artists do—a record to which the child can return time and time again and one that he can share with others. This is what we believe to be the case with Dirk's drawings; with them and through them, he was developing, presenting, and examining his own ideas about the realities of the world.

Drawing to Know

We often talk to children as though there were only one true reality. We say, "Is it *really* true?" "There are no giants and witches," and children ask, "Is there *really* a Santa Claus?" But what is this reality that we insist upon sustaining? It is only one of the four realities described by Hans and Shulamith Kreitler[2]— the *common* reality, the reality that refers to the familiar and everyday perceptions and experiences of objects and events that humans share. The other three realities, each of which we will examine, are the *archeological*, the *normative*, and the *prophetic*.

Inventing the Familiar

Almost as soon as he realizes that the circle he makes on the page can "stand for" an apple just as the shiny red orb in the alphabet book does, the child begins to draw the everyday objects of the common reality. He draws a person, a house, a tree; and it is easy to believe that learning about the familiar things of his world is a simple matter of observing them. But is it? The well known Swiss psychologist Jean Piaget noted that the creation of new thoughts or ideas are not determined "by encounters with the environment, but are constructed within the individual himself . . . the essential thing is that in order for a child to understand

something, he must construct it himself, he must reinvent it."[3] This reinvention is necessary for the child in every aspect of the four realities, as we shall see, and no less so in the understanding of the world around him. Although Piaget's reinventing is a mental structuring, drawing makes these thought structures perceivable to the child.

In their drawings children create characters, objects, and settings very much like those in make-believe play. But the marks representing mommy, house, and baby are more concrete than the simple declarations of play—"You be the mommy and I'll be the baby." Another psychologist, Erik Erikson,

says of play what we know to be true also of much of children's drawing: that it is "the infantile form of the human propensity to create model situations in which aspects of the past are relived, the present represented and renewed."[4] In this way children are the creators of their own worlds, in which things may be seen, and examined, to find out what they are like, what they can do, and how they work.

How do Dirk's drawings reinvent the common reality? Although the drawings about Mr. And and the Change Bugs (see pages 20 and 21) and the monstrous Dubser do not appear to relate in the least to the reality of our everyday existence, there is more to these seeming flights of fantasy than is immediately apparent. The story, in fact, is about control and the way one person can be controlled and forced to do another's bidding. Certainly a small boy feels that he is continually being controlled—by parents, teachers, siblings, and, at times, even friends. It is speculation to say that Dirk's Mr. And series was an unconscious attempt to gain or to understand control through the symbolic practice of controlling, but surely it is a possibility. Could the metamorphoses the characters undergo due to the action of the Change Bugs relate to the often bewildering physical and emotional changes occurring in children every day? The birth of a new character—if only from the nose of a "changed person"—may be an effort to understand birth, a most perplexing process to a child. Even the buildings in Dirk's cities seem to relate to the apartment houses he had seen a few months

earlier on a trip to Germany. His drawings seem to perform a continuous structuring and restructuring, "the past relived, the present represented" in terms that an eight-year-old boy could understand.

When Andy S. was eight and nine, he worked with an astonishing variety of themes and ideas, but, unlike Dirk's more complex ideas, one element persists throughout his entire prodigious output (in the course of three months he filled both sides of nearly 400 sheets of paper with drawings): an attempt to master the depiction of common objects. His work includes drawings of motorcycles in all of their mechanical detail, (2-11 and 2-12) the dimensionality of shoes and cars, and recognizable portraits of the people in his world. (2-13) He is concerned, too, with the mechanics of things and the way they might work; (2-14) he creates models of factories that manufacture not only automobiles but bionic parts and people as well. (2-15–2-17) Sounds also find form in the common reality as Andy seeks to depict the tones emitted by a rock singer. (2-18–2-20)

Hardly a drawing produced by a child is without at least some aspects that relate to depictions of, or the making of models for, the common reality. At times, these depictions symbolize relations between people or growth and other seemingly unfathomable mysteries; at other times they are an attempt to show details, to understand actions and the working of machines, or even to depict the unseen, such as a sound.

Figures 2-11 and 2-12

Andy S. (age 9)
Motorcycle (pencil)
8½″ × 11″

Andy S. (age 9)
M.M.A. (pencil)
8¾″ × 12¼″

These are only two of the dozens of motorcycles that Andy drew over a two-year period. His attention to detail and accuracy has fostered attempts at shading in order to pin down as clearly as possible the many nuances of the common reality. How better to attain a desired treasure than to create it in all its glorious detail, a symbolic wish fulfillment?

Figure 2-14

Andy S. (age 9)
Mechanical Characters (pencil)
8½″ × 14″

For Andy's depiction of these robotlike crea-
tures, he has surely referred to those objects of
the *common reality* that he repeatedly draws—
the motorcycles with their shiny mechanical
parts and the people with their bodily dimen-
sions and movements. As with most drawings,
no one reality is isolated but elements of the
four realities—including the *archeological reality*
of the self (what powers can a young boy envi-
sion?), the *normative reality* (the good and the
evil), and the *prophetic reality* (what may the
future hold?)—are incorporated.

Figure 2-13

Andy S. (age 9)
Portrait of an Old Woman (black crayon)
8½″ × 13¾″

Andy's father, who is an artist too, sometimes draws portraits of his friends. Perhaps
this is where Andy got the idea for this sketch of an elderly neighbor. In recording this
aspect of his common reality, he has attempted some difficult feats and has displayed
remarkable perceptual abilities for a nine-year-old. These are evident in the angle of the
glasses and the interlocked fingers.

Figure 2-15

Andy S. (age 9)
Automobile Factory (pencil)
8½″ × 14″

Andy's drawings of factories that manu-
facture everything from parts for bionic
people to automobiles are like diagrams
and, although they are highly imaginative
they are also attempts to show, or more
accurately to understand, the *common
reality*. After drawing one of his manufac-
turing plants, Andy would go to his father
for approbation ("Is this the way they do
it?") and for reinforcement ("I'm pretty
smart to have figured it out, aren't I?").

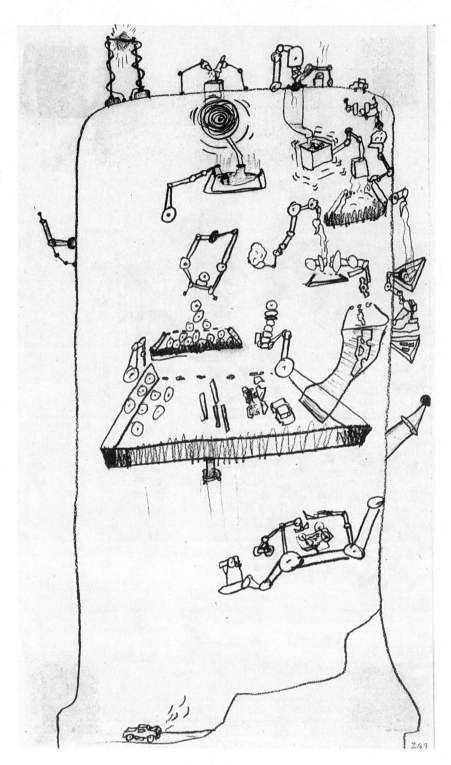

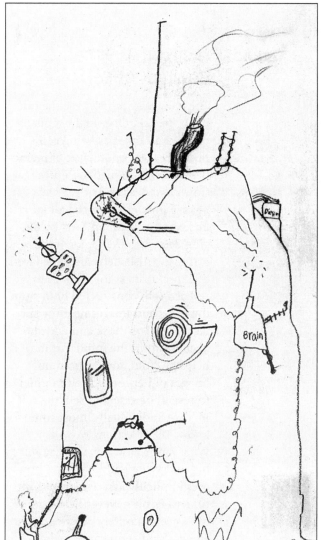

Figure 2-16

Andy S. (age 9)
Machine with a Brain (colored pencil)
8½″ × 14″

While the automobile factory requires no human assistance, this great machine appears to be manipulated by the small figure seated at the controls on the lower left. The homunculus and the humongous machine together may explore possibilities for manufacture, although only the workings are clear; no product of their collaboration is evident. The real subject appears to be control—at the touch of a button.

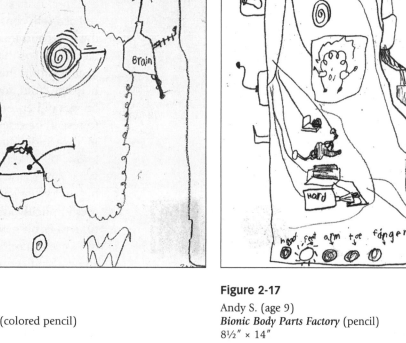

Figure 2-17

Andy S. (age 9)
Bionic Body Parts Factory (pencil)
8½″ × 14″

Any one of the five buttons on this machine—variously labeled head, feet, arm, toe, and finger—can be pushed to create the desired bionic body part. We can see that the button labeled "feet" is in operation and observe the complete process from liquid state (boiling cauldron at top left) to a fully formed skin-colored foot coming off the conveyor belt at the lower right.

Figure 2-18

Andy S. (age 9)
Rock Singer I (pencil)
8½″ × 14″

Sounds find form in the *common reality* as Andy seeks to depict the tones produced by a rock singer. This is perhaps the simplest of Andy's series of singers from whose vibrating tonsils sounds emanate.

Figure 2-19

Andy S. (age 9)
Rock Singer II (pencil)
8½″ × 14″

The head of the singer appears to disintegrate as the "sound" lines that are so numerous and varied all but drown the musician.

Figure 2-20

Andy S. (age 9)
KISS (pencil)
8½″ × 14″

Although the frantic and grotesque theatricality of the rock group *KISS* and the "reality" it invokes are far from common and Andy's depiction uncommonly good, the group is nevertheless a part of the young boy's experience. Andy is able to convey the enormous energy of these musicians in their attitude, arrangements, and actions, and achieves a feeling of space and dimension through the use of overlap and placement on the page.

Delineating a Concept of Self

The *archaeological reality* is the reality of the self. One might think of the human mind as being composed of layer upon layer of memories, feelings, thoughts, impressions, and desires. The Kreitlers believe that, just as archaeologists uncover historical artifacts by digging deep into the layers of the earth, so artists delve into the layers of consciousness through art to reveal a self, constructed both from the ideas and images near the surface as well as those embedded deeply within the mind. Art may help the child, too, to hold up images of her- or himself in order to reveal the essential self, the self that we, individually, must come to know. The questions, Who am I? What am I? How am I? What will I be? and What will I become? however implicitly asked, require a lifetime to answer. Nevertheless, none of us seems entirely satisfied just to sit back and see what will happen. We all engage in an ongoing symbolic investigation of the nature of ourselves. We invent and reinvent self-possibilities through our Walter Mitty–like daydreams, and through measuring ourselves against associates, historical figures, and fictional characters.

This self-defining process is an important dimension of children's drawings. When Erik Erikson spoke of how children experiment with self-images through their play, he might well have been speaking of children's drawings:

Childhood play, in experimenting with self-images and images of otherness, is

most representative of what psycho-analysis calls the ego-ideal—that part of ourselves which we can look up to, at least insofar as we can imagine ourselves as ideal actors in an ideal plot, with the appropriate punishment and exclusion of those who do not make the grade. Thus we experiment with and, in a visionary sense, get ready for a hierarchy of ideal and evil roles which, of course, go beyond those which daily life could permit us to engage in.[5]

And how do Dirk's drawings represent the archeological reality? Returning to his depiction of the reprehensible Mr. And, we would hope that this creation represents a character that Dirk found to be unacceptable and that he rejected as a possibility for himself. (We think that he did.) On the other hand, the monstrous Dubser presents some interesting possibilities for knowing one's self and one's feelings. The size and power of the Dubser, characteristics notably lacking in the person of a small boy, are certainly desirable, a fact to which the popularity of media heroes, antiheroes, and superheroes attests. To possess the extraordinary powers of these larger-than-life heroes is the passionate desire of the small child, whether to fight the forces of evil or to stand toe to toe with the dominating adult. So it may have been in Dirk's struggles with the Dubser, as he experimented with the possibilities of power and size. In Dirk's drawings the Dubser (2-9) always stands alone, outnumbered but never overwhelmed by innumerable diminutive attackers (because like King Kong, the image of whom the Dubser series evokes, he is so much larger than any of his adversaries). He is attacked by formations of jet planes, the artillery, meteorites, and fires, as he stands, undaunted, feet planted firmly on the ground. The world, to a young child, is not only bewildering but threatening, and it is necessary to marshal all of the courage and strength one can in order to protect oneself and solve one's problems. We see Dirk dealing with the layers of the self, with ways he would not wish to be as well as ways that he might like to be, with a myriad of "ideal and evil roles." This is evident in his "weird people," depictions of characters who each possess the potential for being and acting in particular ways, desirable and undesirable, and each represent possible ways that a person might be.

Superhero

From about the age of eight until fourteen, Per, a boy from Sweden, continuously drew the popular 1980s television character, The Incredible Hulk. (2-32) The Hulk may seem like a strange candidate for a young boy's continued eager attention. Of all the superheroes, he was the least physically appealing, at least to most adults. Superman and Batman were handsome, attractively muscular, and always moved with a certain elegance and grace. The Hulk, on the other hand, was muscle-bound, lumpy and lumbering, a jackhammer of a character, almost bestial. Each of the three heroes had an ordinary man as an alterego, but when Clark Kent and Bruce Wayne were changed to Superman and Batman, it was more a matter of changing costume than character. When David Banner changed to the Hulk, on the other hand, he changed from a man to an apelike savage. The excitement, for a child, lies in all of this raw power unleashed, the dream of overpowering one's adversaries. Like Dirk's Dubser or Tami's horse, (2-21) which was bigger and stronger and faster than any other horse, The Incredible Hulk represented the size and power that the child lacks yet desires in order to control his or her world. In addition, the character of the Hulk bought into the cultural myth of the supremacy of the primitive, the noble savage who is purer, more innocent, and therefore more like the child. It is not so surprising, then, that children have been able to relate to this unlikely hero.

Surrogate Self

If the child is experimenting with self-images and self-possibilities, why do we not always see drawings that are recognizable as that child? Just as we recognize as ourselves figures in dreams that bear no physical resemblance to the self we see in the mirror, the dream and the child's drawing present a mirror of a different sort. The reflection we see is a substitute, or a surrogate self. The little girl who tells a story in which a child disobeys and defies authority makes her protagonist a boy; or sometimes the main character in a self-story is an animal, often a horse, or perhaps an insect, or even a car or truck. Just as dream images are created in ways we are unaware of, so the drawn images of the child are created without her being aware of them as self-images. In this way the child

Figure 2-21

Tami (age 7)
Horse (colored markers)
8½″ × 11″

Tami, like countless other young girls, was fascinated by the image of the horse. This was only one of many she drew, all of which stand or gallop regally, beautifully bedecked, their tails brushed and luxurious. In their proud stance and decorativeness, these horses relate to Tami's many drawings of elaborately costumed women.

may safely experiment with even adverse feelings and ways of being that she wishes to understand, so she might hold them up for examination and accept or reject them as possibilities for herself.[6]

When Tami was eight, she experimented with a multitude of images.[7] Many were beautifully drawn horses, (2-21) a typical favorite of many girls of this age. Tami told stories about horses, too—horses that were bigger and faster and more beautiful than any other. Ways that a child might wish to be? Certainly. But even more than ideal horses, Tami experimented with the ideal—and the evil—in her depictions of women. (2-22 and 2-23) Most of Tami's women are beautiful, with long, dark, flowing hair, sometimes falling to the waist (Tami's hair is short and blonde). They are svelte, generously endowed, and sexy—full-lipped, sloe-eyed, elaborately costumed. The cast of characters in Tami's drawings includes dancers and acrobats, a genie, Wonder Woman, spies, detectives, and a vampire woman. These characters, ranging from benign to evil, seem to map the vast terrain of ways that one little girl might be.

If Tami's horses were, ideally, bigger and faster and more beautiful than any other horse, or ways that horses—or little girls—might be, Lois's horses were truly surrogates, not only for her self, but for her family and her teachers as well. Unlike the worlds created by Dirk or Tami or many of the other children whose work we have studied, Lois's world is more pervasive. Her invented world echoes her perceived reality, as the mother horse bakes cookies and goes shopping and brings home goodies for the good horse children, of whom there are four (as there are four children in Lois's family). The father horse has a workshop in back of the barn (in which horse children are not allowed); he drives a station wagon ("just like our car") and he plants a garden. (2-24) The reality of self depicts Lois/horse in any number of roles, each performed in her horse guise. At one time she is drawn sitting at a table, drawing, an array of crayons on the surface in front of her. In another drawing Lois/horse is eating her lunch from a lunchbox at her school desk.

Experimenting with Good and Bad

The *normative reality* is the reality of good and bad, of right and wrong, of just and unjust, a reality of standards, subsuming the implicit and explicit rules by which an individual or a society behaves. Young children must reinvent for themselves the standards of right and wrong—which kinds of behavior are proper and improper—in spite of the fact that they are continually being told to behave in ways perceived to be desirable by adults. Because the consequences of exper-

Figure 2-22

Tami (age 7)
"Evil" Woman (colored marker)

For a seven-year-old there are very clear lines of demarcation between good and bad, black and white, evil and ideal. This obviously evil woman is recognizable not only by her bewitching beauty but by her garments as well. Most of Tami's temptresses throw dark cloaks about them or the cloaks flare widely and surround them in darkness.

Figure 2-23

Tami (age 8)
The 3 Hawiyeye Spiyes [sic]
(colored marker)
4¼" × 4¾"

If her darkly cloaked women represent the ultimate evil for Tami, these three glamorous and beautifully costumed innocents represent the good (and certainly the "ideal" self a young girl strives for). Like many a heroine Tami sees on television, these spies fight the forces of evil, right all wrongs, and restore order to the world.

Figure 2-24

Lois (age 8)
Lois/Horse
16″ × 20″

The horses that Lois drew do almost everything a child does. They sit at a desk, consult the dictionary, and draw with crayons.

Figure 2-25

Lois (age 8)
Lois/Horse
16″ × 22″

The mother fixes dinner in the kitchen, the children wait, and the father rests on the living room floor. When Lois was seven and eight years old she populated imaginary worlds with thousands of horses. Her horses, we think, were "stand-ins" for humans.

imenting with or engaging in actual improper behavior are dangerous at best, symbolically engaging in this improper behavior through drawing makes the exploration of the normative reality a relatively safe pursuit. Through their drawings, children can portray themselves as either the evil or the good—or both (in the same way that in their make-believe play children have universally been alternately *cop* and *robber*, *cowboy* and *Indian*)—and may then plot the consequences of each role. In this way they are able to symbolically determine how they might be and how they ought to be.

In most cases it is not possible to isolate one reality. Several realities are most often jointly explored and fused so that, for example, the ideal and evil roles described as the *archeological reality* of self are held up to careful examination, as the *normative* and the *archeological* fuse. Dirk's drawing of the "Ballet Bragger" (2-10) shows a character who claims that he may not be "good at reading" but that he is "good at ballet," attempting to jump over the "new river." But, "oops," he lands in the water instead, while a little mouselike observer quietly mutters, "Bragger." The story ends with the moral, "Never brag." Dirk was surely experimenting with proper and improper ways to behave and, as an observer like the mouselike creature, could safely stand at a distance, examine the consequences, and perhaps decide against bragging.

A more complex, and possibly the most intense, example of normative-reality testing that we have seen is the comic-book-format pro-duction orchestrated by Bobby when he was in the eighth grade. Instructed by his art teacher to create a superhero, Bobby gave birth to Goldman. Not part of the assignment, however, was the sixteen-page "origin" that Bobby painstakingly drew over a period of several weeks at home on weekends and after school. (2-26) The themes of the story are duty, friendship, and moral obligation explored in a variety of scenarios within the larger framework of adventure, rebirth, and restitution:

Two unemployed "astro-pilots" are forced to take part in a plot to rob Fort Knox. Because Ted has the obligation of a wife and children to support and a "status to live up to," he is more affected by the layoff than the bachelor, Chuck, and so becomes involved with and inevitably in debt to loan sharks. He must go along with their subsequent dastardly plan to rob the gold from Fort Knox in order to repay his debts and implicates Chuck, who agrees, because "what are friends for?" During the robbery, which is elaborately orchestrated to include space shuttles, lasers, underground tunnels, and a complicated coupling of two ships in space, Ted is wounded by a guard's "lucky shot." Refused a doctor's treatment by the crooks, Ted is forced to join Chuck in taking the gold into outer space, where his head wound finally weakens him to the point of unconsciousness.

In an attempt to save his friend and the ship, Chuck jettisons the gold, which is then drawn toward a meteorite "containing fantastic powers far beyond the capacity of man" and subsumed by it until "the characteristic properties of the gold are drastically altered . . . the gold takes on all the awesome powers of the meteorite." Unable to save his failing ship, Chuck is then "hurled out into space where he'd instantly die . . . if not for being sucked into the vacuum. He enters the meteorite . . . the transformed gold pours all over him . . . and so, in that moment that the gold supercharged the body of Chuck Salvin, renewed every cell, was created Goldman!"

After discovering that he has taken on all of the marvelous powers of the meteorite, Chuck returns to earth as Goldman and, as if to atone for his crimes, he performs all manner of good deeds, but foremost is his desire to avenge the death of his friend Ted. He locates and refines gold from the California mountains and restores it to Fort Knox, rounds up the gang of crooks, and finally confronts their leader. In an effort to retreat from the menace of the approaching Goldman, the villain backs through a window, crashes to the sidewalk below, and is killed. Goldman philosophizes, "He was killed by his own cowardice! Well, at least I've learned a lesson from this bloody mess—not to strive for vengeance—but for peace."

Consider the moral issues explored in this graphic narrative by Bobby in the guise of Goldman: the decision to steal in order to aid a friend, risking one's life for a friend, making restitution for past deeds, seeking vengeance but being stopped short of that error, and gaining insight, in the end, into the importance of the conquest of good over evil.

Most drawings by children do not display the number or complexity of good and evil roles that the sequential narrative character of

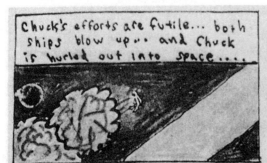

Chuck's efforts are futile... both ships blow up.. and Chuck is hurled out into space....

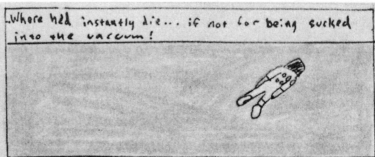

..Where he'd instantly die... if not for being sucked into the vaccum!

He enters the METEORITE!

His space suit, and clothes are instantly singed off! As his skin begins to burn...

The transformed gold pours all over him....

And so, in that moment that the gold super-charged the body of Chuck Salvin, renewed every cell, was created... GOLDMAN! who takes on all the fantastic cosmic powers of the meteorite!

Bobby's drawing allowed, although we do find normative themes to be a consistent concern. The theme we see repeated time and again in scores of children's drawings collected in both the United States and Australia is that of a crime committed, the criminal apprehended and, in the final frame, foiled or occasionally even executed. (2-27 and 2-28) Although the depiction of the act itself may afford the child some measure of excitement or even satisfaction, the more important dimension for children seems to be that the crime is punished. The reaffirmation that *crime does not pay* seems to be a valuable outcome of the exploration-through-drawing of the normative reality.

Certainly, many children are less concerned with exploring the consequences of crime and its punishment than they are with the rewards of good behavior. Lois's stories consistently reveal the advantages of being good. In the first frame of one sequential story, a horse mother calls upstairs to her horse children that they must be good while she goes to the store, "and they were." They are frequently rewarded for their good behavior with a bucket of oats— or a plate of cookies.

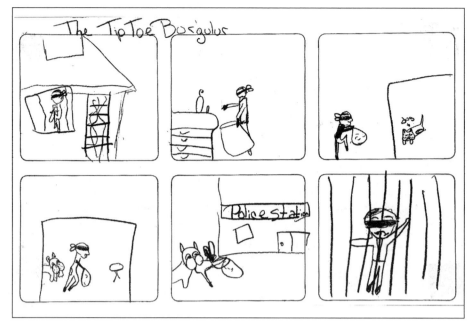

2-27

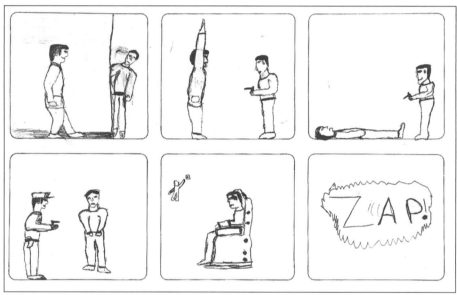

2-28

Figure 2-26

Bobby (age 13)
Page from *Goldman* (colored pencil)
9" × 12"

In this stupendous cosmic explosion, the figure of Goldman emerges like a phoenix from the ashes—renewed, reborn, immortal. Bobby's 16-page adventure has built both narratively and graphically to this climactic point. The themes that pervade the story—duty, friendship, and moral obligation—make this an extraordinary depiction of the *normative reality*.

Figure 2-27

Girl (grade 6)
The Tiptoe Burgulur [sic]
individual frame size 4¼" × 4¾"

There is no question that the "Tiptoe Burgulur" is stealthy, but he is no match for the dog. The story may be humorous. The message, nevertheless, is clear: we will suffer the consequences of our own actions. The "go to jail" ending with the culprit behind bars is common in the story drawings of American and Australian children.

Figure 2-28

Boy (grade 8)
The Electric Chair
individual frame size 4¼" × 4¾"

Crime does not pay. While *The Tiptoe Burgulur* presents a humorous exploration of the consequences of good and evil actions—the *normative reality*—*The Electric Chair* is shocking, not only in its conclusion but in the boy's frank approach to the theme—let the punishment fit the crime!

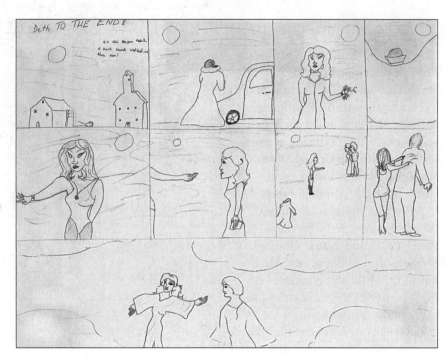

Figure 2-29

Tami (age 9)
Deth [sic] *to the End* (pencil)
18" × 24"

The *normative reality*—of good and evil—and the *future reality* of growing up, of love and death, are all explored in this narrative by Tami. The drawing clearly differentiates good and evil, with the sinister female and the sweet young thing (this is the part Tami has chosen to play herself). Although good and evil are clearly defined, *evil* is shown as attractive, even enticing, as the sinister female beckons in the sixth and seventh frames. Her touch plainly means death, but we are led to wonder exactly what it is that the temptress is offering the young people that leads to their demise. Perhaps it all began with Eve offering the apple to Adam.

Drawing the Future

Not only do the drawings of children create Erikson's model situations "in which aspects of the past are relived, the present represented and renewed," but "the future [is] anticipated" as well. We all anticipate the future and seek to control future wants in a variety of ways. We construct, refine, and rehearse anticipated events, encounters, and conversations. Art has served this future-anticipating function for countless civilizations, probably for as long as art has existed. It is thought that the cave painters produced images on cave walls in order to assure the success of the hunt by invoking images of the animals they wished to control. Middle Eastern Nasrudin tales are seen as "word pictures" which, in the creation of symbolic situations, prepare the listener for similar situations to be encountered in later life.[8] Possible worlds are symboli-

cally created in science fiction; many decades before humans traveled in space and before such travel seemed to be even a remote possibility, Flash Gordon of the comics was there and Jules Verne had journeyed to the moon. Drawings provide a vehicle for children to develop models for their own future selves, actions, and worlds.

Each of Dirk's drawings that we have examined has involved the *prophetic reality* in some way. The control of Mr. And over the Change Bugs may be a way to understand both the present control of others over a little boy, as well as the anticipation of future control or authority over others. The "changed people" and the "weird people," too, show layers of self-past, self-present, and possibilities for self-future.

Tami's drawings of mature women may serve as ways of exploring dimensions of her present self, as well as anticipating what

she may be and how she may look when she herself is a mature woman. This reality is more fully explored in one of her story drawings, "Deth [*sic*] to the End," (2-29) drawn when Tami was nine years old, which creates all of the tensions of a melodrama and deals with several dimensions of the prophetic reality. Tami sets an anticipatory scene in the first frame: a "dark sound" makes us wonder what will happen next. The next frames introduce a sinister vampire-type female whose evil powers are demonstrated through the depiction of a flower that has withered and died at her touch. This death-touch becomes prophetic of the story's end: would such a creature be content merely with the death of a flower? In the sixth frame a teenager, identified by Tami as her (obviously future) self, appears, followed closely by the appearance in the next frame of a boyfriend (also anticipated in the

future). Contact with the vampire precipitates the death of boy and girl, who are reunited in heaven, in spite of the fact that Tami confided, "I don't believe in heaven."

In her story, Tami has dealt with a future life on earth and a possible and perhaps hoped-for life in heaven. Indeed, the drawing anticipates growing up, romance, danger, and death—but, isn't death a morbid and frightening thing for a nine-year-old to anticipate? Death is, in fact, a theme commonly found in children's story drawings. Frightening? Perhaps, but simply another fact of the world to be examined and understood and anticipated, possibly made less frightening, as most of our fears, once revealed. Art once more serves these purposes, whether in a famous painting depicting the glories of heaven, such as Michelangelo's *Last Judgment*, or in a children's book parodying the child's innermost fears in the confrontation with . . . *A Nightmare in My Closet*.[9] Tami's anticipations are not frightening; on the contrary, they are playful, delightful, and optimistic.

Drawing and Becoming an Artist

Children shape symbolic visions of their futures through the drawings they create. It is also the case that some children's drawings have another kind of predictive power. At this very moment a few children are drawing the same topics and themes that they will continue to create when, many years in the future, they become adult artists. Indeed, when we encounter young

people who have an extraordinary gift for drawing, we often wonder "will this kid become an artist?" Some of the children whose work we have studied have certainly become artists. Michael L., for example is now a respected graphic designer who specializes in creating promotional materials and advertisements—which appear in prestigious magazines such as The New Yorker and on New York City busses—for museums such as the Metropolitan Museum of Art, the Museum of Natural History and the Art Institute of Chicago. For Dirk, on the other hand, "Mr. And and the Change Bugs" are a distant memory. He is now a pediatric cardiologist and the imaginative drawings found in his house today are made by his own children.

One of the surest ways to determine the links between childhood drawings and adult artworks is to ask artists, "what was your drawing like when you were young?" In our interviews with artists such as Robert Andrew Parker and David Levine, we have discovered that the themes that pervade adult artwork often have their roots in their childhood experiences—and drawings. Parker, who has illustrated a book on Mary Shelley's *Frankenstein*, recalls an early memory of his parents excitedly discussing a Frankenstein movie they had seen the previous evening. His depictions of wartime may have their roots in the stories of North African campaigns told to Parker by his Italian nurse. David Levine, one of America's foremost political and literary caricaturists describes how his politically-interested mother insisted that his father make drawings of Marx

and Engels to decorate their apartment walls. Levine also recalls one of his first lessons on the power of the political pen. During World War II he was expelled from Erasmus High School in Brooklyn for drawing a statue of Erasmus shedding tears as uniformed boys marched through the school's gates and off to war. The school's vice principal was enraged by Levine's explanation for Erasmus's tears, "but they're not coming back."

During the 1980s, the artist Robert Yarber gained an international reputation for his paintings depicting nocturnal scenes in which figures—some are solitary and others are embracing pairs— fall or float or levitate past hotel and high-rise windows, from the balconies of motels, over cities, over lighted swimming pools. We are fascinated by the paintings of Robert Yarber—both because of the similarity between some of the drawings he made while he was a child and his mature work; and because he continually experiments with new means to create his images. Recently he has begun to explore the various contributions that computer-generated and computer-manipulated imagery might make to his artworks.

One complex drawing that Robert Yarber made between the ages of ten and twelve shows a wild west barroom complete with the requisite indians, beer-swigging piano player, card playing, cigarette smoking cowboys, inebriated figures passed out on the barroom floor, and fancy women. (2-30) Amidst this wonderful cast of characters the action takes place: a shoot-out, a stick-up and the

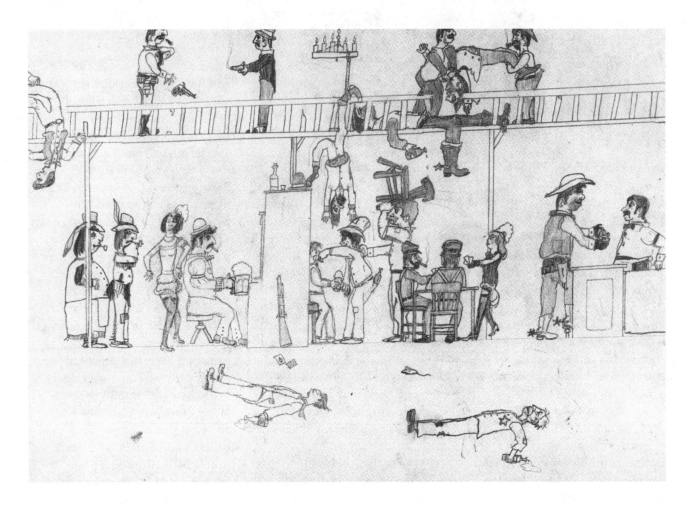

essential barroom brawls. One figure flys over a balcony, another hangs from the chandelier by a rope tied to his ankle, and a third figure is suspended between two men who appear to be about to throw him over the railing to the floor below. In Yarber's 1992 painting (2-31) *Crisis in Western Representation*, we see the interior of a movie theatre. In the immense space just beyond the balcony, a falling figure is silhouetted against the screen, on which Yarber has represented a projected scene from a classic Western movie. In this showdown a wounded gun-fighter seems to hang suspended as he sprawls in the dust. In the lower left corner a couple embraces passionately. In the drawing Robert Yarber made as a boy the barroom

brawl was just a good fight. In his 1992 work, however, the movie theatre becomes a site in which to explore metaphorically not a few of the philosophical issues concerning representation in paint and on film. Sometimes a fight is more than just a fight.

By the age of twelve Yarber had developed considerable skill in depicting the human figure. Nevertheless, he has spent a fair portion of his artistic lifetime perfecting his drawings of flying and falling figures and playing with the meanings of human figures who are mostly subject to the forces of gravity and the few who are able to defy it. The spaces in Yarber's recent works still contain levitating and falling figures, but now Yarber makes some initial sketches for his paintings

FIGURE 2-30

Robert Yarber
(drawn at about age 12)
Untitled.
Pencil on paper.
Courtesy of the artist.

using one of the available graphic programs. With this program he can plot flying figures in any position and show them from any angle. For another painting he scans images into the computer from such disparate sources as figures in old lifesaving manuals and wings borrowed from a Renaissance painting. He then places the assembled figures: an angel and a devil fighting over the body of a recently departed soul, in an appropriate setting—a photograph Yarber took of a cemetery at night. The resulting

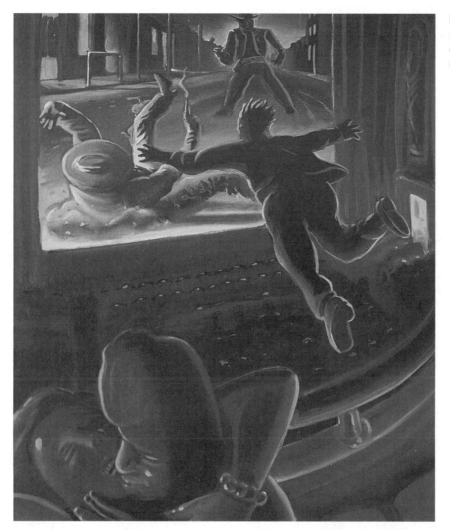

FIGURE 2-31

Robert Yarber
Crisis in Western Representation, 1992,
acrylic on canvas
114.3 x 88.9 cm.

image is printed in a large format on canvas onto which Yarber paints.

And what can we learn from Yarber's shift from his nearly life-long drawing process of putting marker to paper drawing processes to his use of complex technology? One thing is that in some very basic respects the artist's objective, to create a narrative event—a figure or figures in nocurnal settings (which may serve as metaphors for human relationships, conflict, eternal struggles, and who knows what else?) remains a constant. We also learn that the artist continually experiments with new ways of

arriving at images and that today's technologies have altered the way Yarber makes preliminary drawings for artworks. Nevertheless, we're convinced that the sensitivities, skills, and insights the artist gained through many years of drawing figures directly on paper are now being capitalized upon through the new technology-driven means he has recently adopted—and yet the creative act remains essentially the same.

The young people who today create images with pencils, ball point pens, and markers, (and the few young people who also create images with the aid of the computer), will some day make images

in ways that we cannot even imagine. New image-making means notwithstanding, drawing is about so much more than manipulating lines and figures. It is, as Yarber's work shows, about playing with images and ideas.

The Special Role of Drawing in Shaping Realities

Although these illustrations of the ways children expand their conceptions of the four realities center on drawings, other symbolic activities such as play, storytelling, dramatics, singing, dreaming, and daydreaming may also fulfill this function.

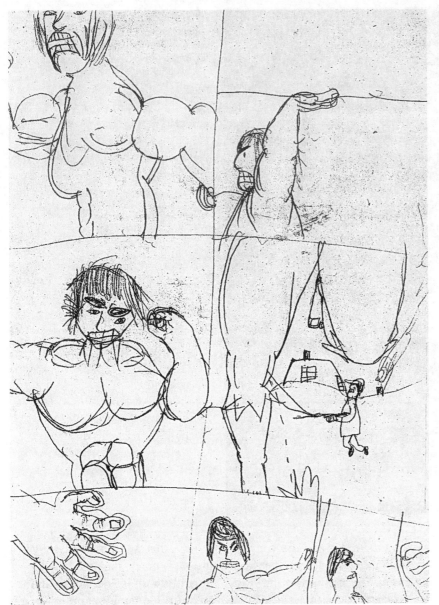

FIGURE 2-32

Per (age 14)

The Incredible Hulk, the television series that fascinated this Swedish boy in the 1980s continues to be compelling, spawning two film versions, in 2003 and 2008.

Drawing, however, has special and unique reality-creating characteristics.

Drawings provide an early means, perhaps the first, by which ideas and feelings can be made concrete and perceivable—they leave a record as no other childhood means of modeling reality can do. Young children learn very quickly, and with no assistance, to form basic graphic symbols for people and objects. These early symbols for a person, a sun, or a vehicle have at least some visual correspondence to objects in the everyday world and are easily understood. With them the child soon learns to create complex meanings. The depiction, for example, of family members—the *person* repeated—inside the *vehicle* may convey a common reality or may anticipate the prophetic reality of a future holiday. More complexity is easily achieved with the addition of the sun or trees or buildings or clouds. Unlike the structure of language, the structure of a drawing does not demand a precise placement of elements in order to convey meaning. In fact, even placed randomly on the page, the elements in the child's drawing can still be understood. In short, drawing provides a more flexible way to develop ideas about the four realities because it is easily acquired and understood, and because it has a visual equivalence to the everyday world.

Beyond the Four Realities: Other Reasons Why Children Draw

In addition to the reality-building functions of drawings, there are many answers to the question, Why do children draw? Some of the reasons have already been mentioned. Here we review these reasons and make a few additional suggestions.

- Drawing is a source of aesthetic and kinesthetic pleasure. At times the act of drawing itself is enjoyable—as in the movement of the hand and arm—and at times the pattern, design, and quality of lines and shapes in drawing produce a pleasurable response.
- Drawing relieves boredom through the creation of excitement and stimulation. Indeed, children may relieve the general tension of boredom through the creation of specific tensions of plots, characters, and events in their drawings.
- Drawing is a means by which children gain recognition or approval from peers, siblings, parents, teachers, and others.
- Drawing is sometimes done for the child's own satisfaction—for the pride of knowing that he or she can do something, and do it well.
- Through the act of drawing an object, a child can symbolically possess that object.
- In drawings, children are able to convey their thoughts and ideas.
- Children are able to use drawing as a means for creating a working model or models of the world—its characters, settings, events, its dangers and joys. Some children may then manipulate and control every aspect of that world in ways that they cannot in the everyday world. Often children relate this form of control to the directing of a play and the actors in the play. One young boy, in describing his eighteenth-century castle and its inhabitants, said, "They did whatever I wanted them to do."
- Drawing is a means by which the child, like the mature artist, can declare "I am; I exist and I have been here."

For all of these reasons and more, and for reasons that we may not ever know, making drawings is an important, even necessary, activity for most children for at least some time in their lives. Drawing is an activity to be encouraged and nurtured; drawings should be looked at, talked about, appreciated, and understood. They should not be disdained, derided, or ignored. There is more to children's drawing than has been widely recognized and certainly a good deal more than meets the eye.

Talking with Children About Their Drawings

Would we know of the marvelous adventures of Mr. And and the Change Bugs or, for that matter, the birth of the Dubser or the mysteries of "Deth to the End" simply by glancing at the drawings? Probably not. Few children have either the ability or the inclination to produce a work like Bobby's "Goldman," which is a literary as well as a graphic narrative. Many children would agree that if they had been able to write the story, there would have been less need to draw it. But most are more than happy to answer the questions we ask that reveal the wonderfully rich and exciting worlds of children like Dirk and Tami and Lois.

The questions we ask are simple. Asking children any questions at all once was considered inappropriate—it was thought advisable only to say, "Tell me about it." Asking "What is it?" was believed to be devastating to a child's ego. Some people still take this position. We consistently ask children, "What is this?" "Who is that?" "What is he doing?" "What is going on here?" Often even marks and configurations that appear to be minimal and insignificant have been found to contain tremendously important ideas.

Questions and even guesses about the contents of children's drawings can have at least two important outcomes. First, they can convince a child that adults are truly interested in his drawings and consequently in the child himself. Second, as we have shown, drawing is, for the child, often infinitely more than play. Every drawing has a purpose and a meaning and deserves both notice and a question or comment by adults. Adults then may be allowed to enter all of the realities of the child's drawing world, in which all manner of marvelous things may then be revealed. That is really half the fun.

3

Learning to
Draw:

Nurturing the Natural

Two hundred years ago, there was no child art, at least as we know it today. What we now know and refer to as child art is a nineteenth-century discovery and has gained importance—along with studies of childhood play, language, and other symbol systems—with the discovery of childhood itself. Franz Cizek has been credited with the discovery of child art.[1] In his native Vienna, Cizek found that the drawings of children to whom he gave paper and drawing instruments were very much alike, and yet not at all like the drawings of adults. Furthermore, he was surprised to find that children in Bohemia produced drawings similar to those of children in Vienna. He concluded that children's drawings were ruled by unconscious, innate "laws of form"—that children follow inborn universal rules as they learn to use the language of drawing.

Since Cizek's observation, countless parents, educators, and psychologists have noted the regularities and similarities among the drawings of children. The psychologist Dale Harris studied children who lived in a visually impoverished environment in the high Andes. The only human-made forms were the huts in which they lived, and there were no printed pictures, no drawings or paper or pencils with which to draw. Even these children, he found, made drawings containing predictable shapes and sequences when given paper and pencil.

After being shown how to use a pencil, a four-year-old boy made scribbles for four days and on the fifth day produced a rudimentary drawing of a man composed of a circle with two leg-like appendages. This so-called tadpole person is one of the first recognizable forms drawn by children and appears even where children have never seen others draw.[2] The form seems to come from within the child rather than from an external influence.[3]

The regularity with which children everywhere produce similar forms has led some observers to conclude that all children possess a universal language of visual symbols, one that is present at birth and needs only to blossom and flower.[4] This early theory of natural flowering has led to a long-standing prohibition—a prohibition still current in many quarters—against interference with the natural course of the child's graphic development, lest the process and the child be adversely and irrevocably affected.[5] We believe, to the contrary, that this hands-off attitude and the reluctance to become involved with the child's developmental drawing processes is itself detrimental.

Since nonintervention means that a child who has a problem reaching a desired goal will not receive the help she needs to attain that goal, this attitude is more likely to impede or arrest drawing development. The same adult who shrinks from showing the child how to draw, say, an apple, would laugh at the thought of withholding from her the information that the round red fruit is *called* an apple.

Learning to draw can be equated with learning to speak. Children first break down human sounds into their simplest compo-nents and, in their babble, experiment with all the possible relationships of sounds. They pass from sounds to single-word sentences, to two-word sentences, and finally produce multi-word sentences, while continuing to follow childhood's own grammatical rules. These rules are quite different from those used by adult speakers, but children gradually assume the standard grammar of the adult speakers with whom they interact.[6]

In this chapter we illustrate some of the common forms children draw wherein they experiment with all possible relationships of lines and shapes. We explain the natural principles that they appear to follow and that determine the nature of the things they draw. We discuss four steps to understanding the child's progress toward a grammar of drawing:

- The reasons children's drawings look the way they do
- Determining where a child stands developmentally
- Anticipating the direction of the child's next possible developmental steps
- What to do and say to nurture a fuller and richer drawing vocabulary

Why Children's Drawings Look the Way They Do

In disagreeing with those who claim that intervention is tantamount to extinguishing the child's natural creative inclinations, so, too, do we disagree with the contention that there is a universal language of visual symbols. It is true that one human mind is structured fundamentally the same way as every other; therefore, all humans approach certain basic tasks in essentially the same ways. Because of an innate preference for certain types of visual order, children all around the world share a predisposition to arrange lines and shapes in certain ways. For this reason the drawings of children everywhere appear to look the same. And just as surely as they look alike, because of cultural influences that interact with and alter the application of innate principles[7]—discussed in the

next chapter—these drawings all look different.

But at the same time we ask why children's drawings look the same in essential ways, we must ask why children draw humans composed of only a head and legs or why the drawings have arms that come out of the head. Seven graphic principles used by children in various situations help explain the nature of these sometimes curious and sometimes humorous drawings. Although several of these principles often characterize a single drawing, we examine only one principle at a time for the sake of clarity. Although these principles are commonly applied by many children, they are not used by all children all of the time. The reason for this gives us greater insight into the complex nature of children's drawings. Finally, children apply these principles differently at different levels of their development.

The Simplicity Principle

The most basic graphic principle— and the one that generally accounts for most of the others—is the *simplicity principle*[8]: the child seems to depict an object in as simple and undifferentiated a way as conforms to the child's expectations for the depiction of the object.[9] (3-1) If an irregular circle with two dots for eyes meets a three-year-old's requirements for the depiction of a human, then she will draw only the irregular circle with its dot eyes. If an older child perceives two unbent legs spread in scissor fashion as adequate to depict the action of running, then he will draw a run-

Figure 3-1
The simplest figure serves as a human for the child, as long as it conforms to the child's requirements for the depiction of the human.

ning person that way. Although it takes less time and energy to depict objects with few details and variations, ease and economy of action alone cannot account for the practice of this principle. Nor can aesthetics, the fact that it looks good that way, account for the practice. Just as the child's conception of "things" proceeds from simple to complex, from general to specific, the child's drawing necessarily follows the same mental processes. Drawing develops by the alteration of simple and undifferentiated ways of drawing to conform to newly devised or borrowed, more complex or differentiated methods. Perceptions may change, for example, when the three-year-old who consistently draws a global figure observes the drawings of others— drawings that have bodies, arms, and legs—or when the older child whose figures neither bend nor move sees a more convincing way to show the action of running.

The Perpendicular Principle

In addition to simplicity, the human mind needs order. That need is satisfied for the child, at least in part, through making images with the greatest possible degree of contrast

Figure 3-2
The chimney of this house is oriented to the roof at a 90-degree angle.

Figure 3-3
Some of these buildings appear to be upside down. For the child, however, they are logically at right angles to their baseline.

between the parts. This is evident in early depictions of crosses and ladders, and in the later orientation of objects at a ninety-degree angle to the baseline. In most cases, as in the examples here, (3-2–3-4) the nearest line often serves as the "baseline" to which the object is anchored. Sometimes the application of this principle and the need for visual order overpower many of the child's (and often the adult's) perceptions of the natural world.

The perpendicular principle explains such diverse graphic phenomena as chimneys and smoke that appear to defy the laws of nature as they stand at right angles to roofs; people who climb hills in fly-like defiance of gravity; and buildings arranged so that those on one side of the street appear to be hanging upside down, a mirror image of the buildings on the other.[10]

Figure 3-4
These figures climbing the hill still adhere to the *perpendicular principle* and will continue to stand at a right angle to the hill, whatever twists and turns it may take.

The Territorial Imperative Principle

In order to present each element in a drawing with the greatest clarity possible, the child allots to each its own inviolable space. The territorial imperative principle not only governs the lack of overlap of one figure by another but applies to body parts as well. If, for example, the child draws long hair first, then she often omits arms rather than violate the space given to the hair.[11] (3-5 and 3-6)

Figure 3-5
There is only one hand and arm drawn on this figure seen "inside" a car. The second hand and arm are omitted because to draw them would mean crossing the line representing the edge of the car.

The Fill-the-Format Principle

Have you ever wondered why children sometimes draw animals with too few or too many legs, or humans with extra fingers and toes? The fill-the-format principle[12] accounts for these seeming inconsistencies. (3-7–3-11) The size and shape of the format determines the number and size of the appendages. For example, if the length of an animal's body accommodates more than the four standard legs, then a child may draw as many legs as will fill the space. If the animal is too short for the proper number of legs, then three or two may do. But what determines the size and shape of the format itself? The young child's inability to coordinate her movements produces animal bodies that are too long or too short. Other factors are the size of

Figure 3-6
Not one figure touches another in this line of little girls. Each has been allotted its own space (territorial imperative), and there are no arms. How could there be, with hair and other figures in the way?

Figure 3-7
The head/body in this drawing of "my mommy" has ample room for six arms.

Figure 3-8

Philip (age 6)
An Indian Story (colored marker), 11″ × 27″

In his Indian story Philip's horse was to have four legs. He adds one to the three he has drawn initially, but he is left with a gap between the third and fourth legs. He hesitates, then draws in a fifth leg.

The "chief Indian" has a headdress that hangs down the length of the body so Philip can't put the second arm on that side lest the arm and the headdress conflict. He decides to draw both arms on the side opposite the headdress, even though one arm must cross the body.

Four Indians need four tents with four horses tethered to the tent stake. As he squeezes in the fourth tent, Philip is chagrined to find that there is only a small space for the last horse. "I don't have room to write the horse—well, I'll have to make a small horse for him." This one has room for only three legs.

It seems that there is no planning at this point. Whatever we need we make to fit the space. If it's a small space, the horse is condensed to fit. Fill *and* fit the format as well.

the page itself and the way elements are placed—so that there is more or less room for inserting another object. This leads also to the need to stretch limbs in order to reach an object or to lengthen or shorten features so that they fit neatly and aesthetically into a given space. Modern artists have made full use of the aesthetic dimension of the fill-the-format principle. An excellent example is Picasso's painting *Three Dancers*,[13] in which each of the three dancers' arms and legs are of markedly different lengths.

Figure 3-9
And sometimes the spaces inside houses need to be filled with decorations.

Figure 3-10
Lack of control probably results in the arms of this figure, drawn with a single line, becoming very large. It then became necessary to accommodate the fingers to the size of the arms.

Figure 3-11
Sometimes the need to *fill the format* also fulfills the aesthetic urge to decorate and to balance one shape with another until all the space is beautifully filled, as in this drawing of mandalas.

The Conservation and Multiple-Application Principle

Those who would conserve our natural resources might take a lesson in conservation from children, who apply the same configuration over and over again in a variety of ways. Suns are reemployed as hands; tadpole people reappear as trees; the head of the human also serves as a head for horses or cows, cats or dogs; arms can be interchanged with legs, and hands with feet. For the child a limited vocabulary of already acquired configurations may serve as many uses as possible and desirable.[14] (3-12–3-15)

Figure 3-12
The first head that the child draws is that of a human. Here it serves as an equally satisfactory head for a horse, until such time as the need arises for a more characteristic animal head.

Figure 3-13
Sun shapes, which were probably developed independent of the figure, are recycled here as both hands and feet.

Figure 3-14
The exact configuration—a line with a loop at the end—serves as an arm with a hand, a tomahawk, and the two legs with feet.

Figure 3-15
The lollipop tree and the first human or tadpole have much in common. Each consists of the elements that the child has at her disposal at that time—the circle and the line—positioned with the circle on top from which two parallel lines protrude.

The Draw Everything Principle

Adults typically depict objects and humans from a single point of view. Children, on the other hand, have no such restriction. Like the Cubists and other artists, for whom these depictions are intentional rather than conventional, they often draw what can be seen from several or all points of view and may include things that cannot actually be seen. The French philosopher Luquet, whose early-twentieth-century studies of children's drawings are well known, called this phenomenon *intellectual realism*,[15] which referred to the fact that children seemed to be drawing everything that was known about an object. The draw everything principle assumes a variety of forms in children's drawings: pictures showing both the inside and outside of houses and cars and even humans; tables seen simultaneously from the side and the top; a bus with half of the wheels on the ground and half appearing to rise from the roof. (3-16–3-18)

Figure 3-16
This Egyptian child shows the inside and the outside of the bus simultaneously.

Figure 3-17
This little girl was drawing a lady who was "too fat." To show just how fat she was, Peggy drew two babies in the lady's too-fat tummy.

Figure 3-18
The boy who drew this race car added two wheels on the bottom and two on the top in order to add up to four. The result is a flattened-out vehicle.

The Plastic Principle

The artists of ancient Egypt depicted members of royalty as larger than their servants. Children, too, exaggerate those objects, persons, and actions in their drawings that are most important. In a family group, "me," or perhaps one parent or another, may be the dominant figure. The action of throwing a ball calls for exaggerating the body part performing the action, with one arm enlarged and the other smaller, shrunken, or even completely absent.[16] (3-19 and 3-20)

The natural predisposition to apply these seven graphic-ordering principles is strong and governs most of the child's early drawing activity. When a principle is not applied—a child draws a chimney at the proper angle to a roof, or arms and legs of the same length regardless of importance, or consistently draws a horse with four legs regardless of the size of the body—and these principles are certainly not always applied, the reason may be one of the following:

- One principle has for some reason taken precedence over another.
- The child has learned through practice and observation to overcome the natural tendencies.

Many adult drawings are still governed by the force of some of these innate principles. Indeed, the fact that these principles continue to influence drawings for a lifetime is not always undesirable—many so-called primitive painters, such as Edward Hicks or Horace Pippin, have produced paintings of great charm and elegance. The continued influence of these principles only hinders the individual when she wishes to overcome them and cannot—either because she does not know how or because she is unable to find assistance in learning how to overcome them.

Figure 3-19
Ryan drew the members of his family, including the baby on all fours, each about the same size, until he was reminded to put himself in the picture—the enormous figure that looms above the rest. Children often exaggerate the person they perceive as most important.

Figure 3-20
When I throw the ball, I use my right arm; it is almost as though the child wishes to show that all of the energy had been transferred to that limb. The other arm shrinks as it loses importance; at times it will disappear altogether.

Should Adults Attempt to Influence the Way Children Draw?

As we have illustrated, the nature of children's drawing is determined by an innate set of graphic-ordering principles. In the next section we illustrate the natural development of the child's drawing. If drawing is, in essence, "doing what comes naturally," then we need to ask, What is the role of the adult in the graphic developmental process?

This chapter began with a brief history of child art and Franz Cizek and the nonintervention theory. We have also stated unequivocally that we do not agree with this hands-off edict. Going beyond our strong disagreement with the common view that adult influence or interference will destroy the child's spontaneity and creativity, we believe that adult assistance is actually necessary to evoke the child's spontaneity and creativity.

Is it possible to avoid influence on the child's drawing activity?
Can a parent or teacher be completely neutral so as not to influence a child's drawing, even unconsciously, in certain ways? Can visual material—the drawings of other children, their own growing perceptions of the world about them, illustrations in books and magazines, television, the work of artists in museums—all be withheld from the child? The answer is obviously no. If we cannot, in the natural course of the child's life, avoid influence, then shouldn't the adult expose the child to those influences that will allow her to develop as fully and as richly as possible?

Without exposure to fine art, the child is forced to rely on images from the popular media that are easily and universally available. Some children will seek out sources of images and ideas for themselves. They can recite at will the names of artists, illustrators, and cartoonists, and tell you what these artists draw, how they draw, and how well. Many others who may not have the same incentive would, nevertheless, continue to draw if given encouragement and shown the way.

Presently, however, few children can adequately explore the rich reality-inventing possibilities of drawing because the things they are able to draw are too few and lack both complexity and expressiveness. Other than offering models from which to draw—to copy—how do these *good* influences help the child to develop her graphic capabilities?

We believe that the innate principles interact with the structure of the world—with influence factors—to allow the child to draw with greater accuracy and completeness. Through the interaction of these two fundamental factors, acting in a continual process of problem-solving, and employing both the senses and motor skills, the child formulates more complex sets of rules for drawing.

In addition to supplying good models, what can adults do to increase drawing activity?
Returning to our earlier language analogy, children learn to speak through interaction with adults—usually the mother.[17] When the mother talks to her infant or young child, she automatically simplifies her speech so that it is just a level or so higher than that of the child. In this way she presents, in her own language, the model for the child's next level of language development or the next set of rules for the child to follow. Similarly, we think that one of the most effective ways to facilitate drawing development is to interact and to present children with drawings at slightly higher levels than their own, as well as verbal descriptions of the next level.

We have observed that when a young child draws alongside an older child who is drawing at a higher level, there is a natural flow in attaining the next higher model of drawing. Few adults, however, are as familiar with the order and sequence of drawing skills as they are with those of language. In order to interact with children sensitively and spontaneously in the course of the graphic developmental process, it is important that adults be able to anticipate the subsequent steps in the child's drawing development. They must, therefore, become familiar with the general course of that development.

Influencing the Course of Drawing Development

The general course of the development of the child's ability to draw is best described through the development of the one object most frequently depicted by children—the human figure. We will therefore trace the evolution of the figure from its genesis in the child's first scribbles, through its unfolding, to its conclusion as a complex depiction of the human form.

This section consists of: (1) illustrations characteristic of the developmental steps, (2) descriptions of typical drawings, and (3) suggestions to provide adults with examples of words and actions that will help them lead children to higher, richer levels of drawing.

In this overview of the human figure, we have purposely avoided any indication of the ages at which these steps occur. What one child draws at eighteen months, another child draws at age four; what one child draws at age four, another draws at age six; and what a few gifted children can draw at age six may easily surpass the drawing of most adults. Although development is essentially linear in nature, a child may jump ahead at any time or return to an earlier type of depiction for reasons and purposes that are entirely her own. Moving back and forth among the various phases is normal and should not be regarded as regression.

Irregular Scribbles

Figure 3-21
Scribbles like this are the result of the child's heavily punching, poking, and jabbing the crayon on and often right through the surface of the paper.

Drawings, Descriptions, and Explanations

This scribble and other early scribbles are the result of the child's grabbing the marker in her fist, her tongue thrust between her teeth, and heavily marking, as well as punching, poking and jabbing, sometimes right through the paper. (3-21)

Although seemingly random, upon close inspection these scribbles can be seen to contain virtually every conceivable direction that a line might take. Just as the babbling child makes the sounds that will combine to become words, the scribbling child makes the lines and shapes that will combine to become recognizable objects. Through this endless variety of irregular scribbles the child is developing graphic skills not only through patterns of muscular movement but also in the ability to perceive the more regular shapes that will be "lifted out" of these first scribbles.[18]

Suggested Responses

When markers and paper begin to interest the young child and tentative scribbles appear, attention and enthusiasm are the best encouragement. You might respond with "ooohs" and "aaahs" or you might join in, scribbling along with the child, on the same page or on a separate one.

Plenty of paper and pencils, crayons, or markers, as well as your attention and interest, should be readily available.

Figure 3-22
In this scribble, shapes begin to emerge—the circle and the square—in addition to some writing-like lines or decorations at the bottom.

Figure 3-23
Vertical and horizontal lines dominate this picture, and the ladders, which are often drawn by children, are the result of the child's natural preference for depicting a maximum amount of contrast.

Drawings, Descriptions, and Explanations

Out of the chaos of the irregular scribbles, the child discerns basic shapes and configurations, which she then begins to repeat, in a more orderly array of circles, ovals, (3-22) vertical and horizontal lines, crosses, ladders, (3-23) squares, and rectangles. At this time the repetition of shapes, particularly the circle, which precedes the square and the rectangle, (3-24) seems to be almost endless. This repetition serves as a means of mastering the skills needed to produce the desired size, form, and arrangement of shapes and configurations to be called upon wherever and whenever needed throughout a lifetime of drawing. (3-25 and 3-26)

The child often proclaims these forms to be daddies or eyes or pillows or animals or whatever other object suits her immediate fancy. This "romancing"[19] (3-27) rarely refers to any recognizable element in the scribble but confirms for the child the fact that drawn shapes cannot only "stand for" or represent "things" but can also present ideas.

As the child begins to repeat basic shapes in her drawings, letters and numbers often appear. Sometimes they are letters of the child's name, sometimes simply letters that are appealing because they include the circles, lines, and crosses that the child delights in producing.

Suggested Responses

The appearance of shapes that are more coherent—at least to an adult—makes referring to "circles," "zigzags," and "ladders," as we recommend that you do, an easier task. Of course, the child's naming of the elements makes talking about the scribble drawings easier still, although you should not be surprised if what was a "mommy" on first telling becomes a "doggie" or a "pillow" in subsequent versions. Your asking "What is it?" may elicit some exciting and excited responses and is often the first step in the child's ventures into narrative (Chapter 6).

Now is the time to show the child, as you draw along with her, circles that are rounder, lines that are straighter, and squares that are squarer than those she has drawn. Be sure not to compare her work with yours and do continue to praise her efforts, but presenting models is designed to show the child the possibilities for her future productions.

You might even attempt the more complex designs that will shortly emerge—circles surrounded by other, smaller circles, crosses superimposed on circles, suns and radials, and even heads with facial features or arms and legs.

Figure 3-24
The circle is repeated over and over again and will soon be used to "stand for" any number of things—eyes, nose, mouth, head, body, arms, legs, fingers, toes, and so on.

Figure 3-25
In this scribble, the shapes are clearly identifiable as rectangles, with a circle in the lower right of the drawing. One also wonders whether the child has purposely attempted to show the letters A or F, both of which are letters of his name.

Figure 3-26
Scribbles are often balanced or symmetrical in nature, as in these concentric circles with matching vertical scribbles on either side.

Figure 3-27

Jonathan (age 5)
This Robot's Dead (pencil and crayon)
14″ × 17″

Jonathan's "as if" scribbles—scribbles that serve merely to accompany the child's verbal narrative and that are treated "as if" they were true graphic illustrations—changed identity as quickly as his imagination dictated. He began by drawing (on the left side of the page) a house on fire, changed it to a giraffe, and soon just as positively declared it to be a Martian with a long neck. "There's his nose, there's his mouth," added a flying "saw-saw" to his picture, and a snake to bite his Martian. Anxious to describe his completed drawing, Jonathan announced that it was "war." His final recounting of the parts of his scribble drawing was the best story of all.

"That robot's dead; *that* robot's dead—yeaaaa!" (creaking sound effects).

"And this robot's dead" (sound effects of bullets—killing him on the spot).

"*Zero!* Gotta make it a zero!"

"And these robots are dead. And this is a building. This building—all the people are dead so ex that out."

"And—one sole survivor."

"All the people are dead in that house—ex that out."

"That one's exed out now."

"The building's out" (making marking noises to illustrate and emphasize the complete annihilation).

At this point, B., who had been listening to Jonathan's commentary—and urging him on with questions such as "That's gone too?" and "One sole survivor?"—declared, "I think it's going to just destroy everything." Jonathan answered gleefully, "Yeah!" and, making a few more stabs at the page with his crayon, announced, "That's it!" and settled back in his chair, pleased that his story had reached such a satisfactory conclusion, a beatific smile on his elfin face. B. agreed, and concluded, "That's it; everything is gone."

Jonathan's scribble has little relationship to his story except in the spirited movements of his crayon and pencil as he marked off the area of the page and the marks that would stand for a house, a giraffe, a Martian, a flying "saw-saw," a robot. The marks simply emphasized the workings of Jonathan's rich imagination and—almost like musical notations—marked with this jumble-tumble, higgledy-piggledy hodgepodge, the high points of the story.

Figure 3-28
The sun shape is one of the first designs to appear in the drawings of some children, who generally make use of it consistently thereafter.

Drawings, Descriptions, and Explanations

Some children may combine the circles, crosses, and straight lines of their early scribbles to produce an astounding variety of images—suns, radials, embedded circles and mandalas (i.e., a circle or square containing a superimposed cross or geometric form). Mandalas can be as elaborate and exquisite as baroque jewelry. (3-28–3-31)

The decorative images indicate the child's natural preference and feeling for symmetry, order, and contrast. Some children may draw many such designs while others, even those who spend a considerable amount of time drawing, produce hardly any designs at all.[20] The child who rarely or never draws designs may be very involved in presenting ideas or narrating stories.

Suggested Responses

Your cue, when these designs appear, is to simply enjoy them with the child. Your verbal expressions of appreciation—"how beautiful," "great," "fantastic"—might be accompanied by queries about to how the designs were made. You can ask the child to demonstrate as you draw along with her, creating designs like hers, with only a little more sophistication and complexity.

Figure 3-29
The radial is a variation of the sun theme, but with all of the rays emanating from a single point.

Figure 3-30
Once the child has mastered the circle, it can be employed in all sorts of decorative ways. Here is a typical concentric circle design.

Figure 3-31
Some observers see designs that include crosses within circles as *mandalas*.

Figure Drawings

Figure 3-32
This *global* person consists of a circular shape that follows the contour of the page, inside of which are facial features and sometimes even body parts.

Figure 3-33
To the child, this *global* figure, complete with navel, "stands for" the complete person, body as well as head.

Drawings, Descriptions, and Explanations

Out of the scribbling activity, the two most useful forms emerge: the circle and the straight line. Many children move directly from drawing circles and straight lines to drawing human heads or figures. Others arrive at the human form only after a journey through the world of pattern and design.

A first human sometimes consists of a circle with eyes, nose, and mouth. The circle often follows the edges of a sheet of paper or, in other cases, (3-32) the edge of the paper itself serves as the boundary within which facial features are placed.[21] Although we may be inclined to consider this presentation as a kind of disembodied head, for the child it is likely the whole human, and often arms, legs, and even "tummy" appear inside the circle. (3-33)

Suggested Responses

The circle that the child draws may "stand for" the head and the body. Therefore a question such as, "Where are the legs?" or "Where are the arms?" may lead to the addition or indication of appendages either outside the circle or within it. Perhaps the best way to provide a model for arms or legs coming from the circle is simply to draw the tadpole for the child, indicating as you do so, "These are arms and these are legs." The child may not begin to add these features on her own immediately. Again, you will simply be providing a model for features that the child may include in her drawings later.

Figure Drawings (continued)

Figure 3-34
This is the figure best known as the *tadpole* person because, like the tadpole, it generally consists of a head and legs only.

Figure 3-35
This Humpty-Dumpty-like *tadpole* represents the child's attempts to delineate where the head ends and the body begins.

Drawings, Descriptions, and Explanations (continued)

Other first humans are characterized by the head, with or without features, atop a pair of legs consisting of two parallel lines, sometimes with two other straight lines protruding horizontally from either side of the head. This figure is known as the tadpole person. (3-34) Still other of these first humans appear to be Humpty Dumptys with a belt around the midsection and arms that typically extend from the head. (3-35) These rudimentary figures may represent both head and body or the body may exist in the space between the legs.

If, on the other hand, the circle "stands for" the head alone, then the question arises, "Why do the arms come from the head?" Norman Freeman found that when he presented children with predrawn figures consisting of either a large head segment and a small body segment or vice versa, children were most likely to attach the arms to the larger segment.[22] And why do the arms emerge from the head with a horizontal orientation? Here we see children following the perpendicular principle—either the contour of the circle or the implied vertical body line seem to serve as the baseline to which the arms are oriented at a ninety-degree angle.

Suggested Responses (continued)

The child may also respond to suggestions that there might be something omitted from her drawing. You may want to play a game in which child and adult together attain more and more complexity as "What else?" suggests feature after feature to the child. Or asking for an unexpected feature such as the "tummy" may produce surprising results. (3-36)

Figure 3-36

Becky (age 3)
Where's the Tummy? (Rolling Writer®)
14″ × 17″

Becky drew a tadpole as a result of a playful exchange. Her many earlier drawings had consisted of colorful scribbling. She was told that this time she would be shown how to draw with lines.

Adult: Do you ever draw people? Show me how you draw people.

(Becky draws a circle.)

Adult: Uh, huh, and what else do people have? (A leg and a shoe appear; another leg and "another shoe.")

Adult: What else do people have?

Becky: Eyes. (She draws one.)

Adult: Oh, that's a beautiful eye—and what else do people have?

Becky: . . . need to do the other eye.

Adult: . . . other eye; and what else do they have?

Becky: A nose.

Adult: Where is it? Right there? (as Becky draws) And what else do they have?

Becky: Hair.

Adult: Hair, OK, yeah . . . and what else do they have?

Becky: Uhhh . . .

Adult: I think you're forgetting something important (indicating arms by emphatically waving his own).

Becky: Arms!

Adult: Right! Where do they go? And what else?

Becky: Hands!

Adult: And what else besides hands?

Becky: Nothing else (thinks of something—draws).

Adult: Aha! what's that?

Becky: Fingers.

Adult: Yeah, 'cause I thought there was more, and I think there's something else you're forgetting, too. You know that? (There is a discussion about talking.)

Becky: Needs a mouth.

Adult: Where is it?

Becky: I don't know (then adds mouth). Right here!

Adult: Oh, I'm wondering something else now.

Becky: What? (she is intrigued)

Adult: Where is the tummy?

Becky: Tummy? Where can I put her tummy? (Becky is truly baffled. If here is a head and these are legs, where can the tummy possibly fit?)

Adult: There's a way you can do it! (Becky sets aside the question of tummies while she works it out.) Oh, how about the cheeks?

Adult: Yeah! Get 'em.

Becky: Gotta have cheeks.

Adult: Gotta have cheeks—oh, that's so beautiful!

Becky: Oh, I forgot something! (Becky has solved the problem of fitting in the tummy and quickly draws a line connecting the two legs) . . . Need that across.

Adult: Then what can you do? Where's the tummy button? (Becky is pleased to have found the solution. She places a "tummy" in the space between the legs which has now become a body, and with a triumphant squeal, adds the button in the center.)

Adult: There—now you have the whole thing!

Figure 3-37
The space in between the legs of this *human* is filled with buttons, one of the first efforts to indicate a body as separate from the head.

Figure 3-38
The tummy of this figure also indicates that the child is endowing her figures with a separate body. Often the navel exists only as a single dot.

Figure 3-39
Here the line that closes off the space between the legs of the figure is often the step before a deliberate and separate body part appears.

Drawings, Descriptions, and Explanations

The next step in the development of the drawing of a person is the indication of a separate body. Sometimes simply a line of buttons (3-37) or a navel placed in the open space between the two parallel "legs" (3-38) signals that the child is ready to locate a body in her depiction.[23] At this stage the child may indicate the presence of a body by closing off the space between the legs with a line. (3-39)

The addition of a shape such as a larger circle, an oval, a square, a rectangle, or another geometric or amorphous shape is a more definite indication of the body. (3-40)

Just as it is possible to add complexity to the circle and see it transformed into a full-fledged figure by simply suggesting that the child may have forgotten some parts, so the addition of a body can be achieved.

While drawing with Philip, M. was asked to "make" a girl, and she proceeded to draw her own concept of a girl with long hair and a skirt, but soon realized that the skirt no longer identifies a girl in today's culture. Asked how he could tell the difference between boys and girls, Philip replied, "'Cause girls have long hair and you can't see their ears." Philip draws a boy— the ears are clearly visible. The figure designated to be a girl has hair covering the area of the head where the ears would be. M. persists (still looking for a skirt): "And how else do we know it's a girl? Sometimes girls wear . . . what?" Philip's answer is clear. "Ummm . . . shirts—like the boys." (But he differentiated by adding stripes to the girl's shirt.)

Figure 3-40
These nine drawings (below and on facing page) show the multiple forms that a body, once established, may take—the square, the triangle, the circle, and a variety of irregular and amorphous shapes.

The Development of Characters

Drawings, Descriptions, and Explanations

Once the child has a complete program for depicting the figure, including the body and all of its parts, she can attend to such factors in her figures as maleness or femaleness, role, age, what they do (action), and how they feel (emotion).

This is accomplished through elaboration—the addition of detail, variation of an astounding number of geometric and amorphous forms, and a seemingly infinite number of combinations of shapes and patterns. It is as though the earlier experimentation with decoration is now being employed to enrich drawings of people.

At this time, also, notice the way the arms begin to emerge from the shoulders and curve down at the sides of the body, replacing the earlier perpendicular extensions. Elbows and knee joints, however, seem not to appear until later.

Suggested Responses

As the child's figures become more complex you can speak to the child about space-men and space-women, princes and princesses, hockey and football players, cowboys, dancers—the list is as long as the child's imagination and her ability to depict.

Just as the tadpole figure became more complex through the discussion about parts that may have been left out, so asking and telling about characters that the child has depicted can help the drawings become richer and more exciting.

Questioning often leads to the best results—calling up the child's own mental images.

- How does the spaceman breathe?
- What sort of suit does he wear?
- Does he carry special equipment?
- How does he move through space? These questions provide more information about the character and enable the child to add complexity to her drawing.

Limbs Are Fused to Bodies

Drawings, Descriptions, and Explanations

Although some children may spend years drawing figures composed of separately formed body parts—arms, legs, hands, and feet—other children move quite rapidly to drawing people whose bodies, arms, and legs are joined in one single embracing contour.[24]

The newly acquired encompassing line may join together two or more body parts—torso, head, arms, legs; torso, arms; torso, legs; head, torso. (3-41)

These fused figures drawn by young children have few details; heads are often large in relation to bodies, and the figures frequently resemble a gingerbread man or a Gumby-like figure.

It is usually at this point that the child is able to show the more extreme human actions, such as running, falling, and climbing. The effect of action is generally achieved through the curving of limbs, which may eventually come to be bent sharply at the knees and elbows. (3-43)

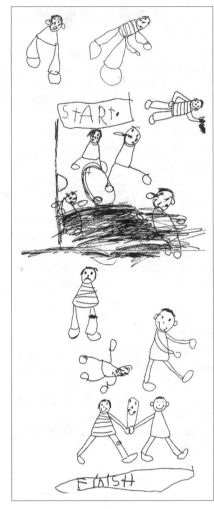

Figure 3-42

Suggested Responses

As with the ascent to each level in turn, the best response remains approval and enthusiasm. Verbal encouragement needs to transcend the usual "Oh, that's very nice" and show a genuine interest and involvement. One such exchange ensued when Philip was ready to show figures in action. (3-42)

Adult: This boy is running, right?

Philip: Right.

Adult: How do you know he's running?

Philip: 'Cause he's got his arms (demonstrates that they are spread out).

Adult: 'Cause he's got his arms out like that. What about his legs?

Philip: Well, I couldn't get 'em very runned.

Adult: Well, what would you have to do to make him look like he was running? When you run what happens?

Philip: Put one foot here and the other foot there (indicating legs apart).

Adult: Right! OK, and what else happens? What are these?

Philip: Knees.

Adult: They're knees. Do they bend?

Philip: Mmm hmm.

Adult: Well, how could you

Philip: I don't know how to make knees—and that's the reason I can't do it [make the boy running].

Adult demonstrates drawing a boy running, knees bent. Philip's subsequent running figures show legs apart in a correct running position, but knees are still a problem.

Figure 3-41
In these four drawings the children have begun to draw figures in which bodily parts are fused within a single contour—heads fused to bodies and, in one instance, head, arms, legs, and body drawn with one continuous encompassing line. Some figures at this stage are still geometric, while others have begun to conform to the contours of the human body.

When the body and limbs of drawn figures are encompassed in a single contour, with clothing detail and bent elbows and knees indicating action, the child has passed the bounds of the natural unfolding process. Only by overcoming or going beyond the principles of simplicity and horizontal/vertical contrast is it possible for a child to show action and complex characterization. The next chapter directs attention to the full extent of drawing development beyond innate principles and natural unfolding and to the factors that affect this further development.

In this chapter we have shown how children's natural preferences for certain kinds of shapes, relationships, arrangements, and order, coupled with their developing mental capacities, lead them to apply innate principles in increasingly advanced ways as they draw.

In the course of the natural development from simple to complex, the child cannot avoid influence either from implicit or explicit criticism or approval from adults, or from growing perceptions of the world. Our map traces the child's developing ability from the first kinesthetic poking and jabbing at the paper through the stages of the scribble, irregular and regular, to simple configurations and figure drawings, from tadpoles to fused figures.

Adults should help children to broaden and extend their drawing development, and we encourage the acceleration of development and the transcendence of the natural principles. This view is not biased against child art or implicitly critical of the way children draw. On the contrary, we share the view of most adults that child art has a rare spontaneous charm to be valued. We go beyond this adult view, however, to the child herself, who so often expresses frustration that her work does not look the way she wants it to, and even frustration with the adult who believes that it should look exactly the way *he* wishes it to. Just as we record and value the development of the child herself, from the very first cry through the many and marvelous stages of her growth, we value the child's graphic development from mark to scribble to drawing.

As enchanting as it might be, we would not wish to retard the child's growth at, say, the crawling stage or the one-word stage; neither should we retard the child's drawing at the point at which we, the adult, find it most delightful, or spontaneous, or charming. Child art is simply "child art" and should be allowed to grow along with the child who produces it. If the child's graphic abilities keep pace with her growing perceptions of the world and her self, then she will see her art as not only satisfactory but pleasing as well. More and more children will continue to construct, through drawing, ever more complex and elaborate realities.

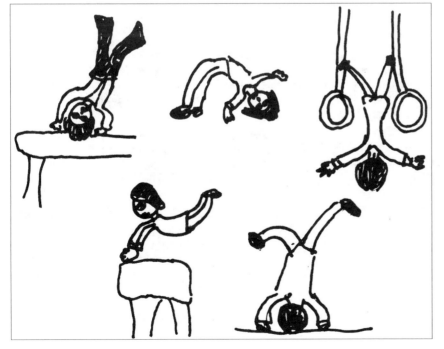

Figure 3-43
These figures are able to perform all manner of gymnastic moves through the simple device of curving limbs and bodies.

4

Learning to **Draw**:

Cultural Aspects of Graphic Development

Two small boys are playing together. One boldly takes hold of the other's toy. The first child puts up a terrible fuss and runs to his mother, crying, "Johnny took my airplane!"

Two young boys are drawing together at a table at school. One sees the other drawing a picture of a football player; he draws a football player on his own paper. The first child puts up a terrible fuss and runs to the teacher, complaining, "Johnny copied my drawing!"

Two boys kneel on the floor drawing together; a large roll of paper is spread out before them. Each is intent on his own drawing but always with an eye on the other's. One boy sees something interesting happening in his partner's drawing. He picks up on it, draws his own version, and adds details of his own. The two are surprised and pleased with the mutations and permutations of images that result from this continuous interaction. The scroll, and their delight, continue to build.

What is the difference between the last two scenarios? Why is the child who copies another child's drawing seen to be like the child who takes another's possession? Are the boys drawing on the scroll simply close friends who have learned to share in their artmaking activities, or are they following, in some measure, a time-honored artistic tradition?

Addressing these questions and others, in this chapter we trace various influences on the drawings of children and show how the interaction of natural and cultural forces determines not only the form but the style of an individual child's drawing. The shapes of the child's first scribbles and tadpole people initially are almost entirely determined by natural forces at work within the individual. But before long the influences of culture begin to interact with those natural forces.

Cultural Images and Children's Drawings

In building reality and thus knowledge, the child searches for information about the environment and then constructs or invents models of the world or models of reality. Children build their own realities incorporating bits and pieces of the already existing world of their own culture, or models of the four realities (discussed in Chapter 2) that exist within that culture. The reality-making drawings of children combine innately determined features encountered in the culture with influences from drawings, illustrations, and other graphic media of the culture they may have assimilated, consciously or unconsciously.[1]

One function of art in the culture has always been to show the viewer a way to look at the world or one aspect of the world: one reality. Does art, then, imitate life or life, art? The answer is yes on both counts. Art holds up the images of the culture as a mirror in which we can see ourselves reflected. Children, for example, see themselves both in the larger-than-life superheroes of the mass media and in the weak and little people saved by the hero. But the figures in art and in fiction symbolize at once the small child afraid of the dark and the adult who turns on the light.

As children use their own drawings and fictions to work out life's dilemmas and to construct their own realities, they rely on models from the art and literature of the culture. And the models that children know best are those of the popular media. Therefore, in the drawings of children we see a plethora of rock stars, media stars, and superheroes. And before these superheroes became the dominant images in spontaneous drawings, children, especially girls, have had a long-standing fascination with the image of the horse.

These cultural influences are both inescapable and essential if the child is to develop drawing abilities beyond the most basic level and to take full advantage of all that drawing has to offer in developing knowledge. But what do we wish to know about the influence of the culture on the drawings of children?

- When do cultural influences begin?
- Why do children borrow the images of other children?
- How are images borrowed from the culture used in children's drawings?
- Can drawings that are influenced by adult art be considered creative?
- Should children's borrowing from the graphic images of others be encouraged or discouraged?

How Children Are Influenced by the Drawings of Other Children

Even before children begin to scribble they are subject to graphic influences. Perhaps the child's first visual experiences with horses or cows or even puppies and kitties are through illustrations—drawings and photographs in picture books and magazines or images on television or the computer. These images provide some of the models for children's drawings but there is another powerful influence that

Figure 4-1

These figures showing the two eyes of the frontal face in a profile view were found extensively in drawings by children in the United States, Western Europe, and England from approximately 1883 until 1923, when they had virtually disappeared from children's drawings in the United States.

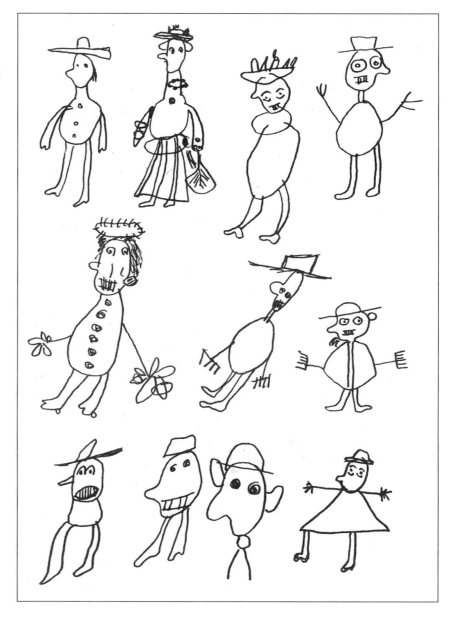

appears just about the time that children begin to draw their first human figures—the images drawn by other children. Young children observe the drawings of older children as well as those of children their own age who are more advanced. Because these drawings are closer to their own level, they are both easier and more appealing to emulate. Learning to draw from other children, at least in part, gives drawings done in different parts of the world or at different periods

quite distinctively different characters.

Of all the rudimentary figures produced by young children today—the global and the tadpole person, in all their diverse forms— none of the forms resembles the one found regularly and consistently in the drawings of young children from about the 1880s to 1930. This strange configuration,[2] like the tadpole, often consists of a head and legs; however, the head, unlike any we are apt to encounter

today, is turned to present a profile view yet still includes the two eyes of the frontal view.[3] (4-1) When first discovered in 1882, the two-eyed profile was declared to be just one phase in the natural development of children's figure drawings. Subsequently, in reports from England, the United States, France, Belgium, Austria, and Germany, the two-eyed profile was accepted as representing the stage between the frontal-view figure and the profile view. At that time the two-eyed

profile apparently flourished in those countries. Strangely enough, the incidence of these figures had sharply declined by 1923, until by about 1953 they had disappeared in the United States. By 1980, in an examination of thousands of figure drawings from Japan, Europe, Australia, and New Guinea, we failed to find a single two-eyed profile. It was not until a visit to Egypt in 1982 that we were to see the two-eyed profile again. (4-2) Where had this strange figure come from, and where, indeed, had it gone? And why was it to appear in a small village in Egypt?

One thing we can conclude with certainty: if the two-eyed profile once existed in such great numbers and now no longer exists in much of the world, it could not have been the result of an innate or natural factor; there were influences at one time that later ceased to operate.

A hundred years ago, there was not the same interest in and encouragement of children's drawings that exists today. Paper and drawing implements were in short supply and printing techniques had not yet developed to accommodate today's sophisticated illustrations, certainly not those that bombard our children daily in all their graphic grandeur and have such influence on their drawings. And yet children's drawings did exist— on walls and fences and any other available surface. If, as we contend, the culture and models from the culture so strongly affect the drawings of young children, and if the children of a hundred years ago had no models from adults or from the media, where did they find

them? Their models, we conclude, came from other children. They were passed down from one child to the next, from one generation of children to the next, and, with the increase in migration, from the children of one country to the next (as the Opies have found in their studies of children's games). However, with the advent of printed periodicals and the comics in the early 1900s, a number of models became available to children, and as they came into use, the two-eyed profile disappeared.

When do cultural influences begin? Although it had long been considered harmful to influence the child in any way, it is obvious that influences are present from the time of the child's earliest art experiences.

The Egyptian Story

Cizek's nineteenth-century "natural" child would grow up on an island isolated from culture and influence. His art, as a result of these pure and untainted surroundings, would be pure and wonderfully natural. Lowenfeld declared that in the remote sections of America, where children were free from the influence of "advertisements, funny books, and education . . . the most beautiful, natural, and clearest examples of children's art" could be found. In Nahia, a small village in Egypt, we found children as close to Cizek's ideal as possible in the twentieth century. (4-2 and 4-3) The Nahia children were certainly free from the influence of advertisements and "funny books," they saw few images from books or other printed media, and the only

adult images they were exposed to were the primitive adult drawings on buildings commemorating a pilgrim's visit to Mecca. And what of their art? Was it "the most beautiful, natural, and clearest example of children's art?"

The short answer is no. Contrary to the predictions of Cizek and Lowenfeld, the figure drawings of the Nahia village children were rudimentary, composed of only a few conventional features which were then varied in a number of ways. The heads of the figures were of two main types: horizontal-oval heads, instead of the vertical-oval heads most often drawn by Western children, and moon-faces that seemed to derive from a calligraphic source—usually the Arabic sign for the numeral 4, or the symbols for the Arabic words *promise*, *sal*, and *Allah*. It is probably the preponderance of profile heads derived from these symbols, combined with a lack of adult and graphic models, that led to the persistence of the two-eyed profile. Bodies consisted mainly of three types—rectangular bodies with fused necks, rectangular bodies without fused necks, and triangular or trapezoidal bodies without fused necks. There was little outside influence, so where did children learn to draw these figures? When we compared the drawings of older and younger Egyptian children, it was obvious that the younger children were attempting to master the fused-neck "Islamic torso" in the drawings of the older children, which were prominently on view on village walls and at school.

Figure 4-2

We thought that the two-eyed-profile had disappeared from children's drawings everywhere until, in the early 1980s, we visited a small village, Giza. Not far from the pyramids, we found large numbers of children who drew human profiles with two eyes. Why did these Egyptian children continue to draw profiles with two eyes when children in other parts of the world did not? Although most of the village dwellings had television, there were few illustrated books or magazines in either the homes or the school. Children's images faced little competition from printed images in the media; children learned to draw two-eyed-profiles from the drawings of other children.

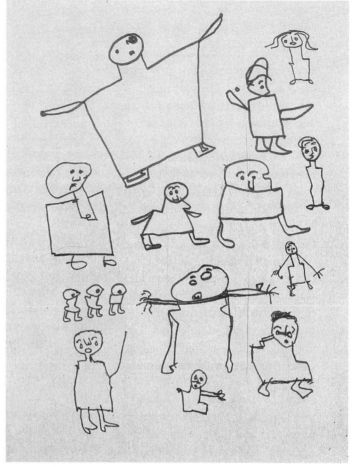

Figure 4-3

In the Egyptian village of Nahia, children drew horizontal oval heads with eyes near the center of the face, rather than at the top—as typically found in America. The "moon-face," which looks like the figure three drawn backward, is derived from the Egyptian way of writing the numeral 4. A rectangle is the most favored shape for a body and young children struggle to master this basic form borrowed from the drawings of other children.

Why Borrow from Others?

Today the influence of children upon other children is still prevalent and extremely important. Other children's drawings are the best models because such works are close to the level of the child doing the borrowing. By modeling drawings upon those that are more advanced—thus representing a level that has not yet been reached—the child can more easily reach the desired level. Because they are closest to his drawing experience, the child most readily calls upon the memory of his own previously drawn images. When he fails to see his own drawing as satisfactory, he turns to the graphic images of other children (as in the case of the Egyptian children), of adults, and of the media.

The child who reacted to the copying of his image as though he had been deprived of a precious possession was reflecting the attitude of adults who for so long lived by the edict, "Never let one child copy the work of another." But why not? Why is it that for hundreds of years, artists have looked to the art of others to learn how to depict the turn of a head, the position of a limb? Why can we learn to draw a horse better by seeking out the wonderful horse drawings of Degas and Lautrec than by going

to the horse itself? It is partly a matter of employing the most expedient means. Civilization might not yet have reached the horse and buggy age if humans had continually had to reinvent the wheel. Art, too, would have remained in the dark ages if artists had not benefited from the discoveries of other artists. Degas and Lautrec have already solved the problem of reducing the three-dimensional horse to a two-dimensional medium—no easy task for a novice artist. When a child sets out to draw a particular object or form, he relies on memory—memories of other drawn or graphic images—as well as perceptions of objects in the phenomenal world. But the graphic image, already stated in two-dimensional terms, is easier to recall because it is simpler and more static than actual three-dimensional objects that move and change about in everyday experience.

Is Borrowing Bad?

When they were young children, the artists Picasso,[4] Beardsley,[5] and Millais[6] excelled at copying the art of others. Indeed, borrowing, imitating, appropriating, modeling after—call it what you will—may be one of the most important factors affecting the early development of artists.

But won't such copying adversely affect the child's own creativity and spontaneity—the child who is, after all, neither Picasso nor Beardsley nor Millais—and force him to depend forever upon such crutches? The mature artist may borrow a technique or style or even an image from another and then extend, recombine, and use these elements in new contexts and in new and individual ways. Children do the same. Most children borrow images and turn them to their own

purposes. The two boys drawing on the scroll in our third scenario were playfully involved in just such a situation. In other cases an idea is caught up as it sparks the imagination of one child and then another. Four-year-old Jonathan was watching a playful drawing exchange between his friend Holly and an adult when a Martian entered the picture. Jonathan's face brightened; he added a Martian to his own drawing, invented a "flying saw-saw," and was off on imaginary flights of his own. In this way, the child's drawings are certainly individual and personal, and most often inventive, original, and creative. The child only remains fixed on a single image or on a single way to draw, like the Egyptian children, if he is not presented with other models or encouraged to seek out other ways to draw.

From Mickey Mouse to *Manga*: Varieties of Cultural Influence

A hundred years ago few would have thought of giving a child paper or crayons and paints. Today, stores are filled with every variety of marker and paper, paint sets, computer graphics programs designed for kids, and other paraphernalia to please the heart of an aspiring young artist. This emphasis on the child's creative graphic endeavors is perhaps the first and most vital aspect of cultural influence. For children who are encouraged to draw, provided with all types of drawing materials and the models of drawing adults and children, drawing becomes almost second

nature. And continual practice leads children to develop their drawing abilities much more quickly and easily than children in cultures where little encouragement is given.

In a culture like ours, it is natural that photographs, illustrations, comics, television, video games and movies should influence children's drawings. Maurice Sendak, the marvelous illustrator of many children's books and fairy tales, writes of things that influenced his own drawing:

People imagine that I was aware of Palmer and Blake and English graph-

ics and German fairy tales when I was a kid. That came later. All I had then were popular influences—comic books, junk books, Gold Diggers movies, monster films, King Kong, Fantasia. I remember a Mickey Mouse mask that came on a big box of cornflakes. What a fantastic mask! Such a big, bright, vivid, gorgeous hunk of face! And that's what a kid in Brooklyn knew at the time.[7]

If the two-eyed profile was the subject of children's spontaneous drawing in 1882, and superheroes lead the lineup more than a hundred years later, (4-4) then specific

Figure 4-4

Boy (age 6)
The Superheroes (pencil and crayon)
9″ × 12″

Superheroes appear in the drawings of children as young as four and, like six-year-old David's, they are made up of figures drawn with an innately derived approach to drawing bodies, limbs, and heads. But the characters of Spiderman with his web, the Hulk (in fashionable green), and Superman with his cape are straight from the models of the culture.

Figure 4-5

Jackie Sue (age 3)
Mickey Mouse (colored pencil)
8½″ × 11″

In the United States, media influences begin early. At age three, Jackie Sue drew little figures she named Mickey Mouse—recognizable mainly by the big round ears.

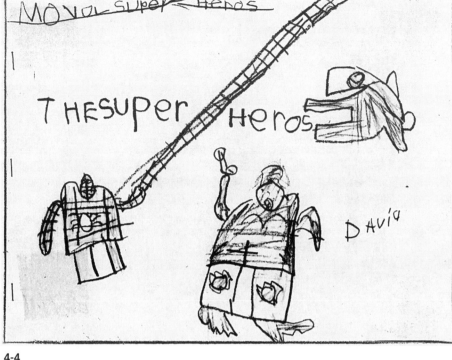

4-4

sets of subject matter are unique to specific times and cultures. What are some of the other images found in the spontaneous drawings of American and other Western children? No list would be complete without rockets and other space vehicles; monsters and dinosaurs; fashion figures; anthropomorphic creatures from Mickey Mouse to cute little bugs and animals (4-5) that talk and act in human ways; battles in space, in the air, and underwater; sports heroes; rock groups, (4-6 and 4-7); complex machines; and fantasy worlds. We know that a hundred years ago none of these images existed and that a hundred years from now they will have disappeared. But because they are so much a part of the fabric of our culture it is sometimes difficult to realize that children's drawings in some parts of the world contain few if any of the images we take for granted in the drawings of American children. (4-8)

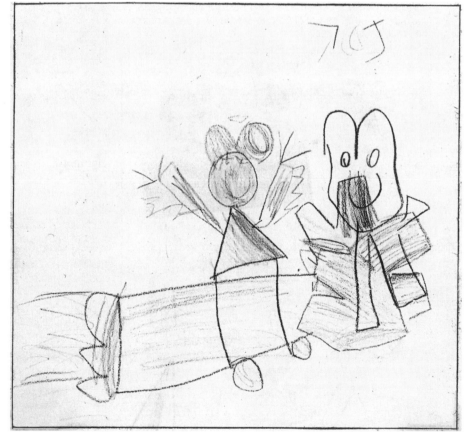

4-5

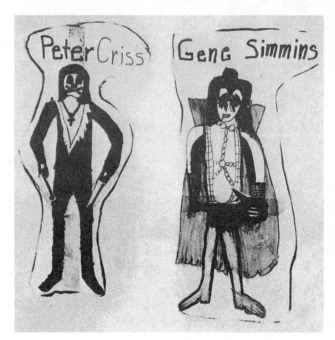

Figure 4-6

Steven (age 8)
KISS (colored marker)
8″ and 9″ figures

Particular musical groups hold a fascination for young people. This is only a small part of eight-year-old Steven's depictions of the group known as KISS.

Figure 4-7

Andy S. (age 11)
KISS (pencil)
8½″ × 14″

Andy S.'s prodigious output of drawings includes so many renditions of this one rock group as to be mind-boggling, and each one shows the members in different attitudes and states of animation. It seems to be the essence of the group that Andy sought to capture rather than the mere appearance, as Steven does.

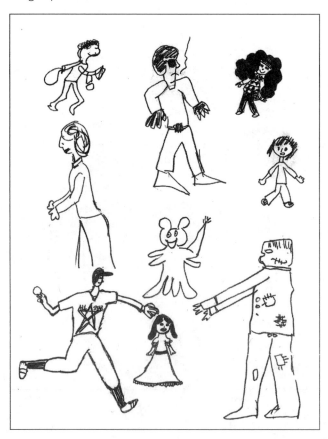

Figure 4-8

These figures are typical of those found in the drawings of children in the United States.

Learning to Draw the Japanese Way: Lessons from *Manga*

In Japan, where nearly forty-percent of all publishing is devoted to *manga*, virtually every child reads these Japanese comic books. Indeed, the graphic environment in which Japanese children live has no equivalent anywhere in the world. *Manga*, in fact, are published for pre-school and early school age children. During the middle-school years, in a decidedly gender-oriented turn, separate *manga* are published for pre-teen and teenage boys and girls. A single weekly *manga* might have 400 to 450 pages and contain twenty or more serialized stories. This means that if a child reads just one *manga*—and many read more—he devours more than 1600 pages of graphic narratives a month.

Japanese children do more than just read *manga*; they create their own. Working by themselves or in *manga* clubs, they publish their own comic books, trade with one another, and take them to enormous *manga* conventions where they rent booths and sell their creations.

When we traveled throughout Japan in 1989 asking thousands of kids to draw stories, we discovered that fifty-four percent of kindergarten children who had just entered school drew stories populated by characters with distinct *manga* characteristics. From two-thirds to three-quarters of the people and animals drawn by students between second and sixth grade were either directly derived from *manga* or strongly influenced by these unprecedented graphic narratives. (4-10–4-12)

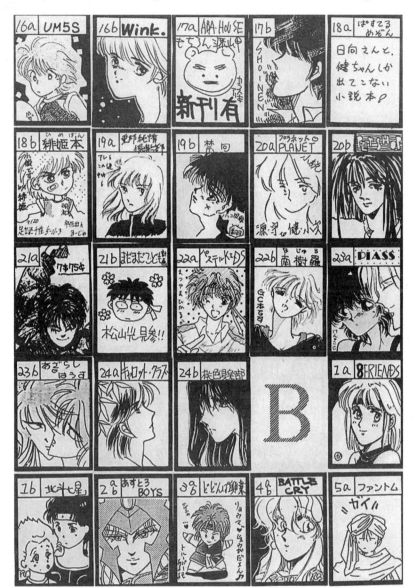

Figure 4-9

In Japan adult *manga* (comic book) have devised distinct ways of depicting people and animals. Young people in Japan create their own *manga* characters derived directly from their favorite comic books. But emulating adult models goes even further. Children place their characters in stories and then publish their own comic books which they sell at comic markets—some enormous, some small—of which there are approximately 2,000 in Japan each year. This page from the 1990 "Tokyo Carnival," a comic market of 800 booths and 1,700 *dojinshi/manga* publications, all created by kids.

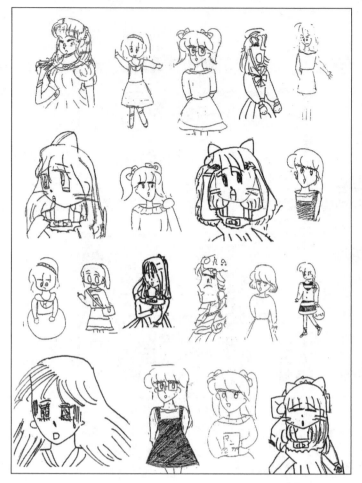

Figure 4-10

Manga artists draw humans with eyes that sometimes fill a third or more of the facial area and Japanese children do the same. In the paradigmatic heart-shaped female face, eyes sparkle with huge highlights. Japanese children who learn to draw by studying *manga* characters learn to create figures with astonishing gestures and facial expressions. Twelve percent of the characters in Japanese children's stories look like this by second grade, nineteen percent by sixth grade.

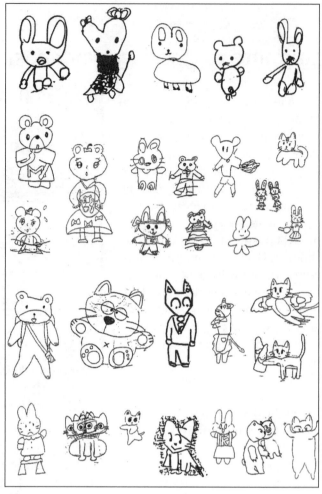

Figure 4-11

Manga created for the youngest children are filled with cute little animals—mostly rabbits and bears. The tradition of including animals in Japanese story drawings actually dates to the twelfth century. Eighteen percent of the stories drawn by second grade students had *manga*-style animals like these. By sixth grade only six percent of the students drew them.

The Meaning of *Manga*

In the *manga*-like characters found in Japanese children's graphic narratives, we see what happens when the youngest members of a society make use of a pervasive elaborate system of shared images that carry meaning, beliefs, and values. In some way, the *manga* characters seem to represent how the Japanese people see themselves, how they want to see themselves, and how they are both attracted to and repelled by individuals from other cultures. Through adult *manga*, Japanese children are presented with characters that show desirable and undesirable traits of character—those traits that must be cultivated or discounted. Collectively the *manga* character types provide the opportunity for acting out social roles—the opportunity to explore what it is like to be beautiful, ugly, cute, plain, ordinary, extraordinary, brilliant, stupid, clever, powerful, stigmatized, revered. *Manga* characters appropriated by children reveal how quickly

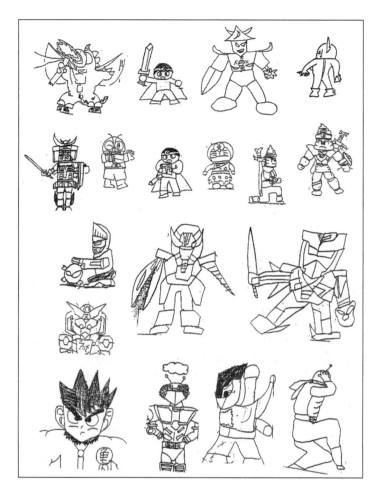

Figure 4-12

As in the West, *manga* has its share of characters who possess extraordinary mental and physical powers. The superheroes that Japanese children borrow from *manga* have their roots in the samurai traditions, they come from muscular robots, and they include a little atomic-powered cat (top and bottom rows: second from the left, and the two center figures). *Manga* provide children with distinctive styles after which to model their own drawings while at the same time providing characters who permit kids to practice being brave problem-solvers. We think that *manga* models accelerate the speed with which Japanese children develop graphically. Many, perhaps even most, Japanese kids draw more advanced figures than kids in other parts of the world.

and how thoroughly children model the complexities of being a Japanese person in Japanese society.

Because of *manga* models, Japanese children draw differently from children in other cultures—and far more skillfully than most. (They also draw differently because of the highly structured school program, but their *manga* drawings bear little resemblance to the contour-like drawings they make during art classes. Japanese children, in effect, speak two graphic languages, one belonging to the school and one belonging to the popular arts.) *Manga* allows Japanese children to take fuller advantage of the graphic/symbolic system—using it more effectively as a tool for human understanding—than any group of young people we have observed anywhere on the globe. Rather than being inhibited by the character models served up by *manga*, Japanese children improvise upon the possibilities provided by the character models. Through the appropriation and creation of their own *manga* characters, they grasp dimensions of human cognition and emotion, pay collective, albeit largely unconscious, attention to the ways Japanese people might be and behave, and grasp the significance of what it means to act as an individual within a conforming society. For these reasons, and more, we think drawing after *manga* characters liberates more than it constrains Japanese children.

Muscles and Movements: Drawing People and Action

The difference between learning to depict all kinds of action, or almost no action at all, seems related to the extent to which children's drawings imitate illustrations in the media. Showing lots of extreme action is basically a cultural phenomenon, wherein images from the culture provide the models.

A national survey conducted in 1974–1975 found that fewer than 20 percent of nine-year-olds and 39 percent of thirteen-year-olds could draw figures that appeared to be running.[8] Yet we consistently find children as young as five or six who are able to depict figures that run, leap, fly, and move in astounding ways. These are children who model their drawings after the actions of characters they see in illustrations, in comics, and on television. (4-11–4-13)

While the ability to depict movement allows the child to bestow the characters who act out his symbolic reality-forming with the power to perform those actions, the way the child draws the figures gives evidence of the very nature of the characters themselves. The muscles of the comics' superheroes represent the powers the heroes possess. The long flowing tresses and the curvaceous form of the heroine represent her feminine charms and beauty.

In order to hone their skills, we see children like Tami, who drew pages and pages of shoes; heads in profile, three-quarter, and front view; lips; and eyes; and Anthony, who experimented with figures in every kind of position imaginable. Some children, like Per, the young boy from Sweden, become fascinated by a comic-book or television hero, who occupies their drawing agenda for years at a time. They are often, at the outset, less concerned about drawing well than they are about the adventures and the actions of the character. At age eight Per first began to draw the Incredible Hulk when that television program first came to Sweden. His early drawings show that a fat green scribble could represent the Hulk very well as long as the Hulk could bash his adversaries. Subsequent drawings displayed a greater concern for the form of the figure, but the action and the excitement of getting the character in and out of trouble still took precedence. It was not until some years later that the figure became important, the drawing refined, and Per created for *his* Hulk a personality more in tune with the boy's burgeoning knowledge of and confidence in his place in the world. It was then that he could create his own superhero, "the Jaguar," with its own character and particular powers.

A visit to a fifth-grade class a few years ago revealed more than one aspiring comic-book artist. One boy in particular had hit upon a formula for showing action and movement with a minimum of drawing and a maximum of imagination. His action-filled adventure strips were peopled with amorphously shaped villains and his superhero, "Super Pickle." In order to make Super Pickle run, the boy had only to draw a lumpy oval at an angle with stick legs and arms bent in the proper attitudes; to make him fly, he drew the figure in a horizontal position. By a simple manipulation of this single elliptical form, Super Pickle could perform all manner of feats.

As part of a drawing experiment, the students in this class were exposed to a series of carefully crafted lessons in drawing the figure, including selected examples of masterly figures drawn by artists ranging from Michelangelo to Burne Hogarth,[9] the artist who drew *Tarzan* for many years. The images were taken from various sources and photographed on overhead transparencies so that after viewing the projected image, the students were able to use the 8½" x 11" transparencies at their desks as they would use reproductions. The students enthusiastically used these images and other resources such as anatomy books to improve or, in some cases, to develop their own drawings of figures.

A few weeks into the experiment, another visit revealed the students to be immersed in their drawings, working on action and musculature and facial expression. One drawing stood out from the rest: the figure was standing, flexing articulate muscles and wearing a menacing scowl on his accurately drawn face. The artist turned out to be the creator of the Super Pickle sagas. We said, "Hey, Jon—

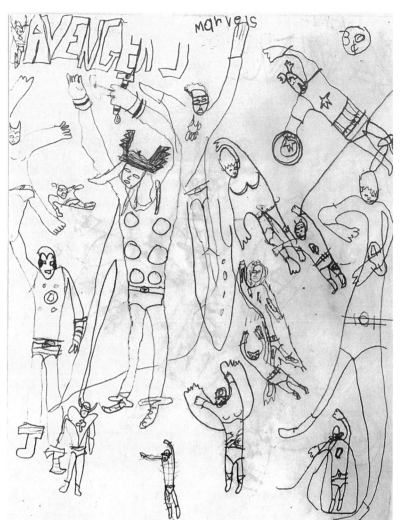

Figure 4-13

Boy (age 8)
Avengers (pencil)
8½" × 11"

It appears that this first-grader's careful observation of comic-book characters has contributed a good deal to his drawing development. On a single page he has drawn sixteen different superheroes, some of whom appear to have been borrowed while others appear to be of his own invention. Notice the great variety of actions that the boy is able to depict, a fact certainly attributable to the moving, running, leaping, and flying figures he has seen in the comic books that he emulates here in this "cover" drawing.

Figure 4-14

Mike S. (age 10)
Killers (pencil)
8½" × 11"

In the multi-sectioned humorous depiction of the team that made it to the Super Bowl—in the stands—the influence of television is evident. The pan from *close-up* to *long shot* showing parts of figures and overlapping action shots produces a very different image from figures that are influenced mainly by comic books. Perhaps because the action of the camera is more obvious in its rapid changes of view and position, the lesson of composition has been learned well in these frames.

whatever happened to Super Pickle?" His answer: "Oh I don't draw *him* anymore. I mean, what can you do with a pickle?"

Students will most certainly turn to the media for their models. As parents and teachers we can make sure that the models they use are the very best ones available—the Michelangelos, the Burne Hogarths—rather than a stereotypical Super Pickle.

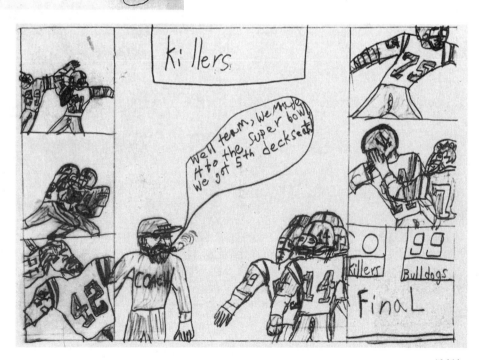

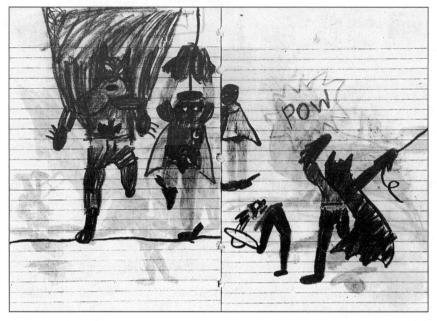

Figure 4-15

Taylor (age 7)
Pow (colored crayon)
10½″ × 15″

Seven-year-old Taylor seems to have
absorbed all of the conventions of the
Batman adventures, as seen on these two
pages of his own Batman adventure. Bat-
man, cape flying behind him, races with
Robin to catch the masked bandit. As they
race toward us on the first page, one leg
is seen in a foreshortened view, which is
reversed as we see Batman from the rear
on the second page. Many adults are
unable to achieve this kind of foreshort-
ening in their drawings, nor could Taylor
without the influence of comics.

Figure 4-16

Boy (grade 6)
A Satire (pencil)
4¼″ × 4¾″

Younger children identify with super-
heroes by their clothes, their gestures, or
their deeds. When they grow older they
understand that they couldn't possibly
perform all of those deeds or move the
way they do without muscles. In this
humorous depiction of a superhero, even
these are a bit exaggerated.

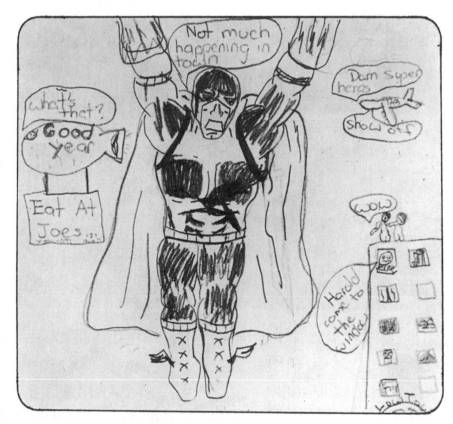

A Bird's Eye View: Depicting Space

Baselines and free-floating figures, fixed locations, tilted planes, and an absence of overlap characterize the "naturally" developing ways that children depict objects in space, and many children are quite satisfied to show objects in these ways. Other children, however, draw in the manner of movie cameras—moving above, below, and around objects. They zoom from long distances to extreme close-ups; they draw scenes in rapid succession, darting from one view to another. The creators of movies, television programs, video games, and comics have learned that they can create fuller, more complex, more believable, and especially more exciting images if they continually alter the viewer's implied location in space with respect to the objects they show. These children have made the same discovery. Movies and TV shows, comics and video games, influenced by cinematography, have taught them how. One young boy, after a teacher showed him how to make streets and buildings recede into the distance, exclaimed, "Wow, that's real power!" and such is the real power of the graphic experience. For children who want to know "how," the ability to move objects in drawing is a power equal to psychokinesis.

Help or Hindrance: Pros and Cons of Copying

In the postmodern age, one artist borrowing images from another is not only the norm but the fashion. This readily sanctioned style even has a name—*appropriation*. For almost as long as there have been artists, part of their training has consisted of slavishly copying the images and style of other artists, down to the tiniest nuance of brushstroke. We have written of well-known and outstanding artists who, as children, copied extensively from the work of others. Yet, some children who copy will be able to produce, in the end, nothing but the most mundane copies. Why should this be so? Let us examine some of the outcomes of copying. First, what are the positive aspects?

- Children gain confidence from the ability to produce drawings that have a style, technique, and accuracy far beyond those in drawings in which the child's natural resources alone come into play.

- Children are able to achieve mastery through copying—mastery of the conventional ways of drawing. Such mastery is necessary before the artist is able to go beyond the conventional to the creative.
- Copying enhances and facilitates perception of details because the more advanced work from which the child copies necessarily contains more detail, which may otherwise have gone unnoticed.

Thus, copying provides important information and a number of skills that contribute to development in art. But, of course, copying doesn't provide all that is needed for artistic development; under certain circumstances, the results of children's copying may even be detrimental to that development.

- Because the child may be incapable of devising new points of view, movement, or variations of the copied objects, the copy often becomes a frozen and inflexible schema that the child is unable to employ in new ways.
- The easily achieved, slick results of copying may become so attractive to the child that his own more individual creations appear pale and crude in comparison. This may result in an unhealthy reliance on copying with no attempt to go beyond the copied image.
- Because some of the images children choose to copy are among the most stereotyped in the culture—e.g., Snoopy's and smiley faces—when we first conducted our research, now, more often than not, figures from *Manga* take precedence. They are least likely to contribute to the development of a taste for fine drawings and drawing techniques.

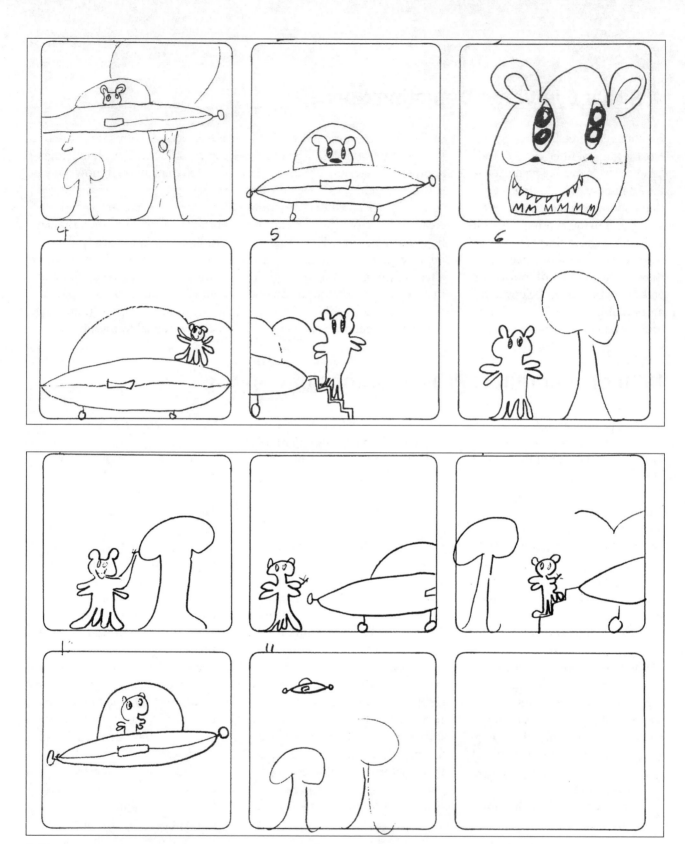

4-17

Figure 4-17

Girl (third grade)
Space Visitor (pencil)
individual frame size 4¼″ × 4¾″

This space odyssey, in the simplest drawings, tells the story of a space creature who lands on another planet, perhaps Earth, plucks a twig from a tree, and returns with it to his own planet. What is remarkable is this third-grader's ability to zoom from a distance shot, to a medium view, to a close-up, back to a full shot of the spaceship, to medium shots for the action, and finally to a long shot of the ship returning home. The influence of the media contributes to graphic accomplishments of which the child herself may not be fully aware.

Figure 4-18

Andy S. (age 11)
Bird's-eye View (pencil)
8½″ × 14″

Andy S. can draw cars and motorcycles, spaceships and planes from nearly every imaginable point of view. This car is seen from above as if the viewer were either high up in the stands watching a race or in a helicopter hovering in the air.

Figure 4-19

Tony (age 8)
Star Wars (pencil)
4″ × 6″

Tony's ability to involve the "power" of perspective is no fluke; he does so in virtually everything he draws, whether cities or houses or spaceships. Because of the profusion of space vehicles depicted in the media, children, especially young boys with a voracious appetite for such things, are able to use perspective and dimensionality in ways that boys of an earlier generation could not.

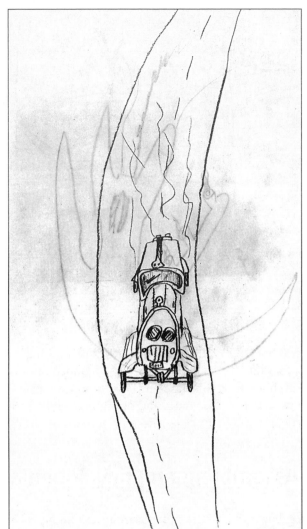

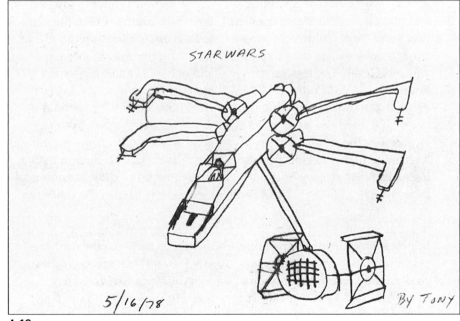

4-19

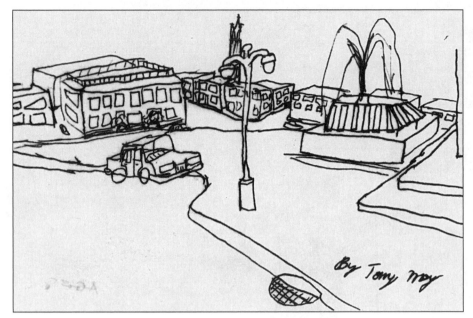

Figure 4-20

Tony (age 8)

Cityscape (ballpoint pen)

4" × 6"

This unusual depiction of space—almost as though one were looking at the cityscape from a third-floor window across the street—is more unusual still because it was drawn by an eight-year-old. Television, photographs, and drawings have certainly served as his models, but Tony's ability to draw from a remembered image and to make the images his own is truly astounding.

Since modeling-after is both inevitable and necessary for skill development, determined children will always seek out the necessary models for their productions.

Children who would use copying as a crutch should be guided out of this dead end. What can we, then, as guides and directors of children's art experiences, do to make their experience a positive one? We can encourage activities that lead to exciting invention rather than mere convention.

From A to Z: Assembling an Encyclopedia of Images

Children cannot produce drawings without the necessary information about the objects, places, actions, and processes they wish to draw. As they grow older, children develop a need to draw with greater accuracy and complexity. The reasons are both personal and cultural. Children's maturational patterns and personal desires as well as values imposed by the culture dictate higher and higher degrees of drawing realism. When they become increasingly critical and demanding of their work, many children—who lack the resources or the resourcefulness to find the necessary information—cease to draw, and thus cease to use this important source of self-knowledge. In order for children to continue to draw, the information they require should be available and accessible.

Sometimes children discover their own sources. Often the sources are photographs and illustrations from fashion magazines and newspaper ads, magazines about cars and motorcycles, or comic books. Children should be provided with a variety of images; a good selection of images not only provides more information than a single image but different points of view as well. To this end, children should be encouraged and assisted in locating, selecting, and collecting images that will supply the necessary information and ideas for their own drawings. The collected images—preferably photographs and drawings, paintings, and illustrations by the best artists—can be kept in an expanding file folder in a place the child can easily access whenever the need arises. Certainly every classroom should contain a large selection of these images in addition to a good collection of art books and reproductions.

The important point is that it is not necessarily unchildlike, unoriginal, or undesirable for children to draw from the images of other artists or from photographs. Child art as well as adult art may come from outside—from other art—just as much as or more than from novel ideas generated from within. What artists and children do is to take existing cultural images and extend them, alter them, recombine them, place them in new contexts,

and use them in new ways. Creativity is seldom achieved through the production of the utterly new but rather through taking those things that belong to the culture and using them in individual ways, resulting in images that are often novel and unique. We might compare this improvisation to that of the jazz musician. The jazz musician begins with a tune which becomes the background for improvisation, playing with a vast number of ways in which the original forms of the piece may be elaborated upon, varied, combined, and used in individual ways, resulting in novel and unique sounds or combinations of sounds. David Sudnow, an ethnographer who taught himself to play jazz piano, documented his mastery of this intricate process as "scaling ways, and up-and-down-a-little ways, rocking ways, and every-other-finger ways, and skipping ways, hopping ways, rippling ways, ways to go a long way with, and more."[10]

From Convention to Invention

Of all the work of young people that we have examined, there is no better illustration of the remarkable transition from that which is merely derivative—in this case, of the comic-book convention—to that which is truly inventive, than fifteen-year-old John's story of Gemini.[11] John's sources are not accidental or indiscriminate, nor are the resulting images exact copies. According to John, his hero is "like [in] *Battlestar Gallactica*; like Buck Rogers; like Spiderman." John thinks that most other comic-book characters are all the same—"it is just the costumes that change." Just as the plot of his complex cosmic tale is an amalgamation of myth and fairy tale and all the tales of adventure and space, of quest and villainy, of romance and combat and jeopardy that have ever been told, so his drawings combine all of what John has seen and drawn and remembered. He has only to lay out before him a vast store of images—most of which now exist in his mind's eye, some of which still exist in the form of photographic or graphic images, and all of which he can call into play when he needs a new image. He has bor-rowed and extended and combined just as generations of artists have done before him. John described his method of working to us:

If I know there is something I can't draw, I'll go get some comic books, sit down, and leaf through them until I find exactly what I want, just look at it for a minute, just to see what the angle is and everything, then put a rough sketch down—just an outline and then do it myself. . . . The cover composition I got from Star Wars. *I got the idea for statues from* Mr. Miracle. *She got her hair style from* Super Girl. *That [pointing to one area] is all original. No, wait, that's from* Comic Kid *and* Superfly. *I drew that part when I was watching* Star Trek. *They had a statue like that. I just added the other stuff onto it. I got that from the launch tubes in* Battlestar Gallactica, *but I changed it.*

Years of drawing from and critical examination of the work of comic-book artists have also enabled John to discriminate between what is good—"There aren't very many of the good artists left; it's getting down to the ones who aren't very good, who don't even try to be good"—and what is not. He aspires to be among the "good" artists and continually strives to improve his own drawings. Young people like John have gone beyond admiration and emulation—"That's great, I'll do one just like it"—to discrimination and invention—"I can do better than that!" And he can! And they can! (4-21 and 4-22)

Seven-year-old Lois's drawings of horses were extraordinarily inventive, particularly for one who had never seen a real horse. Lois was first brought to our attention by her second-grade teacher, who saw in her drawings of horses the same exceptional energy of line and movement evident in the remarkable drawings of a young autistic British girl described in the book Nadia. Like Nadia, Lois had the ability to begin her drawing at any point—the nose, the ear, the hoof, the tail—and to draw with such facility that at times her hand seemed to be moved by an external force. But there the similarity between Nadia and Lois ends. Instead of repeating virtually the same configurations time and again, Lois was able to complete, in seconds and in rapid succession,

Figure 4-21 and 4-22

John (age 15)
(pen and ink)

These drawings represent John's ability to narrate in a single frame, to convey graphically the feelings of power and force and of helplessness against those powers, and to produce an exciting and eloquent image through the use of line and masses of dark and light. They also demonstrate his own unique way of using design and decoration. These may well be established conventions and formulas but the formation is John's own.

horses that ran and walked and cantered and pranced, horses that reared and bucked, that performed any act of horse or human, that faced alternately left or right, front or rear. (4-22) Unlike many young horse fanciers, whose drawings display a limited number of variations, Lois seemed to have an endless reservoir of positions for legs, bodies, and heads. (4-23 and 4-24) Unlike Nadia—who almost seemed to be tracing around an image pro-

jected in front of her, even when it entailed scribbling right off the page or drawing one image over another already-completed image—Lois was so sure of the movement of her hand that she often drew without continuously monitoring the page in what was a joint knowing of image and hand.

Lois not only drew horses in innumerable positions but she also drew many different horses, which she identified by breed. (4-25) The

horses she drew had saddles and riders; they pulled sulkies and carriages, and they exploded from starting gates, but, most remarkably (see Chapter 3), (4-26) they drove cars and baked bread. They went shopping and carried umbrellas and planted vegetables and obeyed their mothers.

Lois incorporated in her drawings not only things she learned from books—about breeds of horses and what they do and how

Figure 4-23

Lois (age 8)

Lois was able to complete in seconds and in rapid succession, horses that run and walk and canter and prance, horses that rear and buck, that perform any act of horse or human, that face alternately left or right, front or rear.

Figure 4-24

Lois (age 8)

The positions and actions of the horses that Lois drew originated with illustrations that she observed in books. From these beginnings, however, Lois began to devise a great array of additional actions.

Figure 4-25

Lois (age 8)

Lois drew dictionaries of horse breeds. In her quick contour drawings she could capture the characteristics of the Shire, the Percheron, and the Clydesdale.

Figure 4-26

Lois (age 8)

Lois displays a remarkably intuitive sense of design, as well as a sense of composition, evidenced by some of her pages of horses in close-up and long-shot, in lines of running horses, and in views of the starting gate, and in displays of bridles.

they move—but things she learned in school and at church and things she had seen on television. She was enraptured by a popular television show of the time, *The Dukes of Hazzard*—about the adventures of two handsome young men and their amazing red stock car, named the General Lee. In her drawings, the Dukes become knights on horses and the General Lee takes on a life of its own. At times it rides a colt and drinks milk through a straw. Clearly, this is not simply a matter of a child's transference of image or idea, but the case of a fertile mind, accumulating visual as well as verbal ideas from wherever they may be found. In the way of creative people, Lois was playing with the endless possibilities: dissecting, combining, and inventing new forms in her drawings. Frequently Lois would comment, "These are very funny things for a horse to do!" and laugh delightedly as she drew—almost as though the ideas had come from someone else in order to entertain her.

Surely entertainment is one of the main motivations for Lois's art activity, but other factors include knowledge and reality-making as well as a control of her world she could not otherwise attain. Importantly, like most young people, Lois's aims are aesthetic as well.

Of the many children we have worked with, Lois employed the greatest range of conventional sources in her drawings and most frequently went beyond them to create new or novel dimensions of the realities. For instance, when horses become humans, Lois's imagined characteristics of horse personality are mapped onto humans, to make people seem more loyal and loving. In her imagined prophetic reality, not only do humans become horses, but inanimate objects behave like humans—as when the General Lee rides a horse and sips milk through a straw.

It is Lois's ability to "dream" while fully awake, to gather random words, images, and ideas and to combine them with whatever she is in the process of drawing that leads to the creation of new facets of the four realities. Most creation, in fact, begins with realities already at hand and consists of first acquiring the conventions, then going beyond that which is merely conventional to that which is novel and original, to invention.

At one time art educators believed that any influence on children's imagery was bad. In our postmodern era we have learned that once children move beyond random scribbling (and perhaps even before) their drawings are influenced from a little to a lot by a complex environment of graphic images. Sometimes, as in Egyptian villages where there are few influences from printed media, children influence one another. In Japan where children encounter thousands of graphic images daily, even before they enter kindergarten some kids have learned to draw in the *manga* style. So children learn to draw from drawings. How might teachers and parents use this information as they encourage children to draw? We have some ideas.

5

More and More:

Expanding **Drawing** Vocabularies

One day when Leif was four years and two months old, he drew his first airplane. He drew two or three more planes before bedtime on that Friday evening. Perhaps it was the airplanes drawn by his eight-year-old brother that inspired Leif's drawings, but the pleasure and excitement of his new accomplishment was unmistakable. His father offered him a 9″×12″ pad of newsprint and told him that he could draw more airplanes in the morning. And draw he did. Between that Friday night and the following Sunday evening—in just forty-eight hours—Leif drew 164 airplanes or partial airplanes. He drew almost every plane on its own sheet of newsprint, and these sheets attest to a little boy's amazing struggle to master, to his own satisfaction, the drawing of a single object. (5-1–5-6) Only forty-five of his planes could be considered complete. These contained a fuselage, two or more wings, wheels, at least one tail, and a propeller. A few planes also had a pilot. Leif surely must have considered these completed airplanes his successes. There were many more failures. Twenty-two sheets contained completed fuselages with one or two wheels, a single wing, or wheels and a wing.

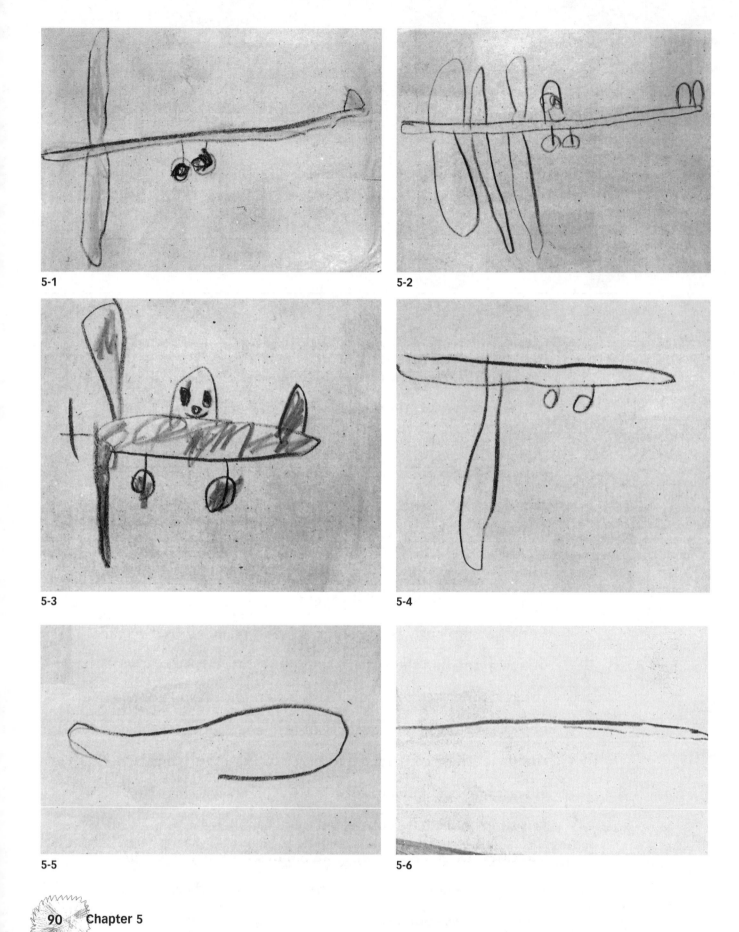

5-1

5-2

5-3

5-4

5-5

5-6

Figure 5-1

Leif (age 4)
Airplanes (colored crayon)
9″ × 12″

Most of Leif's forty-five completed airplanes look like this—complete with the basic fuselage, wings, wheels, tail, and propeller.

Figure 5-2

Leif (age 4)
Airplanes (colored crayon)
9″ × 12″

A few of the planes contained extra wings and tails and the suggestion of a pilot in the cockpit.

Figure 5-3

Leif (age 4)
Airplanes (colored crayon)
9″ × 12″

Even fewer of Leif's planes became almost tadpole planes with the head of the pilot in the cockpit above the leg-like wheels.

Figure 5-4

Leif (age 4)
Airplanes (colored crayon)
9″ × 12″

Twenty-two of Leif's planes were generally completed. This one, however, appears to have been placed in such a way that there was room on the page to place one wing satisfactorily but not two, and thus it was abandoned in mid-flight.

Figure 5-5

Leif (age 4)
Airplanes (colored crayon)
9″ × 12″

This fuselage appears to have been abandoned because it was too broad.

Figure 5-6

Leif (age 4)
Airplanes (colored crayon)
9″ × 12″

This one is too thin. In many of his 164 attempts it is possible to see Leif's struggle to draw airplanes exactly the way he wished them to be.

By studying these drawings it is possible to guess why Leif aborted his mission: often the placement was wrong, or there was room on the page for one wing but not two. But Leif's lack of control led him into even more serious difficulties. Twenty-six of the pages contain complete fuselages and nothing more. Apparently Leif decided that they were either too fat or too long, had undesirable bumps, or for some other reason did not merit becoming full-fledged planes. Another sixty-four sheets contain fuselages that were not even completed. They, too, appear misshapen, poorly positioned, or otherwise out of control. Finally there were five sheets containing indecipherable scribbles. Perhaps airplanes had been begun and scribbled over.

In the pages recording Leif's struggles to draw airplanes, it is not only possible to see the drive to achieve satisfactory graphic control of an image but also to speculate about the reasons success was not achieved. At first Leif couldn't always get the initial placement right, and even when he did, lines often went awry. In the course of a few weeks, however, they came out "right" almost every time. By then, through continuous practice, Leif had gained the skill for which he had worked so hard.

Whether or not Leif will be an artist remains to be seen, but the path that he was following at the tender age of four was the same one followed by Picasso and other artists. The sketches made by Picasso at ages nine and ten reveal page after page of pigeons, and shortly thereafter, hundreds of humans drawn from the front, the back, and the side.[1]

And then there is Anthony.[2] Several years after the date of the drawing shown here, (5-7) we received a letter detailing his latest projects—a new publication with four other artists, *SComix*, published at the University of Southern California, where he was a student; plans for the production of his own comic book; a science fiction novel; two magazine stories; an independent movie; and a newspaper comic strip—with the added declaration, "If I'm lucky, I'll finish them all by Christmas, or explode!" At the age of fourteen Anthony had been filling page after page in notebook after notebook with literally thousands of figures—figures that flew and moved in remarkable ways, sometimes as many as forty to a page. Anthony was practicing drawing figures from the front, the back, and the sides; examining arms and legs at every angle and in every degree of foreshortening; playing with the nuances of the figure and its actions as a musician plays with the notes of a scale, constantly honing, perfecting, and refining his drawing skills.

Anthony's goal was the perfection of the human figure; Leif's was to perfect his airplane. For Picasso and other artists and for children who wish to draw more and better, the goal is sometimes the perfection of a single object, sometimes many objects. In order to accommodate a developing process of reality-making in drawing, it is necessary to acquire correspondingly increasing drawing skills, in both the number of things one can draw

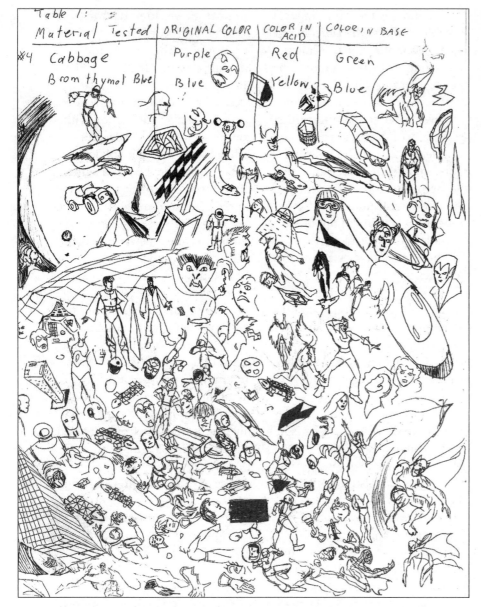

Figure 5-7

Anthony (circa age 14)
Chemistry Lesson (ballpoint pen)
8½" × 11"

On what appears to have been the page of a chemistry worksheet, Anthony has created a world where strange, toad-like vehicles, spaceships, and other conveyances move among an assortment of astronauts, superheroes, robots, and all manner of odd creatures that jump and fly and soar and leap in a wonderfully rich tableau. Although some may dismiss such efforts as mere "doodles," graphic play of this kind is very important to the development of drawing skills.

and the accuracy and variation with which one can draw them.

Anthony and Leif's skill development was self-motivated. Like most children who already draw well, they needed no special encouragement. The desire to make increasingly better drawings and to master the skill it requires is generally all that is necessary to stoke the fires of determination; and the success in working graphic wonders further fuels the child's accelerating momentum.

Not every child will spend countless hours perfecting her entrechats at the ballet practice bar, her scales at the piano, or her drawings of figures or airplanes or anything else. Nor do we believe this to be necessary. There are enjoyable and rewarding ways to improve almost every child's drawing skills, however. Rather than focusing on the refinement of a single object or even a few objects, the following exercises expand children's graphic vocabularies by increasing the number of objects they can draw.

Games to Extend the Number and Variety of Things to Draw

Most children draw only a few dozen things at most. Granted, these things do change over time. Children learn to draw new objects and to discard their old ways and old materials, yet compared with verbal vocabularies, which may contain as many as 2,600 words by the time a child is six, their graphic vocabularies are minuscule. Of course, children don't need to match graphic vocabularies with verbal ones, image for word. Because they do not communicate in their drawings in the same way they do in words, and the receiver of their graphic communications is often only themselves, it is unnecessary to continually say new things in new ways—thus keeping graphic vocabularies small and the possibilities for reality-building in drawing are markedly diminished. The series of graphic games provided here may help to develop children's drawing skills.

One exercise to expand graphic vocabularies is to ask children to draw as many versions of one particular thing as possible. The essence of these graphic-vocabulary-expanding games is to suggest to children that they draw as many of a particular object or character as they can or that they draw something in as many ways as they can. Once children have gone as far as they can on their own, then adults can suggest other possibilities and variations.

How Many Kinds of People Can You Draw?

In the classrooms where these drawings were produced, the teacher asked the children to name as many types of people as they could. The exercise was designed to stimulate the visual imagination. Some children named things such as people's ages and physical characteristics, others listed occupations, and still others mentioned imaginary people. After naming characteristics of people for five or six minutes, the children were asked to fill a page with drawings of different types of people.

Instead of filling his page randomly as most children did, Jeff, a sixth-grader, placed his people in compositions. He worked for three periods instead of the allotted one and created a fantastic world of imaginary people.

Evan, a third-grader, filled his page with young people, old people, a baby sucking his thumb, about eight different types of sports characters (some shown with a remarkable amount of action), musicians, and an artist at his easel.

Here are some other possibilities: Boys, girls, old people, babies, tall people, short people, thin people, heavy people, pretty and plain people, monsters and outer-space people, astronauts, deep-sea divers, racing car drivers, taxi drivers, kings and queens, knights and ladies, dwarfs, fairies, trolls, and giants; acrobats, dancers, soldiers, artists,

wrestlers, models, teachers, old-fashioned people, future people; big-headed people, short-legged people, long-armed people, big-nosed people, two-headed people, ten-eyed people; square people, round people, crooked people, straight people, bent, flat, and curved people; funny people, strange people, and on and on.

Our list is a starting place, and you can make it much longer. Usually a mere suggestion brings an image to a child's mind, and that vision soon becomes a graphic reality. (5-8)

Variations. Each of the types of people can be drawn with several variations, and some with an almost infinite number. Imagine what some children might do with, "How many kinds of monsters can you draw?" or "How many kinds of 'outer-space creatures' can you draw?" or "imaginary" or "future" people, and so forth. (5-9)

The People game can also center on features of people. For example, how many hair styles, costumes, noses, mouths, eyes, hands, feet, and so on can you draw? Artists themselves sometimes engage in activities just such as these. In a sketch for *Guernica*, Picasso surrounded a drawing of a bull with nine highly inventive drawings of eyes. In all of the sketches and prints associated with *Guernica*, Picasso drew nearly 100 different kinds of eyes.[3]

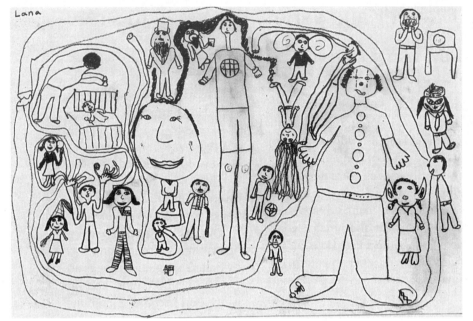

Figure 5-8

Lana (age 8)
How Many People? (pencil)
12" × 18"

In Lana's spontaneous drawings she draws characters—the cowgirl, the princess, the little girl. But when she was asked to draw lots of different kinds of people, she began to experiment with exaggerating features and drawing enormous figures and tiny figures. She drew the person with the world's longest fingernails, arms, and nose, "biggest ears," "most popped-out eyes." And as she drew she told little stories about many of her characters, identified the characters with people she knew, and even discovered that she could draw upside-down people.

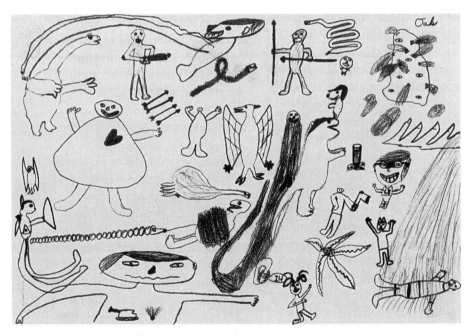

Figure 5-9

Oak (age 10)
Oak's Characters (pencil)
12" × 18"

Oak began by drawing people but they were soon joined by assorted animals, birds, and creatures, and, like his younger sister Lana, he also exaggerated features and verbally narrated the actions and encounters of some of his characters. In this playful game, Oak has drawn characters and actions that he has not previously attempted, and, by doing so and succeeding, he may have been encouraged to try even more.

How Many Kinds of Animals Can You Draw?

When children who only scribble are asked to draw a particular animal—a giraffe, a snake, a dog—they draw more regular scribbles than they do when working without direction. In other words, the Draw the Animal game can have a beneficial effect even before children are able to draw animals.[4]

The game might begin in a variety of ways: "If we were to go to a circus, what kinds of animals might we see?" "Let's name the biggest animals we can think of," or the smallest, the cuddliest, the most frightening, pets, farm animals, dogs, fish, birds, and so forth.

Some children may be able to draw a favorite animal. Boys often can name and draw a surprisingly large number of dinosaurs; but it will be easier for those children who have already done so to draw animals. Younger children simply adapt the drawing of the human and add a horizontal body or sometimes a larger body and more legs. (5-10)

Children who have never drawn an animal and cannot adapt another figure to their own satisfaction may lack information. In that case it is important to find as many

Figure 5-10

Lana (age 8)
How Many Animals? (pencil)
12" × 18"

Lana's menagerie consists of many of the animals you would expect a child to draw—elephant, lion, cat, crocodile, giraffe, octopus—each with distinct but somewhat generalized features. But, as with almost everything else Lana undertook, a sense of humor and playfulness pervaded the drawings. Elephant's trunk, crocodile's tail, and giraffe's neck alike are stretched and extended and writhe snake-like around the page.

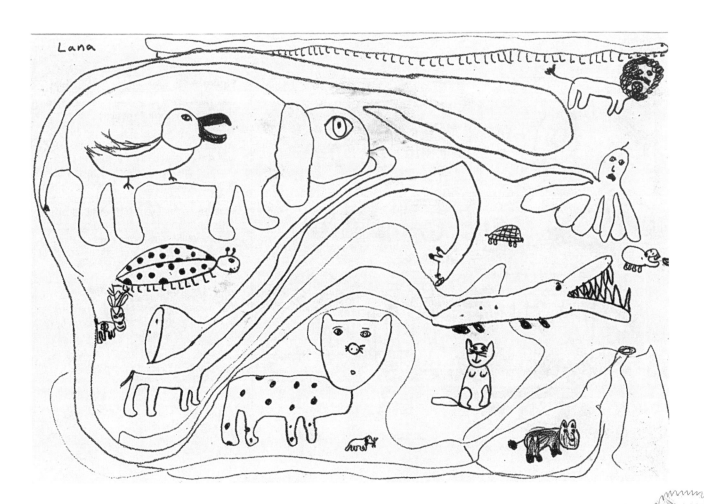

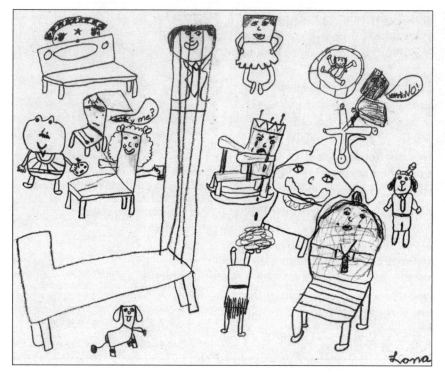

Figure 5-11

Lana (age 8)
How Many Chairs? (pencil)
14" × 17"

Months before we had decided to ask Lana to help us by playing some of the drawing games in this chapter, we were aware that she was having difficulty drawing chairs. The simple foreshortened bench that we had demonstrated for her then was one of the first to be drawn on this page of chairs. But soon Lana began to draw people chairs and, noting our delight, continued to practice not only her graphic skills but her fantasy skills as well. This drawing includes a "clown" chair, a "frog" chair, a chair drinking water, a "puppy dog" chair, a "king's chair—he's sad because he lost all his money," a "father" chair, a "mother" chair and a "brother" chair, as well as a "cat" chair, a "knitting" chair, and a "painting" chair. Had she not run out of paper it seems that Lana could have continued to create chairs endlessly.

Figure 5-12

Oak (age 10)
How Many Vehicles? (pencil)
14" × 17"

While Lana was drawing her chairs, Oak was drawing as many cars as he could. Children are often able to expand their graphic vocabularies by drawing as many varieties of objects as they are able to imagine, each of which presents a slightly different graphic problem and solutions that the child may never have otherwise attempted. The various angles—drawn at our suggestion—show Oak's ability to draw things from the back, side, front, and from above three-dimensionally.

drawings or photographs of animals as possible and to point out for the child the various unique characteristics of each animal—the giraffe's long neck, the camel's hump, the deer's antlers, the elephant's tusks and trunk, his large round body and big ears, the short legs and large head of the hippopotamus, and the surprising array of shapes and sizes of dogs, fish, birds, insects and so on. Without proper information nobody can draw satisfactorily. Children not only need information about ways to depict the characteristics of people or animals or whatever they wish to draw; they also need to be taught how and where to find the necessary information in pictures or from actual objects. And, most importantly, they need to learn that it is appropriate to do so.

How Many Objects Can You Draw?

People and animals are certainly not the only candidates for the How Many Can You Draw? game. This exercise could be extended to hundreds of other subjects. Natural phenomena, plants, and human-made objects also provide rich possibilities: houses, buildings, chairs, shoes, cars, planes, spaceships, ships, flowers, trees, toys, insects. Ask the children to help you expand the list. And remember, these are not finished art projects; they are only exercises that will make finished projects better, especially the narrative ones, because through these exercises children will expand their graphic vocabularies. (5-11 and 5-12)

Showing Action

Recently we did a comparison of the stories drawn by first-, third-, and sixth-grade children from Egypt and the United States. Among other things, we were interested to see how much action the children depicted in the people and animals in their stories. We found that at each age the American children drew figures showing significantly more action than the Egyptian children. (We think that one of the reasons is because the American children see so many action figures on television and in video games, cartoons, comic books, and photographs.) We were surprised, nevertheless, at the small amount of action most American children showed in their drawings. Often the drawings depicted a minimal amount of action even when the story seemed to call for far more. We think most children don't show action in the figures they draw because they have not been taught to do so.

Here is an exercise designed to help children draw figures in action. The directions might go something like this: "Think of a person such as a dancer, an acrobat, a football player, a tennis player, a basketball player, or a superhero who goes through lots of motions. On the left side of the long strip of paper, show the figure about to go into action, and then all the way across the paper show how he or she performs those actions." Children should be encouraged to make the actions as extreme as possible.

After we gave an assignment like this, many children got out of their seats in order to take different poses to see how positions felt or asked classmates to pose for them.

If children learn to draw figures in action, then the stories they draw will be more exciting because their characters will be capable of doing so many different kinds of things.

Games to Show and Increase Expression in Drawings

Often the characters in children's stories encounter situations that should cause them to show various feelings and to display different emotional reactions. Sometimes, however, children do not know how to depict these emotions and feelings very well. This exercise is designed to help them to expand their graphic vocabulary of emotions.

Children seldom use more than the turn of a line to show the emo-

tions of their characters—upturned mouths for happy, down for sad. Other ways of expressing emotions, whether they entail facial expression or the language of the entire body, rarely appear in children's drawings. Yet, often with the merest suggestion or description, or even by demonstration, children are able to depict not only a range of emotions, but a variety of moods.

Facial and Bodily Expression

Have the children draw a face as they usually do, one that is neither happy nor sad. Then have them draw it again, this time making it look very happy or very sad, surprised, angry, pleased, thoughtful, tired, bored, frightened, and so forth. They can draw the faces on a regular sheet of paper, on a sheet that has been divided into sections, or on a long narrow sheet, so that they line up in a row. They may want to label each expression. Or have children play a different game, with children drawing the expressions while a friend, classmate, sibling, or adult guesses what they are.

The latter game might necessitate a clearer or more exaggerated depiction if someone else is to guess which emotion or mood is being expressed. Certainly, the older the child, the greater the range of expressions; younger children should be able to master the more obvious expressions. (5-13)

For those children who find this game difficult, here are some variations:

- Supply children with mirrors and have them create the facial expressions with their own faces, then draw them.
- Have another child or an adult create the facial expression from which the children can draw.

Figure 5-13

Lana (age 8)
Facial Expressions (pencil)
12" × 18"

Lana first folded her paper into six sections and then proceeded to draw a face in repose. As the model assumed the various facial expressions, Lana drew—from left to right, top to bottom—*angry*, eyes narrowed, eyebrows knit, mouth twisted; *frightened*, eyes wide, mouth in an "O"; *unhappy*, eyes turned down, tears streaming, and mouth in an inverted "U"; *pleased*, a moderately smiling mouth and widened eyes; and *very happy*, mouth broadly smiling, showing teeth, eyes narrowed, and what appear to be dimples.

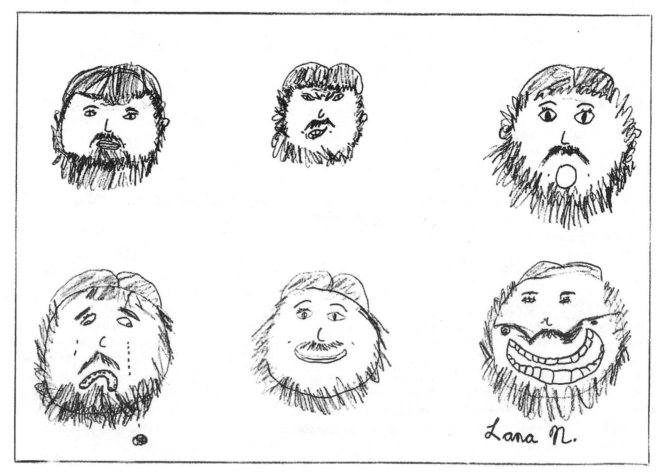

- Look at the ways artists and illustrators show feelings and emotions in their art.

Certainly there are times when the entire body expresses an emotion or a mood. (5-14 and 5-15) Words are often great image makers. For "very angry," for example, the children may recall or you might read the story *Rumpelstiltskin*, which in its many versions ends something like this:

"Who told you that? Who told you that?" shrieked the little man; and in his rage stamped his right foot into the ground so deep that he sank up to his waist. Then, in his passion, he seized his left leg with both hands, and tore himself asunder.[5]

In using this quotation, you would probably begin with a discussion of the word *asunder*, which, although archaic, is particularly descriptive. Have the children think about how Rumpelstiltskin would have "tor[n] himself asunder," and what he might have looked like— and what kind of expression he would have displayed in such a rage—as he did so. Here, too, you can introduce the idea that line and color—heavy jagged lines, black or purple—can help to depict emotions in drawings. Here is a partial list. You and the children with whom you play these games will be able to add many more: unhappy, puzzled, proud, tired, excited, amused. It is often helpful to invoke verbal metaphor and imagery: "proud as a peacock" (how does a peacock strut?); "happy as a lark" (one can actually appear to fly or soar); "he laughed so hard he almost burst." The chil-

Figures 5-14 and 5-15

Lana (age 8)
Very Angry (pencil)
7½" × 10"

Oak (age 10)
Utterly Dejected (pencil)
7½" × 10"

Lana and Oak were trying to draw the various ways the entire body may express an emotion or a mood. Lana's attempt to depict a stamping foot led her to bend the knee of her figure sharply while still employing her usual "sausage" curves on the arms. We don't know to what extent it was deliberate, but Oak's figure is so dejected that even the chair slumps.

dren might act out some of these expressions and draw the way their bodies feel to them, or again, they might draw as others act them out.

Using an Entire Picture to Express Mood

In the last section we mentioned the way line or color might express a particular mood or emotion. Often when children are given descriptions of a scene or situation in which a mood is expressed, they instinctively employ lines and shapes to convey the particular feeling. Works of art abound with descriptive examples—the angry sea (countless paintings by Winslow Homer, J. M. W. Turner) loneliness (Andrew Wyeth's *Christina's World*[8]). The words that describe a mood are often very helpful, such as those found in literature and poetry— Carl Sandburg's *Fog*[9]; Vachel Lindsey's *Congo*.[10] Any of these works

might help children to visualize, imagine, and express.

The following description encourages children to express the force and violence of the storm with dark, jagged, diagonal lines, and crashing and overlapping.[11]

The storm was terrifying. The black sky was streaked with lightning, rain came in torrents, trees fell, branches and other objects flew through the air. Small streams became wide rivers carrying everything in their path. People and animals were frightened and sought shelter and safety. Many other frightening things happened.

Can you imagine how the storm looked? Draw a picture of the terrible storm. Try to make your picture show the feeling of the storm, not just how it looked but how it felt. (5-16–5-18)

This might also bring to mind images of the tornado in *The Wizard of Oz* or even graphic images of tornados on the television news. Here are other examples for which descriptions (either verbal or visual) can be found in literature and poetry and art:

- A rainy day (Hiroshige, *Sudden Shower over Shin-Ohashi Bridge*)[12]
- A mysterious place (Di Chirico, *Melancholy and Mystery of a Street*)
- Joy and celebration (Matisse, *The Dance*; Chagall, *The Birthday Party*)
- A hustling, bustling, noisy city (Boccioni, *The City Rises*)[13]

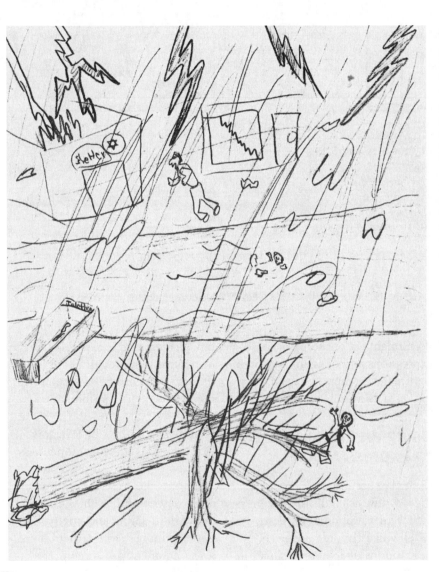

Figure 5-16

(Artist Unknown)
The Storm (pencil)
8½" × 11"

This child has included many of the expressive elements of the terrifying storm in the drawing. Lightning streaks across the sky; trees and even a telephone booth fall; hats and other objects fly through the air; streams turned into rivers flow down the street, even carrying people in their path. The man seeking shelter appears to be bucking the force of the wind while the rain falls in torrents. All of this is drawn with fast, jagged strokes of the pencil that help to convey a feeling of agitation while the faces register terror.

Figure 5-17

Lana (age 8)
Liberated Village I (pencil)
9″ × 11″

After hearing a description of a liberated village, Lana was asked to express the feeling of joyfulness. Her drawing shows elation, joy, and happiness not only in facial expressions but in the triumphant raised arms of the villagers. Lana followed our suggestion to place one figure behind another in order to show a crowd of people, with great enjoyment at this discovery. A close study of the villagers reveals Lana's own story-making abilities in the person of specific characters—a crooked old man at the left, a child in the center who is crying because she has lost her mother in the excitement, and, of course, the expelled invader, who says, "Rats."

Figure 5-18

Oak (age 10)
Liberated Village II (pencil)
9″ × 12″

Oak's concern with the story of the liberated village was less with the villagers themselves than with the way they had been held captive. Oak spent a considerable amount of time drawing this enormous counterweighted bamboo cage. Since Oak and Lana drew at the same table it is clear where Lana's thatched huts on stilts came from. It is also interesting that both children felt the need to supplement the visuals with written labels.

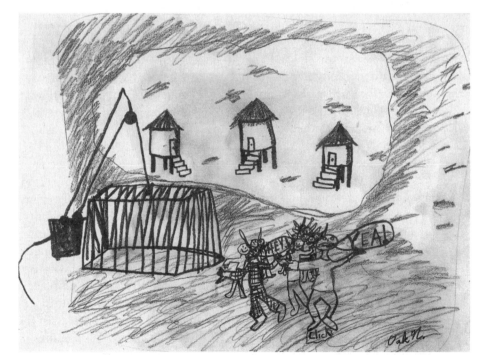

Increasing the Skill to Depict Motion

In Chapter 3 we discussed the difficulties encountered by children in trying to show people and animals in motion. Because the key to showing human movement lies primarily in drawing arms and legs bent at the elbows and knees, the child's innate propensity to keep limbs simple and undifferentiated is often a powerful obstacle to depicting action. Some very simple exercises can help children overcome this obstacle.

College students who had not drawn since elementary school and who could not draw a figure running were shown various ways to depict fast motions. We drew parts of a figure on the board and assigned points to each for the degree to which they depicted action. The torso was drawn leaning forward at a forty-five-degree angle; the forward leg thrust out high, with the knee bent only a little or not at all; the other leg bent backward at a sharp angle; arms swung at sides with elbows bent; and finally the figure was drawn raised off the ground and horizontal lines were added to indicate how fast the figure was running. (5-19) A figure shown running in this manner was worth a number of points for each part depicted; a total number of points was the agreed-upon standard. Immediately after we showed students these parts of a figure and for at least ten weeks thereafter, every student in the class was able to reach and, in most cases, to exceed (with touches of their own) the required number of points for a figure running at

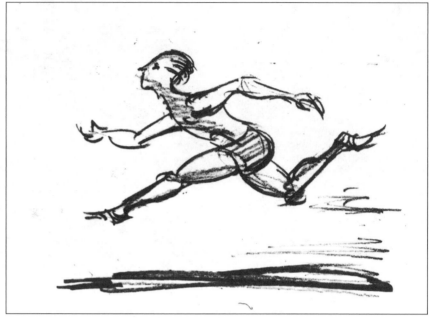

5-19

high speed. This same exercise could easily be used with young children.

Some younger children, however, are not yet able to differentiate elbows and knees and thus to draw them bent. Philip couldn't get his figures "runned" (Chapter 3) even though he knew that bending the knees was the secret. Like many youngsters, he accomplished the effect of running in a way satisfactory to him by merely separating the legs in scissor fashion. Because younger children usually embrace this solution, your goal at this point should be simply to assist the child to this end. When bending limbs is out of the question, try the scissor solution; show the child the figure—as she typically draws it— but with legs spread in a running position (see Philip's "runned" figures in his dialogue, p. 62).

Figure 5-19

The standard by which groups of college students measured their own *running* figures.

Figure 5-20

Lana (age 8)
Horses in Action (pencil)
6" × 18"

Lana drew her first horse standing (right). We then suggested that she try to make her horse run and rear and buck. That accomplished, Lana decided it would be fun to draw a horse-person and another horse standing on its front feet. These two Lana worked out on the spot. Once children are encouraged to perform graphic feats they would never otherwise have attempted, you may be amazed at the heights they are able to reach in developing graphic skills.

5-20

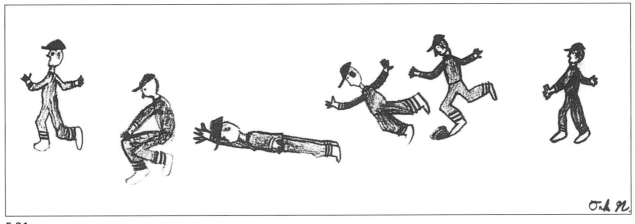

5-21

Animals, too, can be made to move by simply orienting their bodies in various ways and by bending the legs a little or a lot depending upon the desired degree of action.

Drawing Figures in Action

When the child is able to depict action to her own satisfaction, it is time to start action games. Action games can be derived from some of the earlier How Many Can You Draw? exercises. It can be fun to take all of the characters that a child can think of (see p. 93) and put them into some active position—running, jumping, standing on their heads, standing on their hands, kicking a football, dancing, and so forth.

Another game is the Animation game. The object is to take a single figure through a series of actions or steps involved in an action, as in an animated film. Before starting this activity, you may want to refer to books about animation that describe how to create the semblance of movement with a simple flip book.[14] After the child is able to show the steps from walk-run-jump to the more complex actions of dancing or doing a somersault or even diving, you might try a flip book, which requires many more figures and more subtle actions. Remember that it is always best to have the child rather than the adult generate the ideas. (5-20–5-22)

Figure 5-21

Oak (age 10)
Figure in Action (pencil)
6" × 18"

Oak was asked to draw a person moving across the page. Curiously, as in Lana's drawing, the action moves from right to left. The figure starts to walk, trips over a rock, falls flat on his face, struggles to get up (erasures also show Oak's struggle to get this position just right), and finally runs on his way. Oak was able to depict these actions through assuming the positions himself and trying to "feel" the way the action would look.

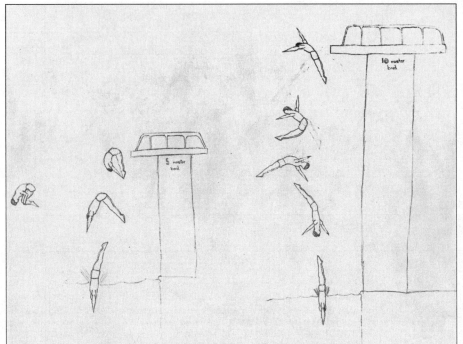

Figure 5-22

Leif (age 11)
Diving Figures (pencil)
12″ × 18″

If Leif had to choose between drawing
and swimming, it would be a difficult deci-
sion to make. In this drawing of figures
diving, Leif manages to combine both
loves, and through his drawing he is able
to work out the mechanics of the dive,
which he was trying to master both on
paper and on the diving board. On this
particular day, he returned home from
practice on the ten-meter board and con-
tinued to feel how the body moves as he
symbolically recreated the perfection of
the dive.

Showing Different Points of View

As the illustrators of comic books
discovered years ago, visual narra-
tives can be made more exciting if
the artist continually shifts the
implied position of the viewer.

In one exercise, we asked chil-
dren to "show one runner as he or
she runs the marathon. Try to show
the runner from all angles, and show
all the different types of scenery
through which the runner passes."

In another exercise, we asked
children to show a dancer "up on
her toes, leaping high into the air,

doing a split, bending over back-
wards, one leg raised very high."

In a third exercise, children
were asked to "show a person far,
far away." Then, "Now show the
person just one foot away from
you." And finally, "How would the
person look walking away from
you?"

Drawings from Graphic Models

Children, and for that matter,
adults, often have difficulty drawing
characters because we do not have
enough image-related information
about what distinguishes one char-
acter from another. Nor have we
developed the graphic programs for
showing the difference. This exer-
cise was designed to expand chil-
dren's vocabularies of trolls. The
children in an art class were doing
several illustrations of *The Hall of
the Mountain King* from *Peer Gynt*. If

children are to draw trolls, they
need to know what trolls look like
since they are not born with knowl-
edge of them nor can trolls ordinar-
ily be observed in everyday life.

For this exercise, the teacher
made a series of ten slides from a
book illustrating trolls. In a semi-
darkened room, as the slides
appeared on the screen, the teacher
made comments about goat-like
faces, sharp noses, hunched backs,
and stringy hair. The children drew

each of the characters as it was pro-
jected, taking about three or four
minutes for each drawing. It is sur-
prising that entire classes of chil-
dren as young as first-graders were
able to show the different character-
istics of each of the ten trolls. After
children completed the exercise, it
was remarkable to see the variety of
trolls that illustrated *The Hall of the
Mountain King*.

Drawing from Actual Objects and Images

We found five-year-old Brandy in the Metropolitan Museum of Art in New York City, intently drawing from a portrait of Benjamin Franklin and producing his own very fine likeness. (5-24) Satisfied with his first drawing, he moved on to a marble sculpture—*The Bather*, by Houdon. (5-23) Brandy's drawings are more accurate in detail than drawings by most five-year-olds because he was drawing from works of art to which he was able to refer repeatedly in order to get things just the way he wanted them. Drawing from observation is a marvelous way for children to expand their drawing skills. It can be done at home or at school as well as in exciting places such as museums. In *Teaching Drawing from Art*, we make other suggestions about drawing from observation.

5-24

5-23

Figure 5-24

Brandy (age 5)
Ben Franklin (black marker)
8½" × 11"

Brandy studiously made this drawing as he sat in front of a portrait of Franklin in New York's Metropolitan Museum of Art. With a few strokes of the marker Brandy was able to capture a likeness of old Ben as well as the feeling of the decorative frame.

Figure 5-23

Brandy (age 5)
Houdon's Bather (black marker)
8½" × 11"

Brandy graduated from portraits to depictions of sculpture in this rendition of a bather by Houdon. Notice the carefully counted fingers and toes. The Metropolitan's stamp in the lower corner of both drawings added an air of authenticity to the fact that Brandy, the artist, was in good company.

At Home and in School

Many children who draw extensively draw pictures of their friends and especially their teachers, of desks and chairs, and whatever other object or image catches their fancy. Not only is it satisfying for the child to know that she has the ability to capture a likeness of a pet, an object, or a person, but these successes give her the incentive to draw more and more difficult things. Observational drawing helps to expand drawing skills, too, because *drawing by looking* supplies new visual information that the child can incorporate into her current drawing programs.

In order to be sure that the child is noticing detail as she begins to draw from observation, a verbal description may be helpful.

Point out such things as roundness or squareness, contrast of large and small, light and dark, the large overall shape as well as small details. Or have the child describe an object as she draws it or before she begins. Remember that the younger child is still working on a *simple* and *undifferentiated* program, so should not be expected to include many details, even though they may be directly in front of her and in spite of her knowledge of them.

Four-year-old Peter may prove the exception to the *simple* and *undifferentiated* rule. He was given a sheet of copy paper and a ballpoint pen to keep him busy while the adults were preparing Thanksgiving dinner. Fascinated by an animated cup and saucer he had just received with his Burger King® meal, he was

determined to draw it. Perhaps he had watched his older sister engaging in observational drawing at one time, but, without any help or suggestion, he was able to show the character of this object, including the handle/nose in a front-view position.

What other kinds of things are candidates for observational drawing? Everything! Dolls, the doll house; chairs; toy cars, trucks, planes, and spaceships; a bowl of fruit; kitchen pots and pans and small appliances; a shoe or shoes; a collection of seashells; the telephone; a stack of books; a table with lots of things on it; scissors; a pencil sharpener; musical instruments. This list can be expanded endlessly and can include things inside as well as outside the window, or you can go outside and

Figure 5-25

Lana (age 8)
Plants (pencil)
9" × 12"

We chose Lana to participate in these drawing games precisely because her drawings were representative of the drawings of most eight-year-olds, because she enjoyed drawing, and was willing and anxious to try anything. She had not customarily drawn from observation. In drawing the five plants that sit on a table in front of her living room window, she was challenged to look for details, to pretend that her eyes were a camera's lens, to show the differences between the pots and the various types of leaves, and to note how the light from the window created dark and light areas. Lana's drawing shows how drawing from actual objects encourages close, careful, sensitive perceptions.

Figure 5-26

Lana (age 8)
My Dolls (pencil)
9" × 13"

Lana has drawn her dolls lined up on a pillow on her bed, but it is obvious that her concern was less for the setting than for capturing the individual characters and characteristics of each doll. Lana was pleased with the result, as well she might be; she is learning to attend to detail and to individual differences as, more and more, she draws those things that make up her *common reality*.

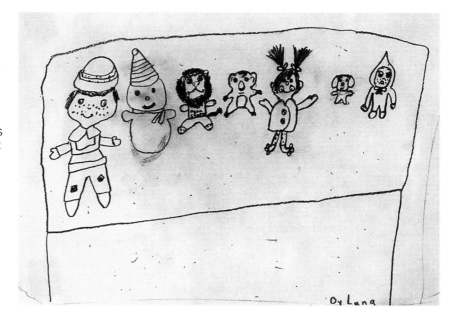

have the child draw things at close range. (5-25 and 5-26)

In Settings

Brandy drew at the Metropolitan Museum of Art. Teachers often take children to museums and then ask them to draw when they are safely back within the confines of the classroom. But think how exciting it would be to be able to draw in the company of artists and works of art! Almost any setting, though, ordinary or extraordinary, can become an exciting place in which to expand children's drawing vocabularies by tackling the problems of *overlap* and *points of view*, showing distance and dimensionality.

When drawings are made in settings such as playgrounds, parks, ball fields, or even at home and in the classroom, many of the innate graphic characteristics (Chapter 3) such as simplification, showing objects from the most characteristic view, and avoidance of overlap may be overcome because of the altered point of view and the uniqueness of the situation.

Before children begin to draw, you may want to point out that things that are farther away appear to be smaller and higher while things that are nearer to the viewer appear to be larger and will be lower on the page, and how the things that are closer overlap those in the background.

Slowly, with Caution

A word of caution here: Many children, certainly younger ones, may be unable to draw any but the most direct point of view; high angles and bird's-eye views may be difficult and frustrating for them. It is our aim to expand and extend children's drawing vocabulary and ability to depict so that they want to continue to draw. Pushing children beyond their ability to the point of frustration usually has the opposite effect—they may lose all confidence and interest and even cease to draw at all. It is unwise to attempt to have children draw things beyond their abilities. Approach all of these activities with caution—proceed from simple to complex, watch the child for signs that you have begun to tread on thin ice, and be ready to retreat. Should this occur, find something with which the child is more comfortable and which is less demanding—perhaps repeat a previously successful game—and begin again. Cautious practice and the variation of these exercises may lead not only to mastery but to innovation and invention as well.

6

And What Happens Next?

Telling Stories Through **Drawing**

Once upon a time there was a man. The end.[1]

This first story, told by a two-year-old, has some interesting similarities to the first tadpole figure drawn by a child. We might even call it a tadpole story, because, like the figure, it possesses a head and tail (legs) only: a beginning and an end. There are other parallels between the systems of symbols children use to express themselves, to communicate and to gain knowledge about the world—speech and music and play, as well as drawing and telling stories. Storytelling, like drawing and play, enables the child to create model situations of past, present, and future possibilities of the four realities. Like drawing, too, storytelling has cultural roots; if there were no tradition of myths and fables and fairy tales, if parents did not read stories to their children, if there were no Mother Goose or Dr. Seuss, if no oral or written stories existed in the culture, children would not tell stories.

But there have been and there continue to be stories; parents tell stories to their children and children tell stories as well. Story takers who repeatedly request stories from children find many gems.[2] But unless there is a willing listener, these stories will most likely go untold. We have come a long way from the oral tradition of the singer of tales, of the elder who passed oral tales from generation to generation. A story that is drawn reflects the graphic tradition of narrative found on walls of Egyptian temples and on Greek vases, as well as contemporary conventions of television and comics—told, nevertheless, because listener and teller are often one and the same.

Spontaneous Story Drawings

There is a narrative dimension to nearly all of children's make-believe play. The rectangular block that "stands for" the racing car goes *vroom, vroom* over the track and under the tunnel; the doll becomes ill and needs to be ministered to by Mommy, the doctor, and Daddy. To the child's story drawings as well, there is often a beginning, middle and end; more specifically, for the sometime shorthand symbols that appear on the page there is both past and future.

The very earliest scribbles, as we have seen, become a pretext for the child's flights of fancy. The adult's "What is this?" can send the child off into stories that are wonderful, exciting, and fantastic. Older children will embroider extraordinary tales around simple drawings. One first-grader, motivated by the drawing she had made of her house, told a story about how she and her sister often slipped into one another's rooms when their parents were asleep.

Although some children are content just to draw simple things—cars and planes and spaceships, horses and princesses and gymnasts—more often the cars are in the Indianapolis 500, the planes are part of elaborate battles, and spaceships land on strange planets peopled by exotic creatures. Princesses or cowboys and cowgirls ride the horses and gymnasts take part in the Olympics. Through extensive studies of children's spontaneous drawings—those drawings that are done for themselves rather than for teachers, for other adults, or for the purposes of others rather than for their own purposes—it has become increasingly evident that children use these drawings for the primary purpose of narrating.[3]

As we have also seen in children's play, the narrative allows the child to create sometimes complete, sometimes fragmentary "as if" models of reality or realities. It is through these stories that the child can explore and thus come to understand more fully life's dramas and processes. The myth, the fable, and the fairy tale serve as models for the child's own reality testing. Bruno Bettelheim believed that the significance of these narrative forms is determined by the degree to which the view they present conforms to our own needs and desires.[4] According to Bettelheim, the fairy tale is the paradigm of narrative forms. In the fairy tale, all situations are simplified; the figures are clearly drawn and the characters conventional; details and shadings are eliminated—there is only black and white, good and evil—which becomes a means for the child to understand himself and the world with which he must cope. The fairy tale is like a mirror that reflects aspects of another world through which the child can better understand and learn how to deal with life's mysteries. We believe that, in his own stories, the child is creating situations that are suited entirely to his own needs and desires, that deal directly, though symbolically, with his own immediate concerns. Brian Sutton-Smith, who has made numerous studies of children's verbal stories, characterizes them as "caricatures," much like "adult soap operas," devised by "persons caught in situations of stress and ambiguity."

For children, as for adults, there is early wonderment as to how one can possibly deal with villainy and deprivation, and whether or not these can be overcome by one's own skill or with the help of benign strangers.[5]

The visual narrative, then, enables the child to use graphic symbols—those that leave a tangible record—whose very tangibility allows an infinite flexibility permitting him to invent and reinvent, supplement and delete, order and reorder realities merely by adding and subtracting lines and forms.

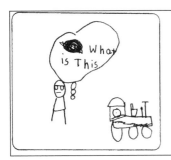 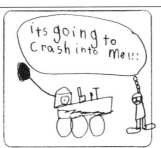 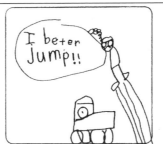

Figure 6-1

Boy (grade 1)
I Beter [sic] *Jump*, black marker
Individual frame size 4¼" × 4¾"

A perfect example of overcoming a threat through one's own devices is this narrative by a first-grade boy. In the first frame a little man confronts a strange locomotive-like vehicle (we are told, however, that it is a "supercycle"). He wonders, "What is this?" In frame 2 the supercycle comes closer—we can tell because it is now larger and the person smaller—and "it's going to crash into me." At this point either a miracle will save the man or he will have to take matters into his own hands. He acts—with a tremendous leap he clears the supercycle, declaring, "I beter [sic] jump!!" and the danger is averted. In the final frame we return to normal, the man smiles and says, "Good, it didn't hit me." It is certainly reason to smile, and to be proud to know that we can fend for ourselves when the necessity arises. This is the rehearsal and practice, through drawing, of a little boy's caring for himself.

Figure 6-2

Boy (grade 5)
SuperPig (black marker)
Individual frame size 4¼" × 4¾"

In this humorous narrative the forces of evil are overcome by the fortuitous intervention of a benevolent super antihero, SuperPig. This satire of all superhero sagas begins with the figure of a boy leaning nonchalantly against a street sign, "just hanging around." His stance and the presence of the yo-yo attest to the fact that the boy is unaware of the danger, in the form of a "giant claw," that lurks in wait and, in the second frame, comes and picks him up to carry him off. In the next frame we see the villains in the form of a robot at a control panel and his "master," a huge, bloated Humpty-Dumpty figure, televised on a screen. All seems to be lost until who should appear but . . . "It's Superpig!" who flies off over the rooftops with the boy safely in his grasp. At times when the odds seem to be overwhelming it is nice to know that we can count on "a little help from our friends." This narrative is remarkable not only for its Orwellian "Big Brother is watching" character but for the ability of the artist to play with dramatically shifting points of view in which the viewer is at once spectator and participant. It is almost as though the character on the screen has brought the viewer into the story and addressed us as he asks, "Have you caught the earthling?"

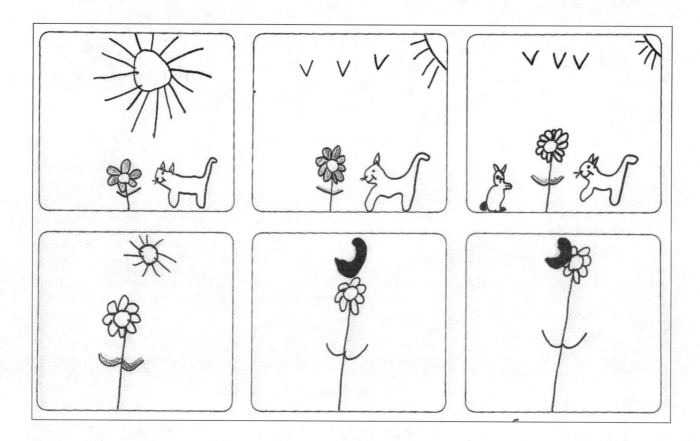

Figure 6-3

Susan (age 6)
Growing Flower (black marker)
Individual frame size 4¼" × 4¾"

In a careful analysis of the various kinds of meanings illustrated in the drawings of this six-year-old girl, we found that she dealt with *nine* separate meaning considerations such as time and size relationships, development, and location. As Susan used words to tell us about this same story, however, she dealt with only *one* meaning dimension, *development*. All she said was "The flower is growing. It's bigger, a little bigger. bigger, and bigger. Biggest."

Words must be set down in a particular order if they are to communicate; drawings, on the other hand, are not bound by the dictates of grammar. (6-1 and 6-2)

In addition, there appears to be a point in the child's development when he can show, in his drawings, dimensions of meaning for which he cannot yet supply the words or even perhaps yet fully understand.

We must all grow up, at least physically. Children, who have the most growing to do, seem especially concerned with gaining cognitive mastery over the growth process. Through a series of narrative drawings, development can be speeded up tremendously so we can see the whole process at one time. In the first frame of one such narrative drawing, Susan, a six-year-old American child, shows a flower, a cat, and the sun. (6-3) In the second frame the position of the sun shows that time has passed and the flower has grown because it is now bigger than the cat. In the third frame more time has elapsed—the sun has moved nearly out of the frame. The flower is now even taller than both the cat and a rabbit that happens on the scene. The rabbit's presence gives the drawing a nice symmetrical balance. The v-shaped birds, too, help to fill the space. In the fourth frame the smaller sun seems to show an even greater passage of time. The flower has now grown so tall that the cat and the rabbit are perhaps far below and out of view. In the fifth and sixth frames more time has passed because the sun has been replaced by a black moon. In the last frame the flower has grown so tall that it appears to touch the moon. Some growing!

In a careful analysis of the various kinds of meanings illustrated

in the drawings of this six-year-old girl, we found that she dealt with *nine* separate meaning considerations such as time and size relationships, development, and location. As she told us about this story, however, she talked about only one meaning dimension: *development.* All she said was, "The flower is growing. It's bigger, a little bigger, bigger, and bigger. Biggest."

Drawing, then, becomes a natural vehicle for the narrative; the narrative, in turn, promotes greater quantities of drawings as well as the need to create figures and objects with more and more complexity, action, and detail. The little first-grader who was drawing a story about King Kong was having difficulty showing how big his character was. He found that he could either fill the entire page with the one figure or make him appear bigger than people and taller than buildings, thus creating a need to draw those other elements as well. It is important to the child's need to narrate, to understand, and to test life's problems and processes, to help him not only to draw skillfully but to be able to use the medium of the story skillfully as well.

Encouraging Drawing Sequences and Story Plots

It was probably because Philip's younger brother, Michael, at the age of four, had already conceived three imaginary friends that their mother despaired that Philip, almost six years old, had "no imagination." Although his fantasies were more conventional than Michael's, Philip was nonetheless able to generate fantastic stories once he was aware of their potential in his own drawing.

The first drawing that Philip showed us was a typical five-year-old's drawing, the figures not much different from the typical first tadpole figure drawn by most children. Two of these figures were contained in a sort of box-like shape. Philip's incredulous response to the request to "tell the story" was, "It's not a story; it's a picture." But further questions: "Who are they?" "What are their names?" "What are they in?" "How did they get there?" "Where are they going?" elicited ready replies, and although Philip and we were aware that he was generating at least some of his answers on the spot, there was the revelation that the drawing was really a

story. We then invited Philip to draw a story.

He drew this first story enthusiastically but not without some degree of prompting. Spiderman appeared as the hero of the adventure in response to questions: "What does Spiderman look like?" "He has no mouth; he has a spider on the back of him." "What can he do?" "Swing on his web." When Philip was satisfied with his picture of Spiderman the dialogue proceeded in this way:

Adult: OK, tell me what Spiderman is doing.

Philip: He's going to swing on his web.

Adult: And then what is he going to do?

Philip: And then he's going to go on the ground.

Adult: Uh huh.

Philip: Here's the rope—like his hand's grabbin'. . .

Adult: And then what's he going to do? Is he going after somebody?

Philip: Yeah!

Adult: Yeah, and who's he going after? Bad guy?

Philip: Yup, the little person.

Adult: What's the little person's name?

Philip: Mad!

Adult: Man?

Philip: No, Mad.

Adult: How do we know he's mad?

Philip: Because Spiderman is chasing him. [Philip is beginning to get into the story.] Spiderman is chasing two bad guys.

Adult: Two bad guys? Oh, this story is getting very exciting [to Philip's mother]—oh, isn't this story getting exciting?

Philip (gaining momentum): And now he put out his foot and hit one of the bad guys and he said, "Ouch."

Adult: I would say "ouch" if Spiderman kicked me, too. Oh, wow! Is the web gonna catch one of those guys? 'Cause there's the web—he's got the web going out there.

Philip: Here's where he's going to

shoot the web (indicating that it comes from his fingertips).

Adult: Oh, and then what?

Philip: He caught one and he caught the other bad guy.

Adult: Oh! Both of them? All at once? Oh, that Spiderman, he's wonderful!

Philip (really encouraged): And then Superman came . . . and Superman flied and took the gun out of their hand.

Adult: And took the gun out of their hand! That's great! Then what—are they going to take them off to . . .

Philip: They took . . . they threw them in jail.

Adult: Oh, that's a good story. I like that story!

Philip insisted that his mother hear the entire story from the beginning as he delightedly pointed out and recited each detail right up to the place where he had written (with a little help on the spelling) E-N-D. (6-4) He told more stories on the same day with little prompting but with a good deal of appreciative acknowledgment of Philip's accomplishment by the adults present.

The second story, following the safe model of familiar superheroes, involved Batman and Robin, (6-5) two crooks (they had robbed a bank), and the police, whom Batman had summoned on his CB radio. One crook was hooked by the Bat rope and hauled to jail by Batman. The police who had been summoned got the second crook and threw him into another jail—complicating both the plot and the picture. (6-6)

The final story that Philip drew that afternoon featured a hero of his own invention, "Big Man." (6-7) When asked if the hero had super-powers, Philip replied, "You'll see; they're in the story."

At this point Philip was less concerned with the quality of the drawing than with the invention of the story. It was as though his first stories had been the tentative strokes of an uncertain swimmer. Philip was sure of his ability to tell this story, narrated from beginning to end (without prompting) as he

Figure 6-4

Philip (age 5)
A Spiderman Story (pencil)
8½" × 11"

This is Philip's first drawn story. To the left is Spiderman minus the mouth—the picture that Philip used as a reference for this figure appeared on his brother's tee shirt, and indeed he had "no mouth." Spiderman's arms are raised and he shoots a web from the hand on the right, and it falls and entangles the two "bad guys" below. On the upper right is Superman, who happens along after "Spidey" has already done all the work and tied up the little person, "Mad," and his partner. Superman helps to disarm the bad guys and they both haul the culprits off to the jail (lower right).

Figure 6-5

Philip (age 5)
Batman and Robin (pencil)
8½″ × 11″

This story differs from the Spiderman story in that Philip has made it bigger and better by doubling all of the elements. There are two superheroes (Batman and Robin), two crooks, two policemen, and ultimately two jails. Batman can be recognized (in the upper left corner) by his flying cape, one crook because he is caught at the end of Batman's rope, the policemen by their caps. The second crook stands beside the first and between the two policemen while Robin, who was home busily "turning into Robin" and arrived on the scene late, hovers in his cape in the middle of the picture. One jail appears on either side of the picture. Philip had to take care of all of the story conventions and no story could be complete without declaring the end of it. He had earlier asked how to spell "THE END" and could now finish each new tale with a flourish as he loudly spelled E-N-D—"THE END."

Figure 6-7

Philip (age 5)
Big Man (pencil)
8½″ × 11″

This story is of Philip's own invention—no borrowed heroes here. Big Man looms larger than anybody else on the page and he needs help from no outside source to catch all the bad guys—there are three of them. He shoots a laser down his arm and ropes from his belt, kicks with his big feet, has a bomb in his ear and some secret weapon in his tummy. And that— announced Philip—"is the E-N-D." But Philip was so pleased with this story that he didn't want it to end, so he added a sun in the upper right-hand corner and gave the story, in addition to the good-guys-always-win ending, a fairy-tale ending: "And the sun came out and they lived happy ever after."

Figure 6-6

Philip (age 5)
Incredible Hulk (pencil)
8½″ × 11″

Everyone knows that the Incredible Hulk, in his righteous fury, hurls objects and people. The Hulk appears in this picture in the upper left-hand corner. He is larger than any of the other figures on the page and his arms are raised in his fiercest growling attitude. Although the figure appears to have scribbles over his body and face, it is obvious that it has been colored in—green men have to be identified in some way—even if the medium is only pencil. Here the object of the Hulk's ire is the bad guy who is thrown "far." You can trace his trajectory across the top of the page. Once the bad guy is subdued, the Hulk can sit down, relax, and "turn into" David Banner (seen smiling next to his alter ego). The bad guy in this story doesn't merely get put in jail. He is shot by the police officer (in the hat) and buried under "buried dirt" that says "BAD GUY."

rapidly drew the few lines representing all the action. Although the story necessarily contained similarities to the previous three—there are always bad guys, aren't there? and stealing money for Philip was the ultimate evil—this was definitely Philip's own. And if his superhero was to have superpowers, there would be many of them and they would be as different from those of Spiderman and Superman and Batman as he could imagine. He shot a laser "down his hand," and ropes out of his belt; he had a bomb in his ear (they were large ears) to blow up the bad guy, and "something in his tummy that went out." Philip was so pleased with his story that, as he recounted it to his mother, he added—spelling and printing E-N-D correctly on his own—"and the sun came out and they all lived happy ever after."

Philip had discovered powers he didn't know he possessed, powers as great as any superhero's: the power not only to tell a story but to create characters he could direct to do whatever he wished them to do. At the same time he was learning to deal with villainy and deprivation and ways to overcome them. Although in the first stories he was relying on the help of benign strangers, or friends, to overcome difficulties (Spiderman had Superman; Batman and Robin, the Incredible Hulk, and David Banner all relied on the police), only his own creation, "Big Man," single-handedly took care of the bad guys—and there were at least three in this last story.

A few days later we were given a book that Philip had made. He had been working on it all week-

end and when he was satisfied that it was finished, he presented it to his mother. The earlier stories he had drawn for us were each done on a single page, with all of the action occurring in one frame. In this story each page served as an individual frame, and the story no longer dealt with superheroes but with a small boy named Petey. (6-8) Philip told the story to his mother this way:

- A little boy named Petey was walking down a path. The sun was shining and there is a rainbow with many colors. There are lights on in the house.
- Petey walked into the woods.
- In the woods he saw a coyote who was going "whoooo" ["You can tell because his mouth is like this"—an O] and standing on a rock.
- He walked farther into the woods [he has drawn many more trees to indicate deep woods].
- The clouds came and it started to rain. Petey saw another coyote and he started to run.
- He ran back through the woods.
- Until he was safe at home.

As we have already noted, drawing a story offers the child the flexibility of arranging and rearranging elements and characters and allows the child to depict aspects of meaning that he may not yet be able to verbalize. A young child, for example, through the simple act of placing a flower closer and closer to the sun, might be able to indicate growth, and by drawing the sun moving across the sky, show the passage of time. We also believe that drawing allows

children to add elements to their stories that might otherwise remain unexpressed. For Philip, Halloween precipitated stories about witches and haunted houses and black cats and ghosts and disembodied faces. This was not unusual in itself; what was interesting was that the sound effects which had begun early in Philip's *Hulk* story and had become an important element in his book about Petey meeting the coyote—it was the "whoooo" of the coyote as much as the storm and the darkness that frightened the boy—show up in the recounting of his Halloween stories: "And the cat goes 'meeeow,' and the ghost goes 'wooooooooo,' and the witch goes 'heh, heh, heh.'" We find that older children also incorporate sound effects in their stories, borrowing the convention from the comic book and adding them in a balloon along with the stars and Xs and curlicues typical of this genre.

Philip continued to use his newfound powers of narration. Because he was able to tell original stories, his kindergarten teacher—who taught her class to read by writing out sentences that the children dictated and then illustrated—allowed him to dictate and illustrate a complete story. This privilege, which set him apart from the rest of the class, further reinforced his pride in his accomplishment. It is important to note that Philip, though not a spontaneous narrator, was nonetheless able to use this ability after only a single day's play at storytelling. He continued to draw with adults and to receive encouragement and reinforcement. Without the play and the encouragement and reinforce-

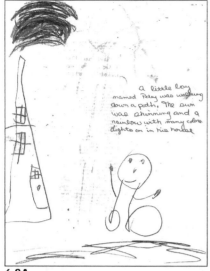

6-8A

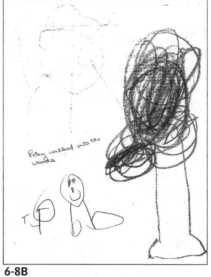

6-8B

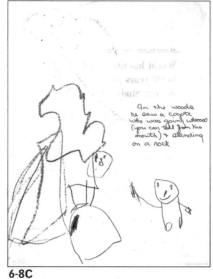

6-8C

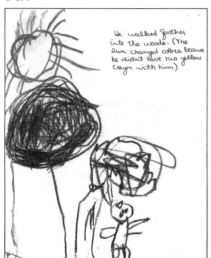

6-8D

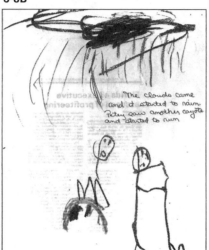

6-8E

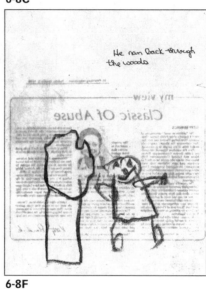

6-8F

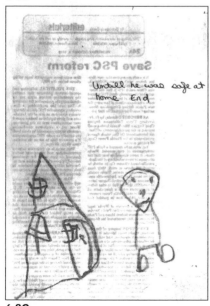

6-8G

Figure 6-8 (A, B, C, D, E, F, G)

Philip (age 5)
Petey's Story (pencil and crayon)
7 pages, 8½″ × 11″

Petey's Story was drawn by Philip over a weekend. He announced to his mother that he was going to draw a story, armed himself with available scrap paper—it had printing on one side—and a few crayons, and settled down for a ride in the car. His story took seven sheets of paper, which he then asked to staple together to form a "book." (His mother wrote the story on the pages just as Philip told it.) The figures are very rudimentary but the story, although simple, is complete with a beginning, a middle, and an end; and while Philip's earlier stories all dealt with villainy, *Petey's Story* seems to relate more to the concerns of a five-year old who is afraid of the dark.

ment, however, he might never have found or used the ability to tell stories in his drawings.

Other children have only to see the narratives of others and they are off and running on their own narrative flights. When Andy was in the second grade, for example, he was asked if he would like to draw a book of his own, as his older friend Bobby had done (*Goldman*, see pages 6 and 7). Andy responded by producing not one book but several. *The Legend of the Theem and the Red Glob* (see page 6) contains fifty figure-packed pages of battles in a remarkable space odyssey. (6-9–6-11)

Still others continually create stories that exist in a single frame. Sometimes these stories are complete but usually they are merely pieces of stories whose beginnings and endings proceed in any number of directions. (6-12)

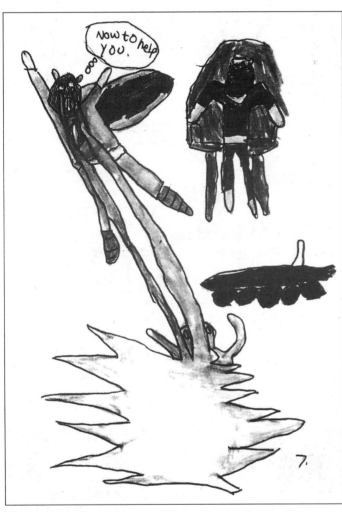

Figure 6-9
Andy (age 7)
Theem and the Red Glob, page 7 (colored marker)
9″ × 12″

"He is unfreezing the Red Glob now. The King is watching. That is a car on their planet with five wheels, like a space buggy, but for them it is a car." Andy found the inspiration for his fifty-page adventure of the Theem not only in his older friend Bobby's 16-page comic book, *Goldman*, but in generations of children who have created generations of superheroes of their own.

Figure 6-10
Andy (age 7)
Theem, page 30 (colored marker)
9″ × 12″

"The Raden is back in his hideout. These are Robots." Each of the fifty pages of Andy's Theem adventure is filled with action and excitement as characters zoom, fly from one planet to another, and freeze and unfreeze each other, with generous doses of humor thrown in.

Figure 6-11

Andy (age 7)
Theem, page 33 (unfinished) (pencil)
9″ × 12″

"The battle is on. The Red Glob is making a giant monster. He can fight by himself but one of his powers is to make different shapes and characters." We wonder if Andy has ever heard of a self-fulfilling prophesy because, of course, one of Andy's powers, one he uses with great skill, is to make different shapes and characters—and stories as well.

Figure 6-12

Jason (age 5)
Plane Crash (wax crayon)
8½″ × 11″

In many children's story drawings the entire action of a narrative is played out in a single frame. This is only one of several airport and airplane drawings done by five-year-old Jason. Here a Delta airplane crashes into some flowers. The most amazing feature of this drawing is not the drawing of the airplane itself but the effect of the crash on the poor defenseless flowers, which have been given facial features that record their various expressions of shock as each looks toward the plummeting plane. "The faceless one is hiding," Jason says. Many of Jason's other stories examine the cause-and-effect theme too. In one such story, described by his mother: "The bird is sitting on her nest in the barn, she flies out the window . . . up the chute, lands on the other barn, goes over the roof, and throws a ball down, which lands on the sheep's back, bounces on his head, and bounces out of the picture." This sort of playful exploration is usually pursued by older children, and is reminiscent of the fantastic machine inventions of Rube Goldberg, a famous 1940s cartoonist.

Making Myths: The Themes of Story Drawings

If the myths of our ancestors consisted of folktales narrated by an elder or by a "singer of tales"[6] in some far-off European village, our own twenty-first-century folktales assume the form of television commercials, magazine and newspaper ads, video games and comics.[7] And whether the enemy to be overcome is a rival king, or a frightening beast or a dirty shirt collar, and whether the beautiful princess invokes magic or merely a better brand of mouthwash in order to win her heart's desire, the themes correspond. Children's story drawings, too, employ the same themes: they are about villainy, like Philip's stories (see p. 113) where there was always a "bad guy" to be dealt with. Or they are about deprivation, as in Bobby's *Goldman* (see p. 7) where there was first a need for money, then for restitution, and finally for revenge. Or they are about both. Within and beyond these broader themes of *villainy* and *lack*,[8] we find children's story drawings dealing with these themes:

- *Origins*, such as the origin of Goldman or other superheroes. Or an origin may be the birth of a character like Dirk's Dubser (see p. 21) or the germination of a seed or the arrival of matter from outer space.
- *Growth* is shown in the development of flowers, plants, trees, animals, and people; and *transformation* in ways natural, as a chrysalis to a butterfly, and unnatural, as a frog to a prince or a Dr. Jekyll to a Mr. Hyde. (6-13–6-15)
- *Quest* appears in children's narratives as a space odyssey, a climb to the top of a mountain, or a search for adventure. (6-16–6-17)
- *Trials* appear as tests of strength, courage, and perseverance, and as *contests* ranging from individual *conflicts* to huge battles and sports events. Most often themes of *good and evil* and *crime and punishment* prevail. Crimes are punished, the culprit caught, and justice served in stories as simple as Philip's or as complex as Bobby's. (6-18–6-22)
- *Creation* covers subjects as diverse as building a house or baking a cake, often followed by *death and destruction* of objects, people, plants, and animals—they are blown up, swallowed, broken, and eaten. (6-23–6-26)
- *Failure* and *success* are other topics—triumphs, rewards, recognition, and achievement. (6-27)

Growth

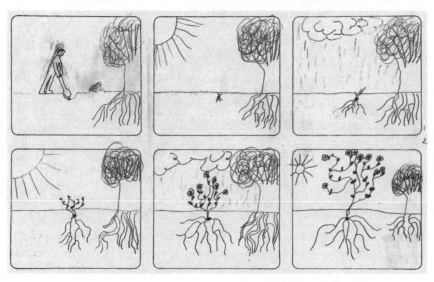

Figure 6-13

Girl (age 9)
The Seed (pencil)
Individual frame size 4¼" × 4¾"

The growth in this narrative by a South Australian girl begins with the planting of a seed that takes root and grows simultaneously above and below the ground, with the help of sun and rain, into a flourishing flowering plant. Perhaps the employment of this persistent theme is a way for a child to better understand her own growth and the growth around her.

Growth (continued)

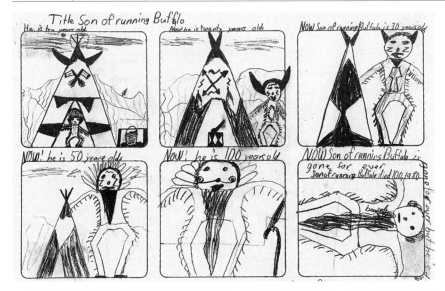

Figure 6-14

Boy (age 7)
Son of Running Buffalo (pencil)
Individual frame size 4¼″ × 4¾″

This humorous and beautifully drawn story by a Zuni boy is of growth and aging (and finally death). The bandy-legged "Son of Running Buffalo" is seen at ages 10 and 20, at 30 and 50, and finally at 100, and he is "gone for ever."

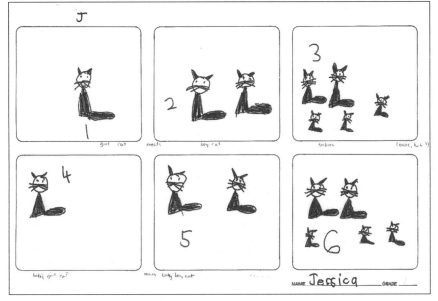

Figure 6-15

Girl (age 6)
Cats and More Cats (marker)
Individual frame size 4¼″ × 4¾″

There are lots of different kinds of growth—population growth, for example. Life is dependent upon procreation—endless generations of mating. It seems that children anticipate the process long before they actively participate in it. The six-year old girl described her drawings as: (1) "A girl cat," (2) "meets a boy cat," (3) "babies," (4) "baby girl cat," (5) "meets a baby boy cat," (6) "more babies." What is more basic than this *prophetic reality* of one of the most natural of life's processes?

- *Fulfillment of wishes* is best accomplished symbolically in children's story drawings, as are *cause and effect*.
- *Natural processes* are often merely visually depicted by seasonal change, volcanic eruptions, and the triumph of nature over man;[9] and *daily rhythms*—the everyday experiences of awakening, going to school, going out to play, and going to sleep. (6-28–6-30)

Although some children are natural narrators, their stories rarely have the kind of completeness and connectedness of adult stories, visual or verbal, or of those cited in this chapter. Although virtually all children's drawings have a narrative, usually it exists in fragmented form. Kelly's drawings (see p. 6), for example, are mainly of elaborate settings in which stories and actions are as varied as she can imagine, but which remain in her own imagination. Michael L.'s eighteenth-century characters (see p. 10) appear to exist without setting or story, both of which Michael could readily supply when asked, while still other young artists like Anthony may draw hundreds of episodes of figures in action without supplying a setting (see p. 92). Many children who do draw stories complete with setting, character, and action often do so in a single frame, as in Dirk's battle of

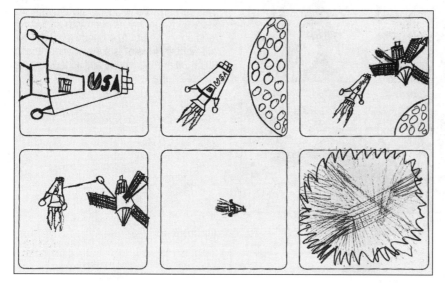

Figure 6-16

Boy (age 8)
Link-up in Space (pencil)
Individual frame size 4¼" × 4¾"

An interesting variation on one of the most popular themes seen in boys' story drawings is the space adventure drawn by an eight-year-old Navajo boy. It is shown first in a close-up and then from farther and farther off in space. In this odyssey, after the successful link-up with a satellite seen in a well-drawn three-dimensional view, the spaceship departs, then explodes. The "zapper" at the end is a common characteristic of children's story drawings.

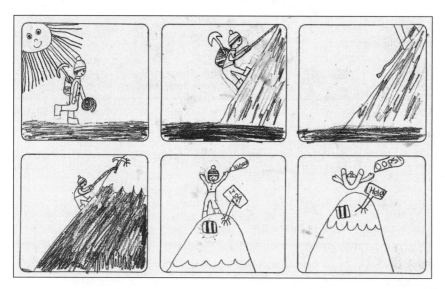

Figure 6-17

Girl (age 11)
I Did It (pencil)
Individual frame size 4¼" × 4¾"

The climb to the top is graphically shown in this clever drawing in which the height the climber reaches is illustrated (in the third frame) by simply depicting a foot, a leg, and the end of the length of rope. We do not need any more information; she has climbed right out of the frame. As she finally struggles to the top, we are quickly reminded that the *bigger* they *are* (the prouder or the more self-satisfied), the *harder* they *fall*, a message that is clear—with even the humor of the marvelous backward tumble of a fall.

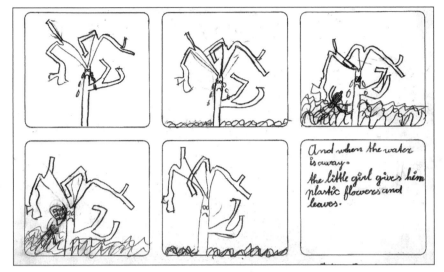

Figure 6-18

Girl (grade 4) (pencil)
The Crying Tree
Individual frame size 4¼″ × 4¾″

The nine-year-old girl who drew *The Crying Tree* shows us a poor, nude tree at the point of drowning in its own tears. The nine-foot tall Alice in Wonderland, we remember, also wept a great pool of tears, into which, when she had shrunk almost out of sight, she fell "up to her chin in salt water. … 'I wish I hadn't cried so much!' said Alice, as she swam about, trying to find her way out. 'I shall be punished for it now, I suppose, by being drowned in my own tears!'" The nine-year-old may not have had Alice in mind, but her theme, is the same.

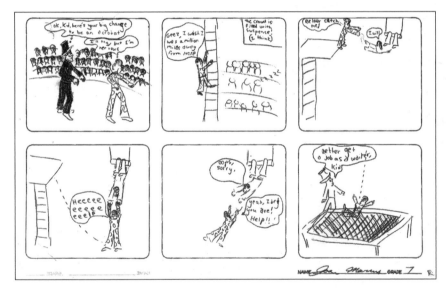

Figure 6-19

Girl (grade 7) (pencil)
The Trapeze Artist
Individual frame size 4¼″ × 4¾″

In their story drawings, children can experiment with all kinds of trials, struggles, successes, and failures while remaining safe from all the dangers that would surely accompany the actual adventures. Yet, whether through symbolic story drawings or actual experiences, the lessons we learn about ourselves are the same. We must be careful not to bite off more than we can chew. Perhaps this is what is being rehearsed by Joan, a seventh-grade girl. In the first frame the young trapeze artist gets his big chance. In the second frame we read "Geez, I wish I was a million miles away from here." (In each frame notice how beautifully the actions are depicted) "Better catch me!" "I will" is the promise in frame three. In frame four there is a long cry of "Heeeeeeeeeeeelp," and in the fifth, "oops, sorry," "yeah, I bet you are! Help!" (Often others let us down.) Finally "better get a job as a waiter, kid."

Trials (continued)

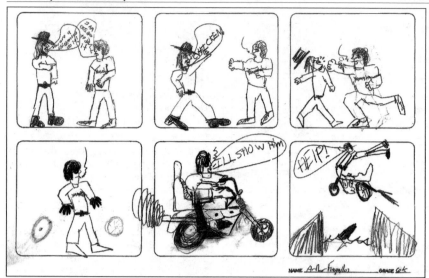

6-20

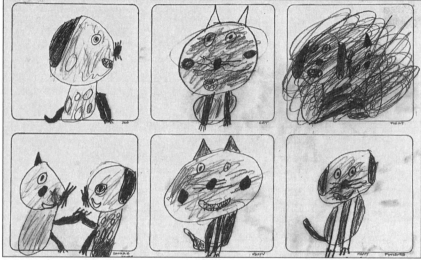

6-21

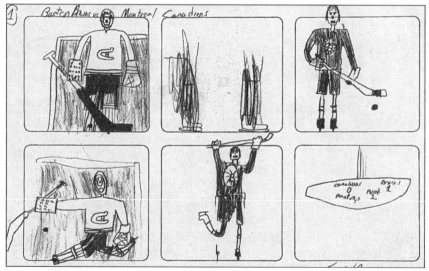

6-22

Figure 6-20
Boy (age 11) (pencil)
Motercycle Dare
Individual frame size 4¼" × 4¾"

In narratives dealing with trials, children sometimes investigate society's methods of punishing wrong-doers and at other times they explore the personal consequences of a foolish act. This is the subject of eleven-year-old Arthur's story. In the first frame, one character says, "You are a chicken to do it," to which the second replies, "I am going to do it." The taunt continues in the second frame with a loud "chicken!" accompanied by preparation for physical revenge. (The word *Yamaha* written on the protagonist's shirt should be noted.) In frame three a smashing fist and flying teeth mark revenge taken by the tauntee. Frame four is eloquent—black leather gloves, helmet, goggles, firm jaw, casual cigarette, ready stance. "I'll show him." Show who? In the last frame it's a case of over-kill. The jump, the water and the shark are a harsh punishment for accepting a foolish dare.

Figure 6-21
Girl (grade 4)
Fighting Like Cats and Dogs (pencil)
Individual frame size 4¼" × 4¾"

This cat-and-dog fight reminds us of the gingham dog and the calico cat in Eugene Fields' poem, *The Duel*, even to the ferocious battle indicated by the fury of the lines in the scribbled cloud of dust that surrounds the two in frame 3. But instead of eating each other up, the two antagonists shake hands and smile happily at the end, as we see conflict (first three frames) and its resolution and resulting satisfaction (final three frames).

Figure 6-22
Boy (grade 7)
The Goal (pencil)
Individual frame size 4¼" × 4¾"

Sports contests appear in the drawings of boys around the world—football, baseball, soccer, basketball, and hockey, as in this well-drawn story. Sports provide endless opportunities for depicting the success of winning and the fulfillment of a boy's wishes to be the best, to triumph over insurmountable odds, to score an impossible field goal, as this Boston player has done (the artist is obviously a Boston fan) against a formidable opponent, Montreal. The drama concludes on the next page (not shown) with a victory.

Creation

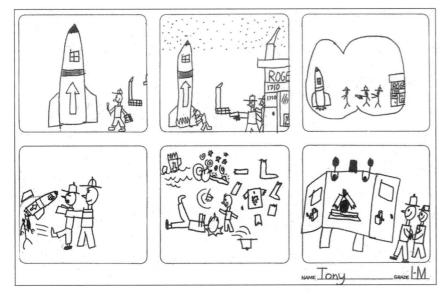

Figure 6-23

Boy (age 6)
The Rocket Villian (marker)
Individual frame size 4¼″ × 4¾″

We have collected hundreds of story drawings in which children deal with crime and punishment. None, however, is more elegant than the one drawn by Tony Moy. In the first frame a man with a devious look on his face and a lighted match in his hand approaches a rocket. In the second frame policemen draw their guns in an attempt to stop the villain. The third frame is a binocular view of the apprehension. Too late! In the fourth frame the rocket blasts off, its fins fall off, and, oh oh, the villain was too close. The fifth frame is very complex; the rocket crashes into the sea, the villain has been blown to bits—the comic-book symbols above him show the extent of his misfortune, and even one of the policemen has been knocked over by the blast. In the final frame the policemen congratulate one another as they observe the villain's remains, which have been loaded into the back of an ambulance. When we asked Tony's parents how a first-grade student could draw with such skill and insight, they told us he was an avid reader of Chinese comic books published in Hong Kong.

Figure 6-24

Girl (grade 7)
The Cake (pencil)
Individual frame size 4¼″ × 4¾″

The ordinary slice-of-life theme of this story drawing also shows the steps in the process of creation—in this case a product as mundane as a cake. Throughout the process we are aware of the passage of time as we watch the hands and almost hear the ticking of the clock. Girls are far more likely than boys to depict slice-of-life incidents.

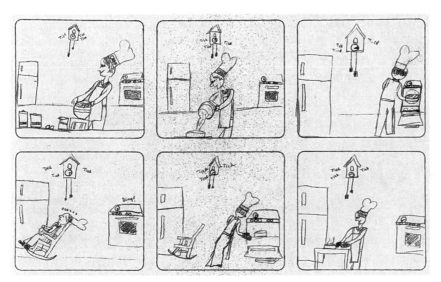

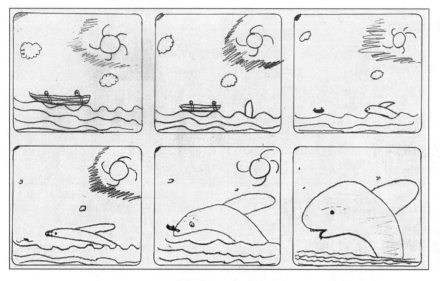

Figure 6-25

Boy (grade 2)
Shark's Dinner (pencil)
Individual frame size 4¼″ × 4¾″

The theme of being gobbled up or otherwise destroyed is a common one. In this story drawing two small figures in what appears to be a small rowboat are pursued by an enormous shark until they are overtaken and devoured, boat and all. It is a temptation to say that the child identified with the small, exposed, imperiled occupants of the boat faced by the threatening force; and yet, since it is the shark that wins out in the end, is it not possible that the small boy is trying on the cloak of that powerful force that looms so large in the final frame that the sun itself becomes a mere speck in the sky?

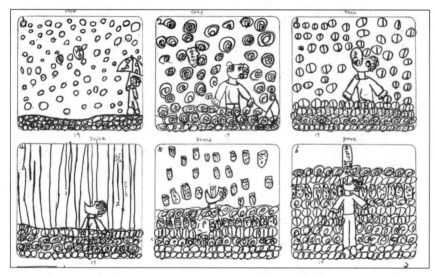

Figure 6-26

Boy (grade 3)
Deadly Rain (marker)
Individual frame size 4¼″ × 4¾″

In the first frame a Japanese child shows a character using an umbrella to protect himself against the snow. In the second frame the snow has changed to cake and the character, with upturned mouth, tries to keep himself from being inundated by gobbling the cake. In the third frame beans rain down, in the fourth it's juice, and in the fifth frame it's bread, and the poor character cannot keep up with the deluge. In the sixth frame the character is engulfed and a slab marks his grave.

Failure and Success

Figure 6-27

Girl (grade 5)
Oops! (pencil)
Individual frame size 4¼″ × 4¾″

The drawings in this story are simple, clear, and to the point. The skier takes off on her skis (we can interpret the smile as either confident or determined), makes a jump, and lands with her skis up in the snow. The grim figure is then hauled off on a sled, her feet wrapped in bandages, as she grimaces and looks sideways out of the frame as if to say, "Boy, am I dumb!" The attitude that we find most remarkable in these story drawings is the child's ability to accept failure, at least symbolically, with a good deal of humor, to rehearse facing the hard knocks that life may bring.

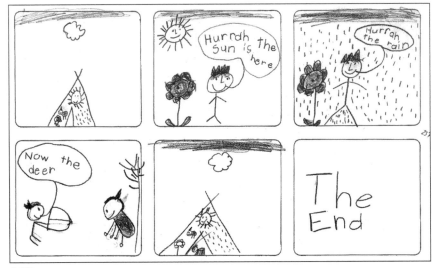

6-28

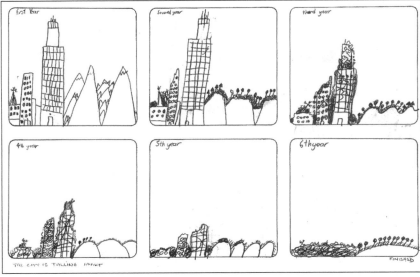

6-29

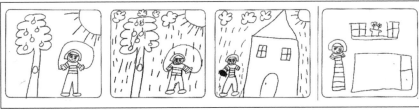

6-30

Figure 6-28

Girl (Grade 1)
Now the Deer (pencil)
Individual frame size 4¼″ × 4¾″

When we see drawings such as this one, we marvel at the complexity of children's minds—and of their wisdom, even if it may only be implicit wisdom. In the first frame of this narrative drawing, a six-year-old has drawn a teepee with the symbols for the sun, a flower, the rain, and a deer. Like the caveman, it appears as if she has drawn the things she wishes to possess. What we wish to possess in actuality, we must first possess symbolically.

Figure 6-29

Boy (grade 5)
The Sixth Year (pencil)
Individual frame size 4¼″ × 4¾″

For many years art and literature have dealt with the triumph and the superiority of nature over man. Hermann Hesse's 1910 story "The City" ends much like the story by this fifth grader, which seems to have accelerated the process of erosion and decay so that an entire landscape—building, mountains, and all—becomes leveled in only six years.

Figure 6-30

Girl (grade 3)
Come In out of the Rain (pencil)
Individual frame size 4¼″ × 4¾″

A large percentage of children's story drawings involve the simple depiction of such everyday events as these. The little girl in the story is jumping rope when it starts to rain. The artist shows that she knows enough to come in out of the rain, and the story ends with the child going home and finally going to bed. Two things are particularly interesting in this drawing: the sun, which remains shining steadfastly from its usual corner in spite of the rain, and the child's depiction of hands only in places where they are necessary to hold the jump rope. The rope is held with two hands in the first two frames and folded in the one hand in the third.

the Dubser (see p. 21); the beginning, middle, and end may be known only to the creator. Because we knew that these stories existed—children are anxious to share them with interested listeners—we wished to see how they would evolve when children were provided with a familiar format for drawing setting, character, action, and plot with a beginning, middle, and end. The story drawings illustrated here are the result of our providing children with a sheet of paper divided into six frames (they could use as few or as many as they needed) and asking the following: (6-31–6-33)

- Have you ever drawn pictures to tell stories?
- Have you ever drawn adventures that you or heroes or animals might have?
- Have you ever drawn adventures that could not happen?
- Have you ever drawn stories about strange creatures in strange worlds?
- Have you ever drawn stories of battles or machines, or of plants and insects?
- Have you drawn stories about sports or vacations or holiday celebrations?
- Have you ever drawn stories about everyday things that happen to people?
- Please draw a story using boxes to show what happens first in your story, what happens next, and how things finally turn out.[10]

We began to provide children with these frames—much like comic books or film storyboards—and asked them to tell stories

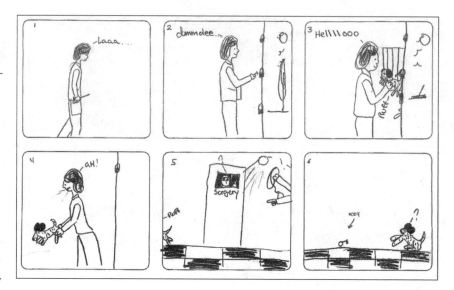

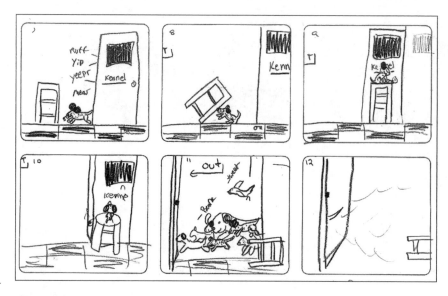

Figure 6-31

Girl (age 12)
Dogs' Freedom (pencil)
Individual frame size 4¼" × 4¾"

We are continually amazed at the ideas that children include in their drawings, and also at the skill with which they show an unfolding event by shifting scenes and depicting actions and gestures. In the first three scenes Kathy establishes a setting—a place that keeps animals under lock and key. In frame four the dog escapes, and in frame five we see that the setting is actually a veterinary hospital. (Frame five has a masterful depiction of the disappearing dog's tail, a puzzled face at the surgery door window, a pointing finger and a hand holding a stethoscope.) In frame six a key is found and in the next four frames we see creative problem-solving on both the dog's part and on Kathy's. Then in frame eleven, we see freedom's noisy stampede while in frame twelve the last tail disappears. Don't we all occasionally feel confined or restrained? This escape narrative could serve as a metaphor for all kinds of freedoms that individuals anticipate.

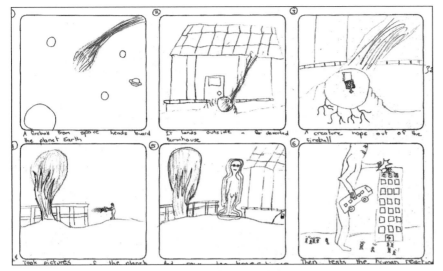

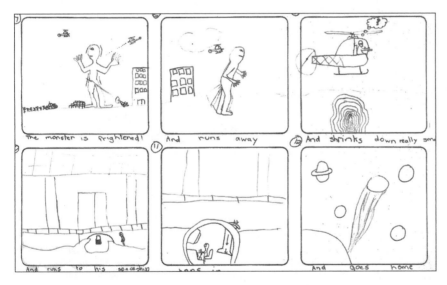

Figure 6-32

Boy (age 12)
The Visitor (pencil)
Individual frame size 4¼″ × 4¾″

The most complex of children's visual narratives have the mythic dimensions of a cosmic odyssey that includes *origin*, *growth*, *trial*, *conflict*, and *destruction*. This is how Michael, a twelve year-old Australian boy, describes his twelve-frame narrative: (1) "A fireball from space heads toward the planet Earth; (2) it lands outside of a deserted farm house; (3) a creature hops out of the fire ball; (4) takes pictures of the planet's atmosphere, (5) and grows ten times bigger, (6) then tests the human reactions, (7) the monster is frightened, (8) and runs away, (9) and shrinks down really small, (10) and runs to his spaceship. (11) hops in, (12) and goes home."

Some myths contain attempts to explain such basic questions as "Where did I come from?", "Why am I here?", and "Where am I going?" Michael's narrative contains uncanny parallels with human life—the arrival in a womb-like spaceship, growth, exploration, trials, conflicts, and finally a return. How true Piaget's statement seems, "In order for a child to understand something, he must construct it himself, he must re-invent it."

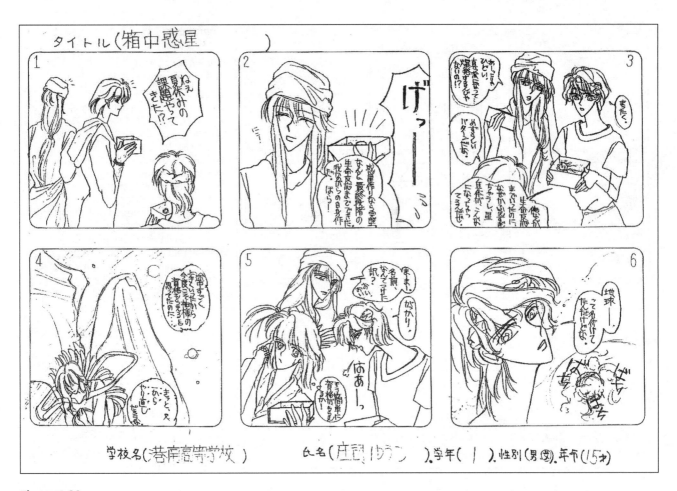

Figure 6-33

Girl (age 15)
Planet in a Box (pencil)
Individual frame size 4¼" × 4¾"

This graphic narrative by a 15-year-old Japanese girl shows the influence of *manga*, Japanese comic books, and demonstrates how well some Japanese children use this model from the popular arts. The student presents an elegantly pessimistic critique of our earth in her story. Here young students who attend a "School for Gods" are asked if they have completed their assignments—to create a planet-in-a-box. One apprentice god proudly presents her obviously successful project. A second student is reluctant to show her creation because it is a failure. She is asked what she was going to call her planet. "I was going to call it Earth," she replies. Perhaps a young person on whose country two atomic bombs were dropped might think of our planet in this way.

through the pictures they drew because we were anxious to see the stories as a whole, not just in parts. The results were astonishing: children were using their story drawings to give visual form to some of life's deepest questions; they were using their drawings, it seemed, to grasp more fully the realities of their lives. Through our study of children's spontaneous narrative drawings we knew that children often depicted the things of utmost importance to them, but we found that a surprising number of the sequential drawings were utterly profound. Story drawings best serve children as means to actively explore the dynamic nature of the four realities—to look at the world and ponder its anomalies, to master its processes and rhythms, to consider one's origins and anticipate one's future, to know oneself, and to make decisions about right and wrong behavior.

Making Story Drawings Happen

Just as important as a visual/graphic vocabulary is the grammar of the story drawings. The model is usually assumed by children from the stories they are told or read, from the first *Once upon a time . . .* to the later more complex and complicated plots of television, movies, comics, and video games. We have also said that the narrative exists in some form, however fragmented, in most children's drawings. Because the more control the child has of this medium, the more control he has of his *self*, we offer the following suggestions for making story drawings happen. These can be done with an individual child or with groups of children:

• Suggest stories to the child, as we have done. (Because this particular set of instructions was developed for purposes of collecting children's story drawings around the world, it is purposely without focus.)

• Suggest a specific story or story line, or a favorite character for the child to draw a story about.
• Suggest that the child invent his own character or superhero.
• Suggest a theme and supply the child with paper that has been cut horizontally to form a long, narrow sheet.
• Supply the child with paper upon which frames have been drawn (or the child can draw his own frames, or trace around a template, or fold paper into sixths or eighths).
• Set one child or a few children loose with a long roll of paper.

Children drawing with other children and children drawing with adults often produce startling results. Some of these drawings are shown in Chapter 8.

Any one of these methods may set into motion the child's story-telling potentialities that are just waiting to happen. The richness of the story drawings in this chapter and throughout the book tell the tale.

7

Could It Be?

Encouraging
Imagination and
Fantasy in **Drawing**

Machines come to life; strange and wonderful worlds appear, peopled with strange creatures that possess marvelous powers; ordinary people assume extraordinary forms and animals evolve with multiple heads and a curious assortment of wings and limbs. What worlds are these? These are everyday occurrences in the world or worlds of the child's rich and vivid imagination. The youngest child often invents imaginary friends, and her fancy may run wild and unfettered. At times these are private worlds, but often they are shared with other children in what is called *sociodramatic play*.

The psychologist Jerome Singer and his wife, Dorothy Singer, have done a good deal of work in the realm of children's play and imagination. He has written of his own early experiences with fantasy. He tells how, as he grew older and ceased to engage in make-believe play with other children, the fantasy characters of that play found their way more and more into his spontaneous drawings and doodles at home and on the pages of notebooks at school.[1]

Beyond the obvious pleasure and excitement that children derive from these inventions, *fantasy* is the main ingredient in their fashioning of the four realities in story drawings. If, for example, a child could draw but did not understand the story form, or if she could draw and understood the story form but could not imagine characters or situations, then there could be no story drawings. Or they would simply be lifeless copies of stories seen or heard, unrelated to a child's own realities, as with Philip (see p. 117), whose first stories of superheroes and derring-do were replaced by a story of a child's own fears.

Further Fantastic Functions: Fantasy and Imagination

We have emphasized the reality-fashioning function of fantasy, but an active imagination may also be important to the child's development, well-being, and happiness. The Singers have observed that children with active imaginations are more likely to actively explore their physical environment; that imaginative children smile more than unimaginative children; that they exercise more self-control and are better able to wait patiently and to entertain themselves. Perhaps the most surprising observation is that imaginative children are more able to discriminate between make-believe and reality.[2] Paradoxically, the children who are most involved in constructing their own private versions of reality know the most about the everyday, or common, reality. This knowledge may derive from the imaginative child's exploration of the similarities and differences between worlds that are perceived and those that are imagined.

Can the child be harmed by too much fantasy? We do not believe so. According to the author Richard de Mille, children who use their imaginations the most are the best adjusted, because the mastery of imaginary situations is good practice for the mastery of everyday situations. Most of the evidence points to the fact that instead of a means of *escaping* reality, as some people fear, fantasy is the means by which children *create* reality.

Encouraging Imagination

In any group of children it is possible to find those who easily engage in fantasy and others who seldom do. The book of imagination games *Put Your Mother on the Ceiling*, by Richard de Mille—to whom we owe a debt of gratitude for many of our own imagination games described here—begins with the dedication, "To Tony who started off with a levitation machine and Cecil who said, 'That's crazy! You can't walk through a tree trunk.'" These two attitudes toward fantasy certainly describe the two poles of the imagination spectrum. However, if adults make the effort to use fantasy for and with children, to engage in activities designed to encourage fantasy and imagination, then unformed imaginations will develop and grow and those already formed will expand.

Although generally we find that children who produce many spontaneous drawings also have vivid imaginations, many children whose imaginations are extremely active seldom draw. Some children act out their fantasies; others express them through music or other symbol systems. We think it is the combination of drawing and imagining that enables them both to flourish. When images are projected only in the mind's eye, as fantastic and as vivid as they may be, they quickly vanish. When drawn, on the other hand, the image is made permanent, perceivable and recognizable to both the conceiver and the observer. Although we are capable of seeing in our mind's eye what a Peter Rabbit or an Alice in Wonderland might look like, it is the drawings by Beatrix Potter and John Tenniel that have made those particular images a permanent part of our collective memories—Peter

sneaking into Mr. MacGregor's garden is a real garden-variety rabbit rather than the cartoon figure another artist might have drawn; and Alice, with her somewhat scraggly hair, her white pinafore, her striped stockings, and her dainty Mary Janes, is and has been for generations of children the "real" Alice.

In addition to amplifying the images of the imagination, drawing often stimulates the imagination as well; a line, a chance mark, a doodle may call into play all sorts of fantastic drawn images.

Imagination Games: Word to Image to Drawing

To realize the powerful combination of drawing and imagining, suggest imagination games in which an adult and a child or a pair of children, an older and a younger child or even children of the same age, can engage.[3] These games sometimes consist of a description of an object or event for the child to imagine and draw or they require the imagination to perform extraordinary feats, with the child drawing the resulting images. Until children become accustomed to playing the imagination-drawing game, the shorter and simpler the games, the easier they will be to play. More complex games require more concentration, imagery, and imagination. You will know by the child's response—when the images on the page seem almost to run away and to delight and amuse—that she is ready to move from a simple to a more complex game.

Richard de Mille emphasized a step-by-step mastery of the imagination, and his fine book points to the best way to help the child gain this mastery. Our own imagination games are designed primarily to expand the imagination in drawing, but the same cautions apply.

We hope that these games lead to lots of other games that you and the child will devise together. In playing these games, the secret is for the leader or reader to pause at each slash (/) in order to give the child time to picture each new image or to elicit spontaneous responses, whether graphic or verbal.

Things Stacked on Top of Other Things

This game can be played with any number of things that are stacked. We have chosen the animal stack-up. We will illustrate the basic game and suggest other variations.

Each one of the games can be played in a number of ways. In Stack-up, there are more imagining activities sandwiched between drawings, but you may choose to save the drawing activity until all of the imagining has taken place. Or, since each of the imaginative descriptions to follow is simpler at the beginning than at the end, you may decide to cut short any description that might overwhelm the child if the game is carried out to its conclusion. Simply stop at a convenient place and invite the child to draw. Whatever the format, however, it is important to wait until the child has signaled that she is ready to go on by verbal assent, by a smile or other facial expression, or by a nod of the head.

Since so many ideas are presented one after the other in the imagining part of the game, the drawing part of the game becomes a test of the child's memory. Don't be concerned if the child forgets to include some of the parts in the drawing. Remember also that to include all of the parts might take a much longer time than the child is willing to devote to drawing. Also, the child may not have the skills to draw many of the things that she is able to easily imagine. Of course, if the child wants you to remind her of some of the parts she has forgotten, you should certainly oblige.

In Animal Stack-up, some of the animals may be difficult for the child to draw. If the child is unable to draw one or more of them, you may want to substitute animals that are easier to draw or you could offer some assistance. Most children, however, are ready to tackle the animals in the game. Remember, too, that animals can be added to the stack-up as you perceive that the child is capable of more difficult depiction.

This game is called Stack-up. *Think of an elephant.* / Make him come really close. / Have

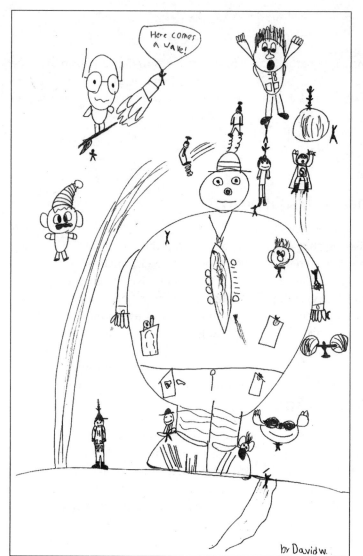

Figure 7-1

David (age 7)
Big and Little People (black marker)
12" × 18"

Seven-and-a-half-year-old David was ready to draw. It was easy to see this by the animation in his face and the way his hand almost imperceptibly traced the form of the drawing he envisioned on the page. David's big man had a big belly indeed, so big that his shirt gaped open in order to span his entire girth. The little man who jumps higher than the big man's head and finally lands on the head of the larger man does so with the aid of both a helicopter hat on his head and springs attached to his feet. The little man who jumps onto the arm of the bigger man stands balanced on a wristwatch (right side of the drawing). But it was only when David unleashed "lots of little men" that the fun really began. Superman and other strange little men jump and fly and even surfboard around the page. They stand on one another's heads and hide in pockets—big little men, medium-sized little men, and small little men. Finally one of the smaller little men burrows beneath the earth. It is very important, as you try these games, to monitor the attitude and involvement of the child or children. Is the child anxious to go on or is she frustrated or unable to complete a suggested drawing? Is she able to go beyond the game or is she ready to stop at any given point? David was not only able and willing, but anxious to go beyond the game. It is his extra personal touches that make the drawing more than a simple exercise.

him move just far enough away that you can see him easily from the side. / Now draw the elephant.

The elephant needs a friend. *Think of a horse.* / Have the horse run up to the elephant. / Have the horse's nose touch the elephant's trunk. / Have the horse run around the elephant. / Now have the horse make an enormous leap and land on the elephant's back. / Have the horse rear up on his hind legs. / Have the horse's front legs come back down on the elephant's back.

/ Draw the horse standing on the elephant's back.

Think of a dog. / Have the dog grow really big. / Make the dog really small. / Make him his regular size. / Have him do a backward somersault in the air. / Have him do another somersault and land on the horse's back. / Have the dog stand on his two front feet on the horse's back. / Have him lie down on the horse's back. / Have him stand up. / Draw the dog on the horse's back.

Think of a rooster. / Have the

rooster spread his wings. / Have the rooster fly around the elephant, the horse, and the dog. / Have the rooster land on the dog's head. / Have the rooster stretch his neck and crow. / Draw the rooster standing on the dog's head.

Have a very tiny flea fly out of the sky and land on the rooster's head. / Draw the flea on the rooster's head.

Note: As you read the instructions you may want to ask additional questions to help the child imagine or stretch her imagination further.

For instance, after a statement such as "Make the elephant come really close" you might ask "How close is it?" or "With the elephant so close to you, how much of it (or what part of it) do you see?"

Variations. The stacking of one thing on top of another can furnish endless enjoyment, just as we continue to delight in the image of the stack-up of the donkey, the dog, the cat, and the rooster in Grimm's fairy tale about the Bremen Town musicians. And with the Stack-up game there are endless possibilities. The more adept the child becomes at playing the game, the more ridiculous the ensuing games might be. Planets might balance on a monster's upturned Pinocchio-like nose and automobiles might balance on butterflies, or parts of the body might be jumbled and stacked in strange ways. The more improbable the combination, the better. (7-2 and 7-3)

Children can also play a One-Thing-Inside-Another game. This game begins with the child drawing a tiny animal or insect in the center of a rectangular or square sheet of paper. Then ask the child to imagine a slightly larger animal and draw it around the first until the page is filled with one animal inside another. The game might move from insect to turtle to fish to horse to dinosaur and, just for fun, end with an "old lady"—a variation on the one who swallowed everything from a fly to a horse. (Ours is *not* dead, of course!) (7-4 and 7-5)

Figure 7-2

David (age 7)
Stack-up (black marker)
6" × 18"

David's "stack-up" began with Game I but it soon became evident that instead of expanding David's active imagination, the game was restricting it. It had been obvious in some of the other drawings David had done (8-1–8-7) that he did his best imaginary drawing when he was given a suggestion and then allowed free rein to expand on it in any direction he wished. After the flea had landed squarely on the rooster's head, we told David that lots of other animals had come along and stacked up one on top of another on the head of the flea. David's animals include a donkey, a lion, two birds (one standing on one leg only), another elephant dressed in a tutu (also balanced on one leg—a little more difficult for the elephant than for the bird), and an owl on the limb of a tree that peeks from the right top edge of the drawing. It is easy to see how much more freely and whimsically David drew this later menagerie.

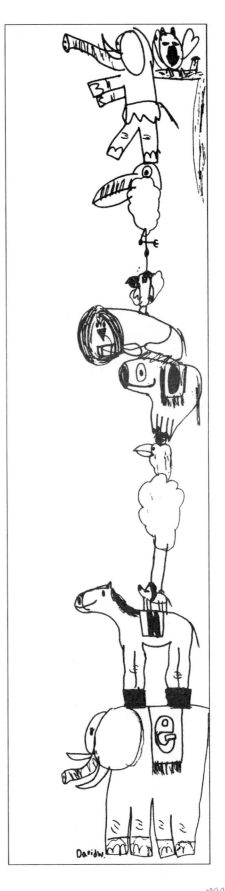

Figure 7-3

Lana (age 8)
Lana's Stack-up (pencil)
6″ × 18″

Given this long sheet of paper and the task of drawing three elephants one on top of the other (with no sense of what would be coming next), Lana proceeded to draw her elephants at the top of the page so they appeared to be lying on their backs, one under the other. After she drew the first two elephants, we interceded to suggest that there would be many more animals in the stack-up so she might want to leave the elephants on their backs. We knew that Lana, who delighted in depicting such flip-flops, would have no trouble with somehow setting the third elephant on the feet of the second, a problem she solved without missing a beat of her rapidly moving pencil. This move, in fact, seemed to free her to attempt some more daring depictions such as the second horse bucking on the back of the first, the dog in the ballet skirt poised on the horse's tail, the second dog's nose balanced on the rear leg of the first, the three roosters in various precarious positions, and finally Lana herself, with flexed muscles, holding up the entire stack.

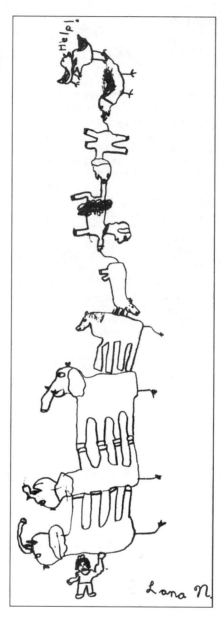

Fabulous Creatures

Some of the wildest inventions can be seen in depictions of creatures that never existed—dragons, griffins, unicorns, harpies, mermaids, monsters. Drawing imaginary creatures imposes few constraints on young artists: because the drawings do not represent anything that has ever existed they need not look like anything in particular. But even imaginary creatures usually begin with the known. This recipe for inventing imaginary animals from actual animals was written by Leonardo da Vinci:

If you wish to make an animal, imagined by you, appear natural—let us say a dragon—then take for its head that of . . . a hound, with the eyes of a cat, the ears of a porcupine, the nose of a greyhound, the brow of a lion, the temples of an old cock, the neck of a water tortoise.[4]

To this recipe Leonardo might have added the wings of a bat, the spots of a leopard, and the claws of a sloth. And why not three heads and twelve limbs? This imaginary creature game consists of a recipe much like Leonardo's.

Variations. The Changing Creature game can begin with almost any type of animal—a cat, dog, turtle, bird, alligator. Similar games might begin with things such as cars, dolls, houses, chairs, light bulbs, trees, and flowers. As quickly as possible, try to get the child to describe to you how things might change. You could both draw from the child's descriptions.

Another way one animal's features can easily become those of

Figures 7-4 and 7-5

Lana (age 8)
And Lana Swallowed Them All (pencil)
12″ × 18″

Oak (age 10)
One-Thing-Inside-Another (pencil)
14″ × 17″

Both Oak and Lana were instructed to start this game with a very small animal. Oak's was a buzzing bumble bee; Lana's a speck that was a flea. Then we asked them, "And what do you think swallowed the flea [bumble bee]?" As they drew enthusiastically and one thing swallowed another, we repeated the same query each time until there was room for no more. Lana appears to have had a large appetite. Lana herself was in the picture. She swallowed a large cat and several small ones; the cat swallowed a fish; the fish swallowed a bird; the bird swallowed a bumble bee, which swallowed a snail, which swallowed the flea.

Oak's final swallower was a whale that swallowed a shark that swallowed an eel that swallowed a fish, a frog, and the bumble bee. Oak, the older child, seemed to feel more bound by logical categories. One can always make suggestions before or during the course of the drawing in order to add more interest, excitement, and imaginary play to these drawing games.

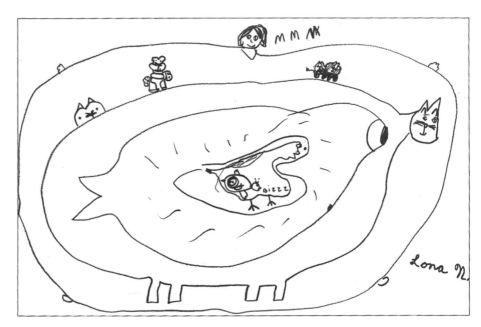

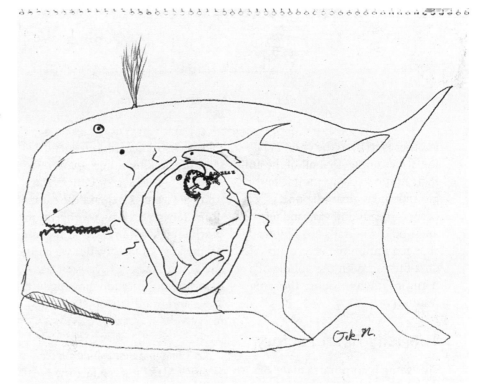

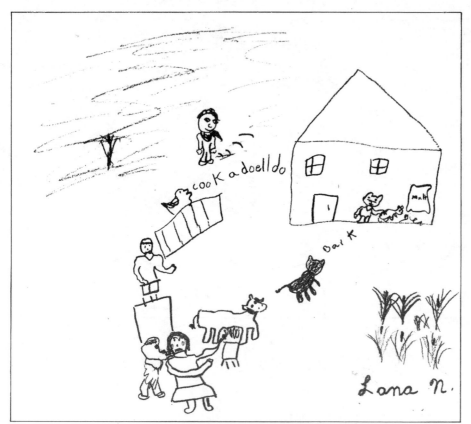

Figure 7-6
Lana (age 8)
"Cook a Doell Do" [*sic*] (pencil)
12" × 13"

Lana's house is hardly large enough to hold all of the strange goings-on of "The House That Jack Built," so much of it takes place around the house. A particularly interesting segment shows the man (who somehow resembles a dog) as he purses his lips to kiss the maiden who was supposed to look forlorn but who seems instead on the verge of giving the presumptuous suitor an elbow in the ribs. Her hands are busy, though, as they reach out, snakelike, to milk the cow. As with the other games, children practice imagining and drawing people, animals, and situations as well as in telling stories in drawings.

another is to have the child imagine, for example, that all of the animals in the stack-up tumble to the ground and a great mix-up occurs—heads and ears and feet and bodies and tails are all interchanged until none is recognizable. Or a firecracker in the middle of a barnyard might produce the same results. (7-7–7-10)

The Jelly Bean Factory

This game incorporates many of the ideas we find in children's spontaneous drawings of machines that make things. Children are concerned not only with the way things look but with what makes them tick. Some children spend their time taking things apart to find their inner secret. Others, like Andy S. (see p. 7), spend the same time drawing their own conception of what makes things work. It could be any kind of factory, but we chose a jelly bean factory because it has many possibilities for showing hundreds and hundreds of jelly beans in every color or size.

Let's imagine that we have a factory. / Make it a big factory. / Give the factory all kinds of machinery. / Give all the machines wheels that go round and round. / Give the machines pulleys and belts that make the machinery go. / What else can machines do? / Make them do that.
Have the factory make jelly beans. / Turn all the jelly beans red. / Turn them blue. / Turn them another color. / What color are they now? / Turn them every color of the rainbow. / Have the jelly beans on a belt that travels from one machine to another. / Where do the jelly beans go now? / Make them go there. / What else can the machine do? / Draw it! (7-11 and 7-12)

Figure 7-7

David (age 7)
Fabulous Creature (pencil)
14" × 17"

David's creature has the body of an armadillo, with two zebra legs, two elephant legs, and two heads as well. The heads are fish heads, complete with turtle necks, bull's horns, and lizard's tongues. David added the wings of an eagle and the tail of a rabbit, from which a snake's rattle emerges. This drawing was made in response to Leonardo's description; the combination and choice of elements, with the exception of the neck of the tortoise, are David's own.

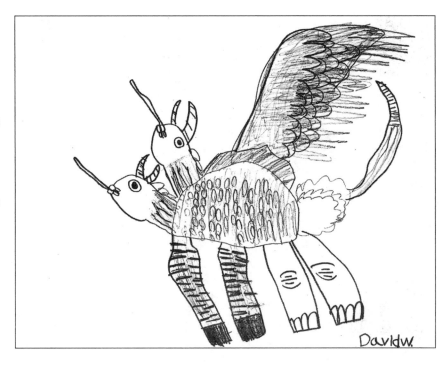

Figure 7-8

Oak (age 10)
Space Visitors (pencil)
7" × 9"

In spite of the fact that Oak knew that the new planet the space visitors landed on was really the head, he was more intrigued by the imagery of the mountains, lakes, and loop-the-loops. Superimposed on the head/planet is the mountain; the eyes are lakes with a stand of trees for eyebrows; the nose becomes a child's playground slide with nostril caves from which streams of air emanate, and a real (though miniature) monster is seen from the mouth of the mouth/cave. A dotted line outlines the path of the space visitors from the X at which they landed to the departing spaceship.

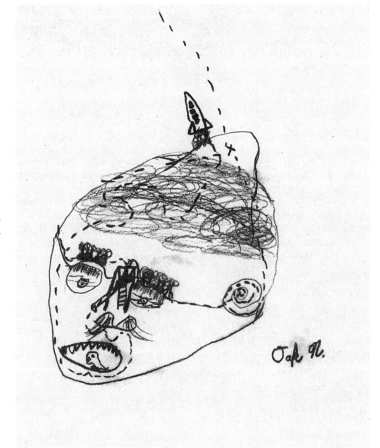

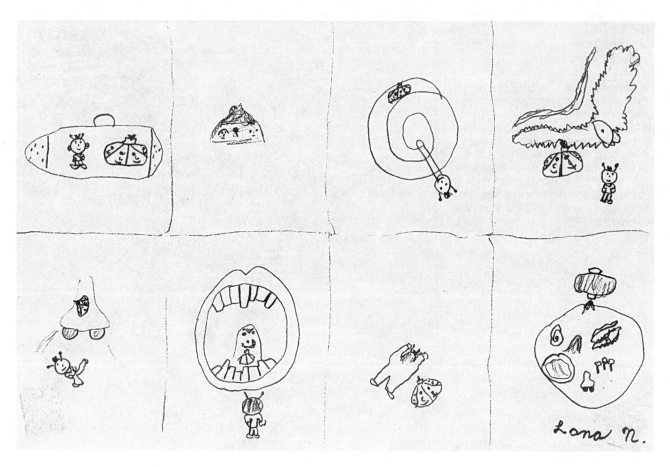

Figure 7-9

Lana (age 8)
Space Visitors Narrative (pencil)
12″ × 18″

Lana's decision to show the journey of the space visitors in separate frames resulted in this eight-part narrative. In the first frame two space creatures are inside a space ship; in the second frame the creatures are peering through the trees of the mountain forest. In the next frames they proceed to loop-the-loop around ears, peer into lake/eyes, slide down noses, become frightened by a tongue monster inside a huge, cave-like mouth, and finally blast off. Children do not always do what we adults expect—if we think that a head that has been described as a planet will be shown as a head with all of its parts in their proper places, we are often surprised. Lana's depiction of the planet in the final frame shows all the parts of the story, as seen in the first frames, but certainly not in any order, facial or otherwise.

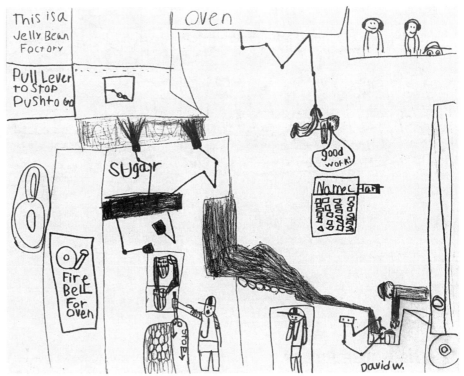

Figure 7-10

David (age 7)
Mountain Planet with Orifices
(black marker)
12″ × 18″

Of the three illustrations we have shown here of the space visitors, David's is the most surprising. The fact that the new planet was actually the human head was only an incidental detail to David's conception. His mountain is a great, tall, most unheadlike structure that appears to be more cyclopsian than human. The orifices that dominate the structure are the single "lake" close to the wooded top of the "mountain"; below that appear two small caves and, lower still, the large mouth/cave complete with monster. The space creatures appear at each site and flight lines trace their hasty retreat from the last fright of the monster in the cave back to their spaceship and its fiery flight for home.

Figure 7-11

David (age 7)
Jelly Bean Factory (pencil)
14″ × 17″

David needed very little encouragement to produce this complex drawing of a jelly bean factory. His own unique brand of humor makes the drawing more enjoyable. Sugar and color are added by pincerlike arms that appear to constitute the main workings of the machine, while the jobs of the men are merely to pull levers ("pull . . . to stop; push to go"), stand around and direct activity on the floor, or stand above in a booth that looks like a broadcasters' booth at a sporting event or a presidential convention. (It bugs me that every time I use the adverb about, Allison changes it to "around." I frankly think it is an uglier-sounding phrase and what I mean is "about.") Our vote for the best job of the lot goes to the man who shouts "Good work!" as he is held aloft (apparently to survey the operation) by a mechanical hand on a pulley below the oven. Of all of the characters, the only one who seems to do any work is the figure who leans out of the truck on the lower right as he takes boxes of jelly beans off the conveyor belt and loads them into the truck. But they all get paid; at least, they punch a time clock, seen just below the hanging figure.

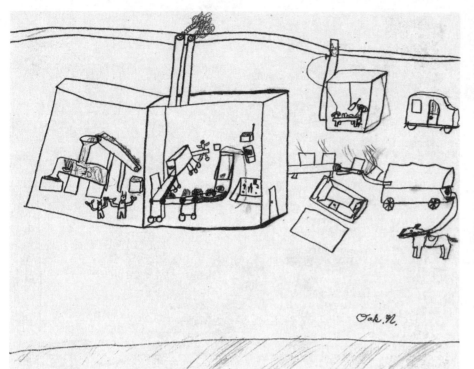

Figure 7-12

Oak (age 10)
Jelly Bean Factory (pencil)
14" × 17"

Oak might have been perfectly content to limit his jelly bean factory to the building in the center of the page and one simple machine, but the continual queries of "And where do the jelly beans go then?" "Who runs the machines?" "How do they get the orders?" "How are they shipped?" brought about this fairly complete operation and a much richer drawing. The question about how the jelly beans were shipped was followed by "By covered wagon or what?" and answered with the appearance of a covered wagon complete with horse in the "parking lot" next to the parked car and below the truck. Just as skill development is increased, imagination is encouraged through gentle nudging and prodding and a little humor.

The House Full of Rooms

This game requires the child to imagine that she is like a movie camera that first takes a long shot, gradually moves in for a close-up and a wide-angle shot, and pans through a series of medium shots of the rooms of a house. The parts of this game are not difficult to imagine, but it is unlikely that children will be able to remember all of the complex things that are in the house when they begin to draw. We suggest using a large sheet of paper for this game.

This game is called "The House Full of Rooms." *Think of a house far away in the distance.* / Have the house come closer and closer. / Now have the house grow larger and larger. / Put three roofs on the house. / Make the roofs very tall and pointed. / Take away the front of the house so that you can see all of the rooms. / Give the house hundreds of rooms. / Have lots of rooms on top of other rooms. / Make some of the rooms very large and other rooms as tiny as closets. / Look inside one of the big rooms. / Put beautiful large paintings on the walls of the room. / Put a table in the middle of the room. / Have a cow stand on the table. / Look at all the rooms in the house again. / Make stairs going from the top of the house to the bottom of the house. / Have people walking up and down the stairs. / In one of the rooms have people sleeping in their beds. / In another room have some people enjoying a party. / Have all the people at the party turn into all kinds of animals. / Have the animals wear funny hats and clothes. / In another room have people swing from ropes hanging from the ceiling. / Have another room piled full of broken tables and chairs. / Draw the house with its three roofs, all of its big and little rooms, on top of one another, stairs, people, party, and animals, furniture, and anything else you would like to put into the house.

Variations. There are dozens of exciting variations of this X-ray view game. Here are a few other things you can have children draw:

- A mountain sliced to expose tunnels, caverns filled with cities, cars running through the caverns, fires, invading armies
- A huge ocean liner with an X-ray view of cabins, cargo, swimming pools, parties
- An aircraft carrier with planes and helicopters above and below

decks, sailors, pilots, engine rooms
- A series of views of the insides of a robot
- Animals hibernating underground
- The inner workings of a plant that manufactures automobiles, airplanes, toys, dolls, or bionic people
- The interior of an enormous clock, computer, television set
- Trips to the center of the earth or inside a whale

These imagination games began with absurd situations and progressed to imaginary creatures, imaginary landscapes, and imaginary worlds. We have referred to nursery rhymes and fairy tales.

Inspiration may also come from science fiction or from such imaginary worlds as Lewis Carroll's *Alice in Wonderland* or *Through the Looking Glass*, Tolkien's *Middle Earth*[5], or C. S. Lewis's *Narnia*.[6] In searching for models for more games, you may explore worlds that you have never entered or that you may have forgotten, worlds that are rich and exciting and that will inspire all sorts of fascinating games you and the child may devise. (7-13–7-16) Even more important, however, is the child's own generation of imaginary creatures and landscapes, imaginary situations and worlds that encourage her to produce imaginary drawings on her own or to spontaneously play these games with other children.

As we have said, these games are merely models and beginnings. There are many more fantastic descriptions in fiction and art that we do not have room to mention, but the richest and most fantastic journeys into the world of the imagination come from children themselves. Many of the ideas listed here, in fact, derive from the things that we see in children's spontaneous drawings. In the end, it is the child who teaches the adult not only what to see but how to see it. We are privileged to be allowed into these magical worlds and to use the vision these journeys have afforded us to show other children the path to fantastic worlds of their own making.

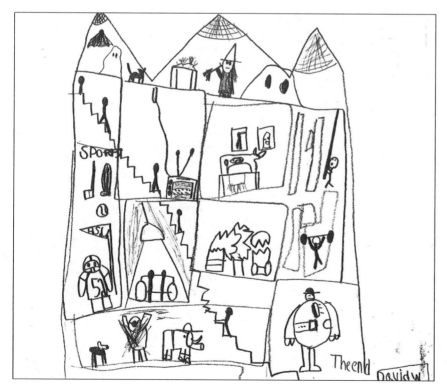

Figure 7-13

David (age 7)
House Full of Rooms (pencil)
14" × 17"

This game really appealed to David, perhaps because of the opportunity it offered to depict all sorts of nonsensical situations. He could hardly wait for the the verbal description to be over before applying his pencil to paper. His eyes gleaming, and smiling in anticipation of the images he had already generated in his mind and was anxious to record, David quickly gave form to the outline of the house, three roofs and all, followed in rapid succession by the walls dividing the rooms and the long staircase. He had no trouble remembering the contents of the rooms—paintings on the wall and the cow standing on the table; people turning into all kinds of animals and swinging from ropes; broken furniture—then proceeded on to his own agenda. He added a football player, a person lifting barbells, a fat man, a television set, and, in the attic, ghosts, witches, and black cats.

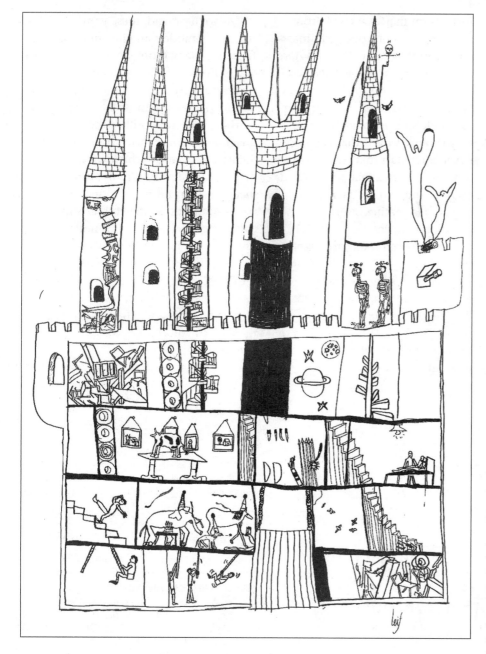

Figure 7-14

Leif (age 11)
Castle Full of Rooms (black marker)

Leif's house full of rooms became a castle complete with seven turrets. What best characterizes Leif's drawing is the progression from idea to image to concept and, finally, to variations on a theme, until he is satisfied with the result. Because he is older than David, Leif is less concerned with getting the images down on paper than with getting them exactly the way he wishes them to be. Like David, he has added some whimsical touches of his own—rooms full of automobile tires; the solar system; bows, arrows, and spears; skeletons, ghosts, moths; and a mechanical dragon. In the lower-left-corner room of the castle a man swings on a rope, although not very successfully; the men in the room to the right seem to perform this same feat in three steps, with the third figure swinging with ease, aided by lines of motion. The room in the bottom right-hand corner contains the broken furniture but the second attempt (the room at the upper left of the castle below the turrets) is more satisfactory. Perhaps the most interesting of Leif's progressions involved his attempts to draw a staircase. On the left we see a staircase with a man who appears to be falling over backward. On the right, another, more complex staircase ascends through two levels. Above that is what appears to be a modern sculpture but is in actuality an aborted spiral staircase; Leif considered this a failure. The model for this staircase was one that Leif climbed every day for the weeks that he visited with us and the one that he resolutely sat down with pad and paper to conquer. After he had drawn it to his satisfaction from observation, he returned to his castle drawing and added two exquisite spiral staircases, one on top of the other. While David's house was completed in a matter of minutes, Leif worked on his drawing on and off for the better part of a week. Although it is not always possible, necessary, or desirable to allow that much time for drawing, when the child and the situation seem to call for such attention, it may be a good idea to do so.

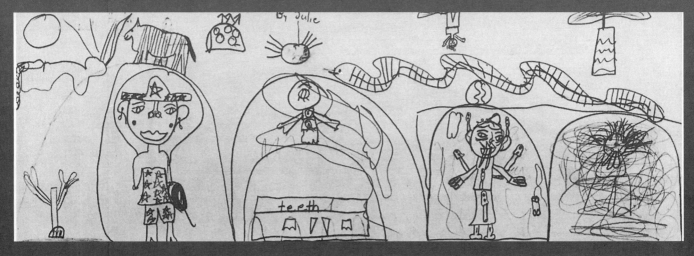

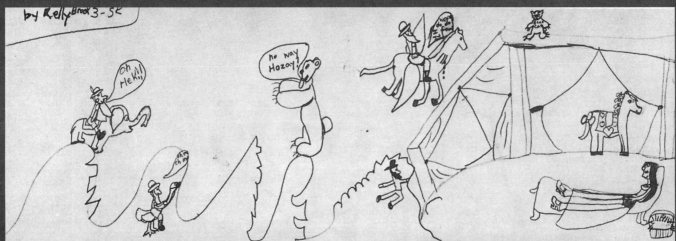

Figures 7-15 and 7-16

Girl (grade 3)
(pencil) 6" × 18"

Girl (grade 3)
(pencil) 6" × 18"

These wonderfully rich drawings were made by third-graders as part of a class response to a fantasy game that we devised and administered. We narrated each part, pausing to ask questions, to receive as many responses as possible (all of which were correct assumptions, of course), and to wait until the children had drawn the required elements.

Once upon a time there was a hill—oops—not just one hill but lots of hills—and, oh, were they strange! They had the strangest shapes you could ever imagine. Some of them looked like _____, others like _____ (make suggestions of your own: ice cream cones, alligator tails, etc.).

At the very end of the hill was something most valued, something that people have always wanted. It was _____ or some _____.

A group of explorers and adventurers (what do you think *they* looked like?) decided to climb up and down and over and across the strange hills to reach the treasure. To help them the explorers took _____ and _____. Can you show them traveling all the way across the hills?

During the journey they were attacked by _____ and _____. What did they do? Did they finally reach the treasure? What happened when they finally got there?

8

You **Draw** then I **Draw**:
The Graphic Dialogue

Alex and her mother, Joan, are busily engaged in verbal dialogue. Alex babbles, "da da da da," to which Joan responds, "ma-ma, ma-ma." As the sequence repeats again and again, Alex laughs delightedly. She wriggles her toes and frequently arranges her mouth as though preparing to form the sound of "mmm." Finally, one morning Alex calls from her crib, "Ma ma ma." Although she may not yet have made a connection between the person of her mother and the "ma-ma" sounds, Alex has learned the new sounds through their continual dialogue, as she will learn the next sounds and the next.[1] This interaction is necessary to the child's development of language.

The child who only listens to language does not learn to speak. A boy with normal hearing, whose parents were deaf mutes, heard language only through a daily diet of television and failed to develop verbal speech. There had been no interaction; one doesn't talk to a television set, nor can the set answer back. The boy did learn to communicate, however, through the interaction that he did experience—the sign language used by his parents.[2]

Since the mother begins her dialogue with the child at birth, a dialogue made up of coos and other sounds, of words, of questions, it would be rare for interaction not to occur in verbal language. It is unusual, however, for children to "speak" through drawings to adults who "answer back" with drawings of their own. Chap-

ter 3 offers suggestions for interacting verbally with the young child to assist them through early drawing development. Since children can benefit tremendously from graphic as well as verbal interaction, in this chapter we introduce a model for graphic interaction by presenting a series of drawing conversations between adults and children as young as five and among children of various ages.

Graphic Dialogues: Some Sources

The Italian philosopher and poet, Corrado Ricci, who wrote the first book devoted entirely to children's drawings, actually discovered his topic when he took shelter from the rain under a portico. While he waited for the rain to subside he began to study the children's drawings he found on the walls, noting how the older children seemed to influence one another, while the younger children's drawings located lower on the wall appeared fresher and more spontaneous. In this first encounter with children's drawings, Ricci appears to have discovered the graphic conversations that take place among children when they draw in the same setting.

Brent Wilson recalls his early experience with communal drawing:

In the fall and winter of 1942 and the spring of 1943, during WWII, American forces in the Pacific had just achieved their first success in the battles of the Coral Sea and Guadalcanal. In North Africa, Field Marshal Rommel was storming Egypt, American forces were landing in Algeria, and far

behind the lines, on the blackboards of the third- and fourth-grade classroom in Fairview Grade School in Fairview, Idaho parallel battles were being fought with chalk and blackboard erasers as principle weapons. During the long winter noontime break and morning and afternoon recesses, Clair Drury, Tony Knudsen, Blake Harding, and I drew aerial dogfights. One day the U.S. Army Airforce battled Germany, and the next day, Japan. Chalk tat-tat-tats marked machine gun bursts, radial zig-zags recorded hits, the corners of erasers and wavy chalk lines were used to show planes in the early processes of disintegration as pilots parachuted to the ground. Below, a similar process was repeated simultaneously with tanks, trucks, jeeps, cannons, and soldiers. I can still remember our conversations about drawing styles as we stepped back to admire our glorious panoramas. We could tell, just by looking, who had drawn every plane, truck, tank, and soldier. We also borrowed any good idea that appealed to us. Clair Drury always drew with firm pressure. From him I learned the value of precision and how

to draw flaring front fenders on my trucks with their radiators jutting forward in an exaggerated version of the Chrysler "Airstream." The entire board at the front of the room would be filled and then erased before class began.

Memories of Fairview Grade School came flooding back when, during the late 1970s, in a Brookline, Massachusetts, elementary school art classroom, we watched two fourth- or fifth-grade boys drawing together. They had completed the art assignment and had asked their teacher if they could use a fresh piece of 18" x 24" white drawing paper. On it they began to draw a space battle with fighters and rockets shooting at one another while emitting long orange back-blasts drawn with a colored pencil and a yardstick. One of us asked, "may I draw with you?" to which the answer was "yes." To accommodate the new player, an additional sheet of paper was taped to the first. Soon more students asked to join the battle, and more sheets were taped to the first. The excitement was palpable and we witnessed

again the dynamic and seductive power of making drawings together. We draw with children nearly every chance that comes our way and we encourage children to draw with one another.

Graphic Dialogues between Adults and Children

Three-year-old Becky (see figure 3-36) had just drawn a navel on the completed figure of a dog in the picture story. "It's called a belly button," she explained patiently to the adult who was drawing with her. "Oh," he said, "and what did I call it?" "A pupil," said Becky.

For some time the adult and the child had been engrossed in conversation—conversation in that it was an exchange of ideas—but although there was a good deal of verbal give and take, most of the discourse took place on the large sheet of paper on the table before them. We call this form of conversation a *graphic dialogue* or a *drawing dialogue*.

Through graphic dialogue the child can more easily pass through the early stages of graphic development to greater fluency in the language of art. In his book *Strategies of Representation in Young Children*, Norman Freeman considered the reasons for stereotypes in children's drawings, suggesting that perhaps drawing was a "relatively solitary pursuit":

Contrast [drawing] with conversation or social games and it becomes clear that there is rather limited scope for ongoing social interaction to alter the course of drawing. . . . People simply

do not usually play social drawing games in which the adult and child act as colleagues.

For several years, however, we have been engaging in just such social drawing games and the adults and children in our graphic dialogues do indeed act as colleagues.

In verbal dialogue first one person speaks, then the other, in a rapid exchange of ideas ranging from highly serious to playful interchanges. The drawing dialogue is also an interchange—I draw and then you draw. And, although always a serious business to those who participate, graphic interaction has many characteristics in common with the best and most spontaneous play. The participants enter into play willingly; they may tacitly agree to a few simple rules such as taking turns (although they remain free both to make and to break rules in the context of the play). Sometimes they may also agree to a general theme for the play.

As in play, once a drawing dialogue has begun there is no adult and child—merely two players. There is an excitement, a flow of ideas, a sensitive and willing response to unexpected cues suggested by the other or to the serendipitous occurrences in one's own drawings. Sometimes one leads, sometimes the other. There is total absorption. Graphic play at its best is like being somewhere else—living within the bounds of a sheet of paper, in the world created there, to master or be mastered, good guy or bad, in real (if symbolic) events. Because these dialogues are free, playful, stimulating, and fun (for

children and adults alike) they may be the very best way to expand the child's narrative abilities, drawing skills, and inclination toward invention and fantasy. Through drawing dialogues and conversations in the company of adults, children have the opportunity to create, preview, rehearse, and test in symbolic form the very patterns of past, present, and future realities.

Becky

For Becky, who always had the desire and the encouragement to draw, the drawing dialogue recorded here was her first excursion into the realm of figure drawing. A few months earlier, at Christmastime, she diligently practiced circles and wove intricate stories about her scribbles; it is utterly astounding that only a few minutes before she began this dialogue, Becky had drawn her very first human figure (see *Where's the Tummy*, p. 59).

This drawing dialogue began with the adult recreating Becky's own first figure in the upper left-hand corner of the paper as Becky gave encouragement—"See, this is how I maked it . . . yes!"—and instructions—"and then you have to make some fingers, too"—until the figure was completed to her satisfaction. The one thing that seemed to both fascinate and confuse Becky throughout the dialogue was the discrepancy in the verbal designations that she and the adult had given to a dot or a small circle within a larger circle: *navel* was called a *tummy button* by the adult and a *belly button* by Becky; the *pupil* of the eye was called a *pupil* by

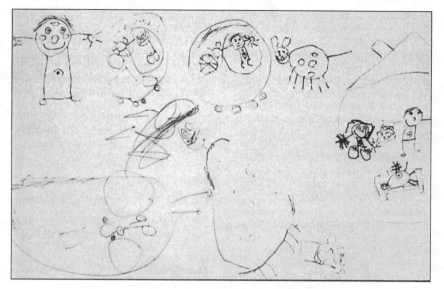

Figure 8-1

Becky, age 3 and B., an adult
Becky's Red Car
14" x 18"

In this drawing dialogue, Becky drew a fig-
ure (second from the left at the top of the
page) inside a car. As she drew, the car
and a person merged on the lower left
and the car/person bumped into an enor-
mous dog (also drawn by Becky). In the
hospital (far right), Becky and B. each
added pieces in the other's drawing of
the small figure (to the left) and the
bedridden dog (bottom).
Credit: Schools Arts, October 1981.

the adult but an *eyeball* by the child.
This confusion was such that finally
for Becky *pupil* became not a mis-
named eyeball but a misplaced
navel. But if Becky was confused by
a play on words, her graphic play
was lively and exciting and not at
all confusing.

When the adult suggested that
the person drawn on the page be
"Becky," an ever-animated child
responded "Me?" with a high-
pitched squeal of joy. Getting into
the story was even easier than antic-
ipated: Becky was never at a loss for
ideas or suggestions or enthusiasm,
and she was prepared to try her
hand at anything in the way of
drawing challenges. Because she
was drawing with a red pen, Becky
was inspired to suggest that if the
little girl in the drawing was going
somewhere, she should be given a
"red car." It was Becky's turn to
draw and she was confident that
she could draw the red car if only
she knew how: "But how do you
make a car?"

The most interesting result of
this drawing dialogue was that
Becky drew not only the human
figure but cars with steering wheels
and big windows and dogs (that are
silly and don't know enough to get
out of the way of red cars). If a car
sometimes had hair and legs as well
as wheels, Becky explained it as a
"person-car," and if a dog had six
legs, it was a "mean dog" so it was
given "mean hair" and buttons.
Nobody minded. Sometimes Becky
simply talked the adult through the
drawing; sometimes they drew
together on the same figure. But
there was no part of the drawing or
the story to which Becky did not
contribute. Becky, at the age of
three years, nine months, is the
youngest child we have played this
game with.

The basic element of the narra-
tive is telling or showing what hap-
pens and then what happens next.
This element is even more exciting
when it becomes a series of getting-
into and getting-out-of difficult sit-
uations. When two play this draw-
ing game, move and countermove
often follow in quick succession.
This was certainly the case with
some of the drawings we did with
Sam.

"Sam's Barriers"

Our dialogue with ten-year-old Sam demonstrated the "argumentative" flavor of many dialogues—in the best possible sense of the word. And, as in the best arguments, the necessity to counter the thrusts of one's opponent leads to the further development and refinement of one's own ideas.

This dialogue had begun with a long strip of paper. B.'s character is confronted by one of Sam's "weird people" with a "weird long arm," and "You'd better not move or you'll get rays." But the character easily collects the rays from the ray gun in a "handy collector" box. Sam adds some "long, long, long grass," and then "what comes out of it is a snake" which "goes over the weird person's head—and what he does, he goes around the collector. He's called a clear snake; you can see right through him." Sam's younger brother, Brent, who is drawing across the table, disagrees. "This one is," retorts Sam. "Listen, Brent, this is my imagination, not yours."

B.'s character turns into a plastic man and slithers along the top of the page, avoiding the snake. Sam is stumped, but he soon adds "a giant ant mound with a bunch of flying ants that get on his hand—walk all over him." B.'s response is to supply his character with even greater flexibility, sprouting five "anteater tongues" with which he sucks up the ants. Sam's verbal response is, "Yucky, yucky, yucky!"

Sam adds yet another anthill and a "spitting cobra" and a wall that "never stops." As B. attempts to get out of this predicament, Sam adds, "Hold it. You forgot about the wall, OK, the wall never stops; you gotta get through the cobra and ants before you can go through the wall—if you have anything to go through the wall with." At this point the verbal assault runs alongside the visual barriers, and Sam reminds B. that he is a formidable opponent. "And also you're too full of ants so you can't eat 'em." Sam watches as B. draws. "What's that?"

"He seems to be getting smaller, doesn't he?" says B.

"Yeah, but you know what? The ants are filling up these cracks." And then, aside, "I'm making it hard for you." But B.'s character becomes a "very small" atomic bomb that blasts the cobra "named Ralph" and heads toward the wall.

Sam is ready with his verbal barrage. "Now the ants—he's too full to eat 'em all. Remember, he can't get through the crack, 'cause the ants know what he looks like," and Sam giggles with glee to think he may have stumped B. after all.

But B. is undaunted. Turned into a screw, his character screws an opening through the wall, emerges, encounters a minefield, and is blown to bits. The bits ricochet from wall to wall of Sam's shed full of TNT. B. is trying to get Sam to draw figures. He taunts, "The only way you can get this guy is to get somebody as smart as him to take him on: snakes aren't smart enough," and "I think you're going to have to create a character that has at least the same powers that mine has; otherwise, how can you take care of him?"

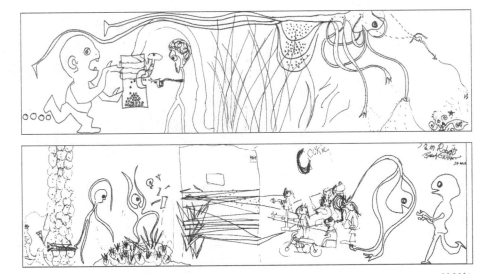

Figure 8-2

Sam (age 10) and B., an adult
Sam's Barriers (colored marker and pen)
6" × 54"

Sam accepts the challenge. "OK, I'll show you." He hedges still with hills and land mines and buildings but succumbs with a promise of "a motorcycle gang [in case B.'s character should surmount the other barriers] with guns and daggers and brass knuckles." He is finally cajoled into "putting his pencil where his mouth is." He draws a motorcycle. "There's the motorcycle."

"Where's the gang?" B. asks.

Giggle. "Inside the motorcycle—that's the motorcycle gang."

B. threatens to have his character make his getaway on the motorcycle. "I'm glad you left the motorcycle for him. Maybe he couldn't ride it if somebody was on it or something." Sam tentatively starts to draw a motorcyclist with "shaggy hair, a big nose, and white eyes."

B., seeing that Sam has started his figure too high on the page, asks, "Is he standing behind it or is he on it?" Sam counters, "Oh, he's real short so he's standing on it," and encouraged, draws another. "I'm not done yet," but laughing, "I told you I'm not good at making people, space people, yeah."

B. continues to playfully tease Sam. "Is he standing on his [the first guy's] motorcycle, too?" Sam laughs, but says, "That's not all,

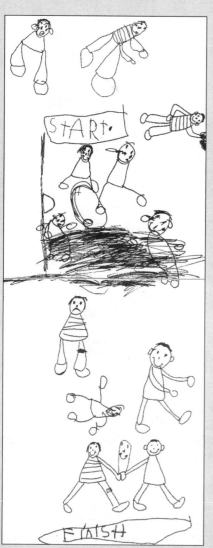

Figure 8-3

Philip (age 6) and M., an adult
The Race (colored marker)
11" × 27¼"

This dialogue between Philip and an adult took place three months after Philip's first stories (see p. 113). Before the dialogue began there had been a discussion of figures running (Chapter 3), so what follows is a continuation of that exchange.

M: Start with a little boy and a little girl. Think about the story—do you know what they're going to be doing?

Philip: They're having a race. [He adds a sign, asks how to spell start.] S-T-A-R-T period!

M: Now there's a man . . . and he's standing over here.

Philip: I know what you're going to do with the man. You're going to make him hold a gun and it goes "pow." [The drawing of the referee is very similar to the best of Philip's own figures. He adds black scribbles and red flame from the gun—to indicate that it has been shot.]

M: Here is the ground and there's this big rock.

Philip: [Quickly points out the error of that move. His runners were proceeding down the page rather than across the page. Because he was not yet ready to do a profile view, his figures were drawn as if seen from above. He then proceeds to redraw the ground line with the proper orientation.] Now here comes the biiiiig rock—they're already trippin'—ohh—the boy's gonna trip right to here—and the girl falls down, too.

M: Are they going to help each other to get up, or what?

Philip: They can get up their selves [but he looks again at his drawing] . . . but not without they have arms [and Philip adds arms to his figures, but not until he has gotten down on the floor to show just how hard it would be to get up without using his arms.]

M: The boy is running very fast.

Philip: Are you going to make the boy win?

M: Here is the girl.

Philip: She's way behind. [But she is sad. Philip guesses she is sad because the boy has gotten so far ahead.] But she isn't running. [The girl has hurt her knee.]

M: Do you think the boy will feel sorry and go back and help the girl?

Philip: Bring her a Band-aid. [He draws the boy as he turns to go back to the girl. This figure is drawn perpendicular to the others—still from a bird's-eye view.] The boy and girl are both running together and they are smiling and holding hands.

Philip is pleased with this turn of events [He adds a finish line—again asks about the spelling and writes F-I-N-I-S-H and places between the clasped hands of the girl and boy . . . a trophy.] They have both won the race.

behind them is the Muppet gang. Nobody can go through them— Kermit the Frog and all those weirdos." There is a discussion involving Sam's brother, who is not sure that Sam can draw "all them," and B. again teases Sam about men standing on top of motorcycles, but all's fair and, "Come on," says Sam, "your guy has two thousand tongues and eats ants."

And as Sam proceeds, B. gently encourages him. "I thought you couldn't do that; that's better than mine." Accepting the praise, Sam answers, "'Cause I'm using your pen." Encouraged, he adds more characters. "He's dancing," and "Miss Piggy—has a dress on," and "and then there's Cookie Monster." Sam has discovered that he really *can* draw people.

The story ends with the bits of B.'s character finally blasting out from the TNT-filled room and plastering themselves to the faces of Sam's gang. When a bit hits Miss Piggy, the creature recomposes, as if kissed by the fairy-tale princess. Sam finally decides the only way to take care of this creature is to create another like it. The final figure is his and it runs to encounter B.'s creature. Perhaps the important thing here is that Sam's figure is running. Not only is he drawing figures, now his figure runs—a first for Sam.

In the getting-into and getting-out-of-difficulty dialogues, each new countermove virtually demands new drawing skills of the players, but because the playing is so much fun the new skills develop almost effortlessly (p. 153).

Elephant Story

Almost always when we draw stories with children, we ask the child to draw first. This permits us to observe the level at which he draws—so that we can draw at slightly higher levels while at the same time drawing in a style similar to that of the child. This is what B. did as he drew with Teal. (8-4)

(8-4A) Teal was just four years and five months when she drew the little figure— hardly more than a tadpole—taking a shower.

(8-4B & 8-4C) B. drew the empty shower with the little girl leaving it, getting dressed, and putting on her beautiful hat with a flower on it. The drawing of both the shower and the little girl getting dressed continues the sequential action element—showering and getting dressed— while adding the element of time by showing the empty shower the little girl has left.

(8-4D) Teal models her next drawing after B.'s previous two drawings; she shows the little girl going outside by drawing the door and the little girl beyond it—echoing the girl in B.'s drawing.

(8-4E) It's B.'s turn again. He takes the opportunity to introduce an unexpected element. He has the little girl begin to push her doll carriage. Surprise! A huge elephant sits in the place where one might expect to find a doll. It's unlikely that Teal would have done something as silly as drawing an elephant in the doll's place on her own. Most four-year-old children are quite content to tell ordinary slice-of-life stories—first we did this, then we did this, and then this; the end. The role of the adult partner is to add a bit of spice to ordinary stories.

(8-4F) Teal's next drawing is very tiny—just one-half inch tall and an inch long. It shows the little girl

and an even smaller elephant approaching a body of water. We wonder if the smallness of the

drawing may reveal Teal's tentative thoughts about drawing elephants or about what might happen next. Never mind, she got us to the water.

(8-4G) In the seventh drawing, B. has the little girl and her elephant friend board a boat and sail away—with the elephant standing precariously close to the edge of the boat. "Oh oh! What's going to happen next." A well placed verbal cue sends a signal that it is time for more disequilibrium.

(8-4H) Teal has taken the cue nicely; the elephant, seen from above, has fallen off the boat and is now under water.

(8-4I) B. suggests that the little girl toss a line to the elephant.

(8-4J) Teal draws the elephant attached to the line, and the elephant blows water out of its trunk.

(8-4K) Back aboard the boat, Teal draws the little girl standing atop B.'s elephant as they sail for shore.

(8-4L) Home safely! Teal draws the elephant and the little girl walking through the door of their house.

(8-4M and 8-4N) B. draws the elephant asleep in its bed and Teal draws the little girl asleep in her own bed.

Figure 8-4

Teal (age 4) and B., an adult. *Elephant Story* (black "rolling-writer") 7" x 15¾"

The Two Nice Sisters, the Cat, and the Lion

(8-5A) Once there were two sisters. They were always nice to each other. They went for a walk and saw a big box.

(8-5B) They opened the box and saw a little cat. Oh oh! They saw a big lion too. The little sister grabbed the little cat. (Teal drew the little sister and the cat and B. drew the surprised older sister and the lion.)

Sometimes a child's level of drawing changes considerably more than the level of her story telling, even when she draws with an adult. Teal and B. drew the story of "The Two Nice Sisters, the Cat, and the Lion" (8-5) when she was nine years and nine months old—five years after they drew the elephant story.

As in her earlier story, Teal drew the first frame—a picture of two sisters, probably Teal and her younger sister Kess. B. added a box to her drawing. One never knows what a box might hold. Once the story was finished, Teal recounted it verbally. (It's interesting that the elephant in the earlier story needed to be rescued, while the lion, in this later story, gets himself out of the lake.)

(8-5C) When they got home they began to play with the cat. At the side of the house they saw the big lion. (Teal drew everything but the lion.)

(8-5D) The big lion started to chase them. They ran down to the lake, the little cat was with them. B. drew almost everything but the cat.)

(8-5E) The lion tripped on a rock and fell in the lake. The two sisters were surprised and the cat began to cry because the lion was its friend. (Teal drew almost everything but the two sisters showing their distress. It appears that the water provided a means to neutralize any threat posed by the lion.)

(8-5F) The lion climbed out of the lake, onto some rocks that were nearby. The girls got a towel for the lion to dry himself and they all became friends.

(8-5G) The final drawing in the series was inspired by Teal's retelling the story to her family. It shows the sisters and the sleeping cat, drawn by Teal, and the lion drawn by Teal and B.

Figure 8-5

Teal (age 9) and B., an adult
The Two Nice Sisters, the Cat, and the Lion
(black "rolling-writer")

The Space Horse (That Shoots Fire) and the Mean Robot

When Teal's older brother, Dane, was five years and one month old, he also drew a story with B.—one of many they have drawn together over the years.

In Chapter 3, we talked about how children discover regular configurations within their irregular scribbles. Some children (and some adults too) continue the practice of beginning to draw with a scribble, looking to see what it reminds them of, and then taking additional steps to transform the marks into what they appeared to resemble. This is how Dane started "The Space Horse and the Mean Robot."

(8-6A) Dane began a random scribble on the left-hand page of a sketchbook. Almost immediately he saw the head of a horse, jaws open, an ear, and front feet. Where the horse's back might be, however, he had scribbled a curious volcano-like cone shape. No matter, he named it "a space horse that is a robot. He shoots fire." Lines were quickly added to represent the volcano's eruption—and wings were added to the horse. Its possible that, for Dane, the space horse became a robot because another scribbled shape where the horse's tail might be reminded Dane of the mechanical

8-6A

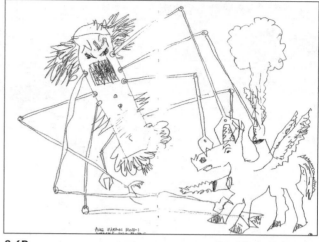

8-6B

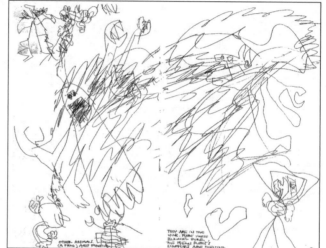

8-6C

hand of a robot. The quarter moon and a star were added to show that this fire-spouting horse was certainly in space.

On the right hand page, Dane drew more stars, more volcanic eruption, and "a mean robot with snoppers (like Leif does)." Dane had recently seen a story drawing made by his uncle Leif and B. (8-7) In this story, a robot named Hornen possessed huge mechanical hands, which Dane called "snoppers."

(8-6B) It was B.'s turn to draw. Because Dane and B. had been drawing together since Dane was two and one-half years old, B. knew that Dane was unperturbed if he drew several levels above the five-year-old's developmental level. In fact, using the more advanced drawings as models, Dane frequently raised the level of his own drawing. On the next two pages, B. drew the mean robot with snoppers attacking the robot horse.

(8-6C) When it was Dane's turn to draw, B.'s static drawing inspired a veritable firestorm of action that spread over the next two pages. On the right hand page Dane drew the

horse in the act of breathing fire on the poor robot (drawn on the left-hand page). The furiously-scribbled mass of lines show the ferocity of the flames. Dane shows the mean robot's distress by the expression on his face, borrowed from B.'s drawing on the previous two pages, and by the two snoppers the mean robot holds high as if to escape the flames. Dane told the story this way "they are in the war. Robot horse blowing fire. The mean robot's snoppers are melting." All around the mean robot, Dane adds "other animals, a frog, are fighting too." In addition to a Kermit-like frog

(directly above the mean robot's head), Dane had drawn birds and other marvelous creatures who join the battle to subdue the mean robot.

(8-6D) It was B.'s turn to draw. Turning the page, he drew the fire-breathing horse standing triumphantly over the mean robot. The story could have ended there, but Dane had already planted the seeds of the next phase with his introduction of animals who joined the battle. As B. began to draw more animals being set free, Dane joined in, creating a mar-

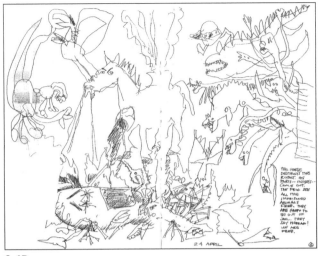

8-6D

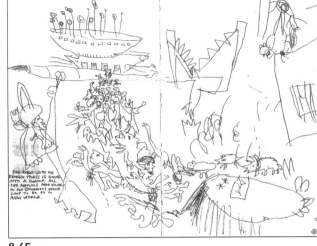

8-6E

velous menagerie of birds, dinosaur-like creatures, and fish. When this part of the story was complete, Dane told it this way: "the horse destroys the robot. His parts—insides—come out. The frog sets all the imprisoned animals free. They are happy to be out of jail. They say hurrah! We are free." ("Imprisoned" must have been a term B. used as he drew; it's not a word one expects to find in a five-year-old's vocabulary.)

(8-6E) Dane started his next drawing with the mean robot in the swamp. The empty animal prison (on the far right) is drawn with a single animal standing on top. Dane had the idea that the animals should go to a new world. B.'s enthusiastic response to the idea was the drawing of an ark-like rocket ship, to which Dane added an interesting unnamed structure to its right. Following the Noah's ark model, B. had the animals board the ship, drawing the animals nearest the rocket ship receding in size. Dane's recounting was: "the robot with his broken parts is going into a swamp. All the animals are going

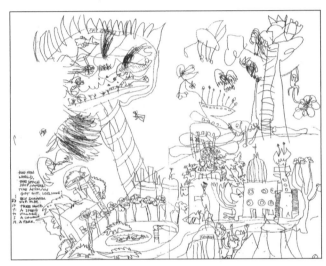

8-6F

to an enormous space ship to go to a new world."

(8-6F) B. established the context for the new world by drawing a curved line to show the contour of the planet and Dane immediately drew the ark-spaceship resting on its surface. There was enormous excitement as Dane and B. began to plot how their new world would look. Dane's description of this part of the story was: "The new world. The spaceship landed and the animals got out. Welcome! Skyscraper for fish. Tree house. A steggie (Stegosaurus) village. A church. A park."

B. began to draw a huge skyscraper in the shape of an inverted fishbowl mounted atop a tower (on the left). Dane quickly drew a row of jagged teeth-like shapes across the top of the bowl. "What are those?" B. asked. "Scrapers," Dane replied. Of course! Skyscrapers are not complete until they have their scrapers. Dane's skyscraper on the right has them too. No longer was it your turn, and then my turn. Dane and B. drew whenever and wherever they wished as the new world grew and grew.

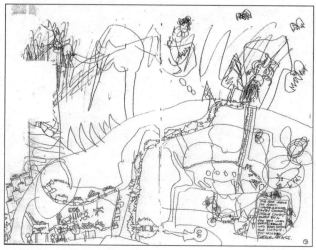

8-6G

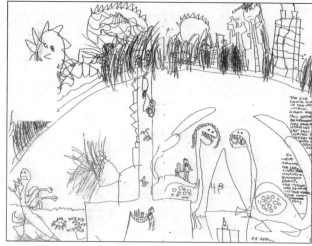

8-6H

(8-6G) The new world came to exist both above and below ground. This drawing shows the new world at night. Underground there is a factory for the manufacture of candy Stegosauruses and a long tunnel to convey the steggies above ground. A huge rat begins to eat the steggies and has to be contained in a glass bottle. Above ground a little boy eats too many steggies and throws up.

(8-6H) At about drawing number eight, most of which was drawn by Dane, the five-year-old recited, "The sun came out in the new world. A farm had tall grass. The grandfather and grandson were lost in the tall grass. The grass-eating dinosaurs couldn't eat it up. So they (the grandfather and the grandson) went underground (actually they fell down a shaft—this is the part that B. drew). The Diplocauses (a kind of dinosaur?) were having a birthday party. The tyrant (Tyrannosaurus Rex) was swimming in the water (in the far left corner)." Dane wanted everyone who viewed the drawing to note the "loud-speaker too" (directed toward the

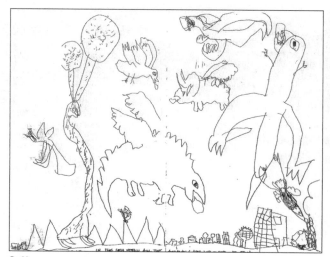

8-6I

tyrant.) This was enough drawing for one day.

(8-6I) The drawing was continued the following day. About this drawing Dane said: "In the new world all the animals are learning to fly." The two dinosaur-like creatures in the center were drawn by B. but Dane drew the rest. When B. asked Dane, "where did you learn to draw birds like that?" he already knew the answer. B. had been reading the book *Cave Birds: An Alchemical Cave Drama*, with poems by Ted Hughes

and drawings by Leonard Baskin 1978, New York, Viking Press). As B. read the book aloud, Dane looked over his shoulder and asked about each of Baskin's illustrations, "Is that a good bird or a bad bird?" Dane's marvelous birds had been drawn from his memory of Baskin's birds.

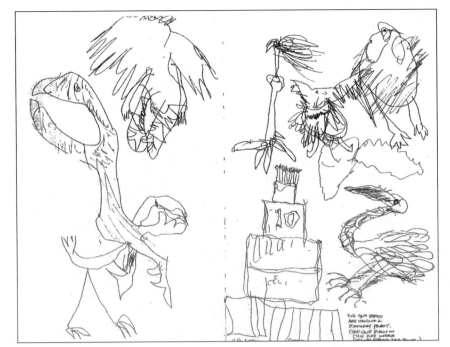

8-6J

(8-6J) The cave birds began to dominate the story. About this drawing Dane said: "the cave birds are having a party." Dane drew the birds on the left side from memory, and on the right side of the page he drew birds while looking at Baskin's illustrations. B. drew the cake and the bird in the lower right hand corner.

(8-6K) Dane drew the big birds above, and B. drew the small birds below. Now the story had evolved from a space adventure to the challenge of drawing birds in the style of Baskin.

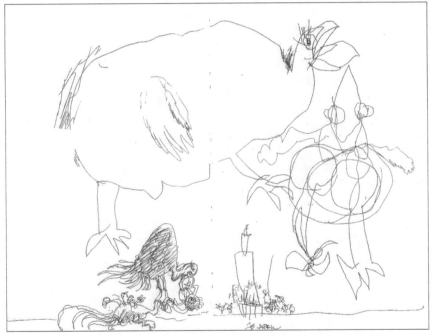

8-6K

The Return of the Hornen

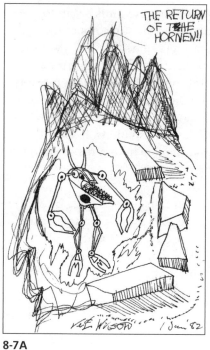

8-7A

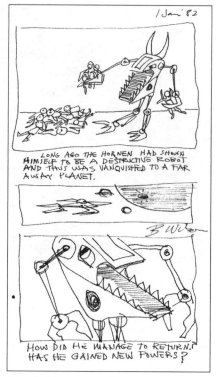

8-7B

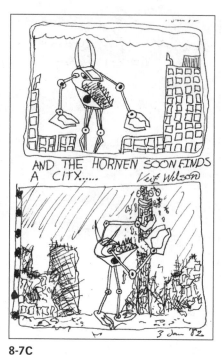

8-7C

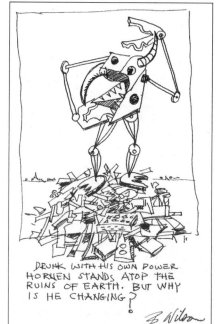

8-7D

(8-7A) Leif had just turned twelve when he drew a robot he named Hornen. A day earlier Leif and B. had drawn a story about robots, but Hornen was a new character. (Note that Hornen has mechanical hands—the ones that Dane had seen and called snoppers, which he drew on his mean robot. (8-6A) (See Leif's attempts to draw airplanes when he was age 4 [5-1–5-6].)

(8-7B) When it was B.'s turn to draw, he divided the page into three panels and established Hornen's origin—that he was a destructive robot who had been vanquished from earth. With the cropping of Hornen in the third frame B. attempted to establish a new convention for Leif. B.'s question, "how did he manage to return? Has he gained new powers?" was intended as a narrative challenge to Leif.

(8-7C) Leif borrowed the idea of making panels from B.'s drawing, but cropped Hornen only slightly in the first of two frames. The city that Hornen found was Birmingham, England, where Leif lived. The tower Hornen attacked was the Birmingham Post Office Tower. In the second drawing Leif shows his skill in depicting the robot from an unusual perspective.

(8-7D) B. proved to be inept at showing Hornen in perspective. The answer to Leif's "why is he (the robot) changing?" is that B. couldn't draw the perspective of the head correctly. Consequently, the misdrawn head became a new transformational narrative element.

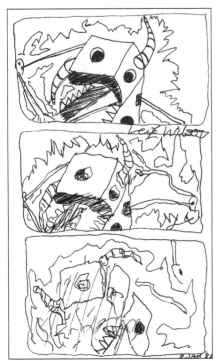

8-7E

(8-7E) When it was Leif's turn to draw again, he used both multiple panels and cropping to show Hornen's disintegration.

The Extended Graphic Dialogue

In the "you-draw-I-draw" graphic dialogue, the act of drawing alongside an adult accelerates a young person's ability to depict details, actions, events, and cause-and-effect in remarkable ways. The rapid-fire graphic interaction that leads to engrossing narrative sequences, however, discourages the careful and thoughtful development of a drawing's composition, expressive qualities, and detail. These features take time, and one's graphic partner can hardly be expected to wait patiently, even stifling his or her own enthusiastic response while the other labors to complete a detail in a highly complex drawing. The extended graphic dialogue makes such an opportunity possible. Rather than the immediate exchange that takes place on a single piece of paper, this dialogue consists of a series of drawings produced individually and sent to one's partner only after being fully worked to one's own satisfaction.

Ordeals of the Zargonian

This "Ordeals of the Zargonian" (8-8) was created by Jeff and B. Jeff was eleven at the time, but already he was something of a Renaissance man. In the course of the previous two years, he had written six or seven plays, two of which he not only produced and directed, but in which he also starred. The most recent was a James Bond spoof, "Thames Bland." Perhaps his most astounding play was a complex twenty-five-page, true-to-myth drama of the Trojan Wars. One of

his poems had been published in an arts festival booklet, and he was writing two books, one of which consisted of a series of illustrated short stories about "The Ultraverse," a star system composed of thirteen planets, including Erthrogg, Nargal, Zargon, Hivaak and Paagon, each with its own distinctive ecology and inhabitants. So it was no surprise that when Jeff began the dialogue he chose an Erthrogg cave as the setting.

(8-8A) In extended dialogues, written notes serve the same purpose as verbal dialogues between graphic narrators. Notes signal intent, explain implications, and represent attempts to move the story in preferred directions. Jeff notes below his first drawing: "This somewhat gory little doodad takes place on the arid planet of Erthrogg. That Zargonian Samurai who effectively skewered the Nargalian won't be so

8-8A

8-8B

8-8C

8-8D

ecstatic when the other Nargalian webs him up and whatever is in the cave takes a hand in the situation."

(8-8B) In his drawing B. throws the question of what the cave conceals right back to Jeff. "The worms will have Zar for lunch if help doesn't arrive soon! What is in the cave?"

(8-8C) Jeff supplies the help, but leaves the cave question hanging. "It looks like everybody's attacking everybody right now, except Zar, of course. Who—what—will save him?"

(8-8D) As Jeff had done before him, B. directs his interest toward the action, but also raises the possibility that another force might provide Zar with a means of escape. "Meanwhile, inside Zar's head, a complex of biologically mechanical circuitry begins to . . ."

(8-8E) Perhaps Jeff is more experienced than B. at juggling the many complex threads of such a fantastic tale, because although he thwarts any hope of Zar's self-help project with a single self-destruct command, he does manage to dispatch whomever or whatever was in the cave once and for all. Jeff's note reads: " . . . activate his self-destruct mechanism, and in a moment, Zar the drone Zargonian is dead, along with every living thing in the cave."

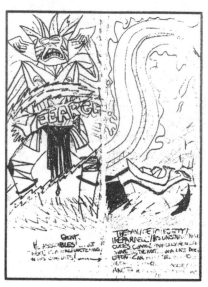

8-8E

8-8F

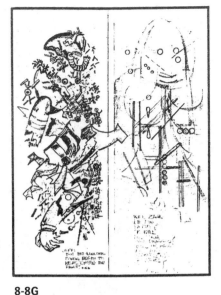

8-8G

Figure 8-8
Jeff (age 11) and B., an adult
Ordeals of the Zargonian (pencil)
9" x 12"

(8-8F) B., by now having grown fond of Zar and determined that he will prevail in some form or another, brings about the Zargonian's recomposition, leaving the exact form to Jeff. The caption reads: "But bioelectric forces begin to reassemble the parts . . . Will Zar be the same? Or will his form have changed? Will he have new and marvelous powers?"

(8-8G) Nothing comes easily, especially if you control all the forces of the universe with your mind and hand, and Jeff continues to play with ideas and images and to toy with his partner, never fully losing control of the situation. Under his drawing, Jeff has written: "He assembles! But there is a malfunctioning in his circuits! The damage to his body is irreparable! His unstable molecules change painfully from one shape to the next. In a last-ditch effort, Zar releases his bio-mechanical life force to seek out another body to house his life forces! He finds . . ." And the dialogue continues.

The narrative tensions of the dialogue are evident, but what may be less apparent are the ways in which Jeff and B. influence one another graphically. Of course, B. had to learn to draw Zar and the various creatures, circuitry, and mechanical elements with which Jeff was already familiar. At the same time,

because B. showed dimensionality in his drawing, Jeff was encouraged to add volume to his own subsequent drawing of rocks and cubes and figures as well. The two talked about shading and contrast, and after B. provided him with a 3B drawing pencil, Jeff bought his own set of drawing and charcoal pencils. Each new visual expression presented in the dialogue literally demands that the respondent draw things he has not previously drawn and to imagine what he has never imagined. This is the power of the *extended graphic dialogue.*

The *extended graphic dialogue* formalizes and accelerates an important, perhaps essential, aspect of art learning. It facilitates the process of working from and responding to the images of other artists. Far from inhibiting creativity, working with and alongside the images of others actually mandates invention and novelty as in the illustrations we have provided.

The Hidden Sequence

The graphic dialogues that we have shown thus far are sequential narratives, where—with a bit of description, it is possible to tell what happened first, and next, and next. There is another form of communal drawing where bits are added both sequentially and simultaneously. Consequently, when the drawing is finished, it is often impossible to tell, or even to remember, what came first and what came later.

Around Holly's House

What happens when children who have not drawn interactively are introduced to the graphic dialogue? This was the question we asked ourselves as we began to draw with Holly. Holly was eight-years-old and liked to draw—a fact confirmed by the display of artwork on the family refrigerator. Holly's drawings were those of a typical eight-year-old girl: flowers and houses, single figures ("Daddy" adorns the refrigerator door), and colorful designs. There was no indication from the drawings we saw that Holly had ever used any storytelling or fantasy in her drawings and it was difficult to predict what would happen when she was introduced to the idea. A great many exciting things did happen, not just with Holly, but also with her five-year-old sister Lindsey and Lindsey's friend Jonathan, also five. When the dialogue acquired "eavesdroppers," in fact, it became so exciting that the only way to convey the richness of this four-way

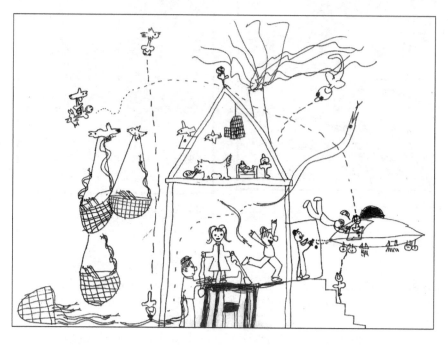

Figure 8-9

Holly (age 8) and B., an adult
Holly's House (colored marker)
13½" × 17"

conversation is to describe three drawings at once.

B. asked Holly if she would like to draw something. Holly seemed eager to try although she appeared to be unsure of what was expected of her, and it was clear that she had no story in mind as she carefully drew a table and chair at the very bottom of the page. (8-9)

Because there is really no story without characters and because he hoped that Holly would soon initiate some action, B. supplied a character, a boy standing beside the table, and then it was Holly's turn. For each of B.'s moves, Holly would cautiously add a detail to the drawing—a hat on a figure, a dish of marshmallows on the table—but it would take several more turns before there was any action.

Meanwhile five-year-old Lindsey was busily drawing on her own

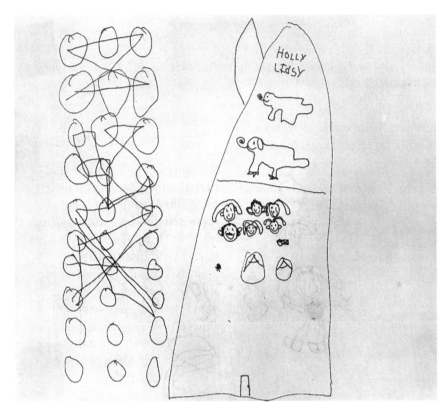

Figure 8-10
Lindsey (age 5)
Lindsey's Dog House (colored marker)
13½" × 17"

paper on the other side of the table, with a watchful eye out for the activities of her sister and B. But it wasn't until B. enclosed table, figures, and everything else within a frame and Holly added a roof that Lindsey, quickly recognizing the familiar "house" configuration, turned her own paper over and drew a house. (8-10)

When Holly answered B.'s next query about what might live in the top of the house by suggesting a dog, B. said that he was "not very good at dogs." As he drew, Lindsey allowed that she could draw a dog, but "I'm not good at it either." She then proceeded to draw a dog in the same part of her house as B. was drawing his. When B. wondered if his dog was really a cat, Holly assured him there could be no mistaking its dogness by adding a balloon reading "RFF." So that

her dog would resemble B.'s, Lindsey then added a curlicue, like Holly's "RFF," coming from the mouth of her dog.

At this point, Lindsey's friend Jonathan came in, joined the group at the table, and obligingly began to draw. As B. urged Holly to be "silly" as she drew, Jonathan declared that he would make a silly drawing. (8-11)

Although Holly seemed to be enjoying her participation in the drawing, it wasn't until some time later that things began to happen, but happen they did, and in rapid succession. Birds appeared, escaped from cages, and flew into the air carrying baskets. The baskets sprouted snakes (this was Holly's inspired addition); a snake crawled up and bit a bird; the bird dropped the basket of snakes; one snake slithered into the house and bit the

boy standing at the table; the boy jumped, ran across the table and out the door, and came face to face with a spaceship complete with Martian.

It is necessary, though difficult, to keep track of what was happening on both sides of the table because the conversation and interaction were to influence each of the three drawings. Jonathan talked incessantly, explaining his drawing and his markings, which were surely more kinesthetic than graphic. (Jonathan's drawing quickly became a mass of lines laid one on top of another.) The staccato beat of his pencil and his chatter, however, added an infectious note of excitement to the proceedings. His animated questions, such as, "What's happening to the snakes?" also triggered some more imaginative responses from Holly;

or he could be heard arguing with Lindsey about the merits of a snake's biting somebody.

"They should!" said Jonathan.

"They shouldn't, Jonathan," admonished Lindsey.

We believe, also, that it was Jonathan's enthusiasm about the "flying saw-saw" that had appeared in Holly's and B.'s drawing and his stated determination to add Martians to his own drawing that caused the appearance of Holly's Martian.

Ideas bounced from one side of the table to the other and fed three separate drawings. The flying saucer had inspired Jonathan to invent Martians, and Holly absorbed the idea from him. Jonathan, in turn, wanted a "flying saw-saw" in his drawing, and as the Martian idea bounced back to him when he saw Holly's man from Mars, he began to chant (because Jonathan's ability to fantasize outdistances his drawing skills, there was little on the paper that was recognizably Martian-like), "There's his nose; there's his mouth!" Lindsey joined in, "I'm going to make a Martian," thus completing the cycle.

The electric mood that sparked the completion of this story is best conveyed by presenting the dialogue exactly as it occurred.

Jonathan is still talking excitedly about his Martian who, he now says, "has no nose."

B. continues to narrate, as he has done throughout the session in order to keep the story going, "This gets more and more complicated; the Martian has

fallen [after having leaped through the air]—what's he fallen on?"

Holly is now primed to expect bizarre situations and is completely involved in the action. She answers brightly, "A snake."

B. asks, "And what does a Martian do when it's fallen on a snake?"

Jonathan pipes up, "It gets bitted!"

The snake makes a truly enormous leap.

"Oh, what a picture!" Lindsey marvels. She has abandoned her own drawing and is now intently watching the drawing activity of Holly and B.

B. continues, "And the poor Martian that was on it?"

Jonathan (gleefully), "Got bit!"

B., "He really didn't."

Jonathan (determined), "He should've!"

B. goes on, "He was flying in the air, up into the smoke. He still has an unhappy look on his face—as you can imagine."

Holly interrupts, "He has a bump on his head." This is a detail she had added earlier and she wants to be sure that B. does not leave it out.

Lindsey (eagerly), "He got bitten."

B. says, "So there he is flying away from the snakes . . . "

Jonathan is explaining that the Martian in his picture was bitten by a snake (if no one else would oblige).

And then B.'s Martian "says he's so terribly tired, finds a bed and, closing his eyes, goes to sleep. Shall we have

that be the end?"

Holly agrees.

"The Lion and the Bats"

The story of Holly's house had ended but the excitement lingered on. Another story was begun immediately. This time the plan was that Holly, Lindsey, and B., at least, would draw together. Jonathan, unsure of his drawing abilities, declined to join in at first but, as we shall see, was finally enticed by his own curiosity and imagination to participate in the adventure unfolding on the paper across the table.

It was another example of the residual effect of "Holly's House" that the drawing that Jonathan began on his own started with a bird carrying snakes in a basket. Jonathan says that his "bird is going to be in trouble—this is a copperhead snake and he's going to bite him." He is still determined that somebody will be bitten by a snake one way or another.

Jonathan makes a biting sound. "Oh, poor, poor bird." It is hard to concentrate on one's own story with Jonathan being so insistently vocal. "Supersnake to the rescue!" he shouts, and then, as the snakes attack the house, "Charge!"

"The Lion and the Bats," drawn by Holly, Lindsey, and B., also contained suggestions of the earlier effort. (8-8) Lindsey began by drawing a house. Holly's first suggestion that a snake lived there, however, was gently sidestepped. The birdcage that Holly had invented for the earlier production

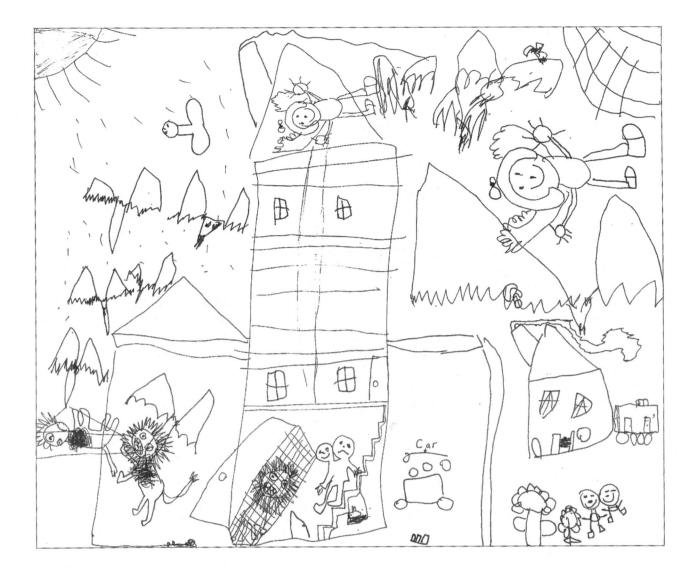

was enlarged for the lion she had just drawn. She perhaps was certain that B. would free the lion as he had the bird (he did). And it is here that Jonathan was lured into taking part in the story; after all, there had already been a snake story and what imaginative five-year-old could resist a runaway lion? By this time Jonathan was intently examining the situation and already had the solution to the problem—a bat would swoop down and bite the lion. Of course! "I'm going to draw a bat!" Jonathan began to draw a wing and was sur-

prised and pleased with the result—his other drawings, as we have noted, had been very complex scribbles with few recognizable elements. "Hey, I drawed a good wing." He is encouraged by praise from all. "It's the best wing you've ever made!" Holly marvels.

He continues to draw. "He has a spear [it is actually a large front tooth . . . sound effects]—he's going to kill the lion." Truly encouraged by this time, Jonathan draws another bat swooping down on the lion—and still another, "good bats because the lion is

Figure 8-11

Holly (age 8), Lindsey (age 5), Jonathan (age 5), and B., an adult
Bats (colored marker)
13½" × 17"

bad . . . sharp teeth." He is really wound up now. He counts, "One, two, three, four, five—five bats."

B. determines that, in spite of the digressions, something has to be done about the poor lion: "Is he dead or is he just wounded?"

"He's wounded bad," Jonathan replies.

"I'm sorry." B. says that is what the bats say to the lion (who wasn't a bad sort after all).

"They just wanted to keep him quiet," Jonathan pipes in.

B. says that the bats will carry him away to the hospital.

"There's lots of bats," Jonathan says (enough to carry the lion). Jonathan is making baby bats now, all sizes of bats. "I'll count the bats—four, five, six, seven, eight, nine bats."

B. counts ten bats.

Holly thinks there are eleven but counts again. There are ten.

Lindsey adds a fire to the hospital, "just to keep him warm."

"OK," says B. "Let's decide. Does the lion get better?"

All agree, and the story ends on a happy note.

There are several important aspects of the drawing conversation, but "the ten bats of Jonathan" is of special interest. Jonathan was a bright, imaginative, and energetic five-year-old. His ability to tell stories and to fantasize was great, but Jonathan did not customarily draw. His mother revealed that, although his older sister Amy drew continu-

ally, Jonathan generally refused to participate in any drawing activity. It then becomes significant that he consented to draw with us, became caught up in the excitement, and on his own, produced ten bats.

Let's examine the circumstances of his bat production. Jonathan had come to play with Lindsey and found her and Holly drawing at the table with a couple of unfamiliar adults. They all seemed to be enjoying themselves so when he was invited to join in he accepted. He readily became part of the group; his first declaration as he prepared to draw was, "I'll make a silly one [drawing]," and he found the making fun. As we have noted, Jonathan's participation was at first more verbal than pictorial; he was timid about drawing and often asked for help. When he was drawing his bird (the one carrying a basket of snakes) he enlisted B.'s aid and B. patiently drew for him, "like a circle, and then another circle on the head, and then a big beak and an eye—and then they have wings like that and other wings down there and sometimes they have feet going down below the wings." A short time later he was drawing "eight, nine [ten] bats."

Perhaps Jonathan's drawing ability would eventually catch up to his ability to narrate, to fantasize, to verbalize. It might catch up quickly and he may develop a more positive attitude toward his own drawings, given the open accept-

ance of his limited ability in the drawing dialogues—encouragement such as Holly's "It's the best wing you've ever made!"—and B.'s demonstrations of simple ways for him to give form to his more complex fantasies.

It is important to note again that it was also the excitement of the interaction in the drawing session that inspired Jonathan's participation, the way ideas bounced across the table and found their way into all of the drawings produced that afternoon. The first idea, that a drawing could tell a story, seemed natural to Jonathan, but Holly and Lindsey were also intrigued by the notion. (And we know that Holly continued to draw "silly" stories with her friend Amy after we had left.) Snakes and Martians ricocheted from drawing to drawing, and the bullets with which Jonathan was bombarding his "flying saw-saw" became, for Lindsey, a pattern of small circles with interconnecting lines on the side of her paper. Lindsey's ability to reproduce almost anything she saw drawn proved extraordinary. And Jonathan's enthusiasm and imagination certainly added to the excitement of each drawing; if he was not contributing a part of the drawn story then he was animating the story verbally. Surely, the most enjoyable kind of learning was shared by all that afternoon.

Worldmaking

As we have said, one way the child develops his ideas about the four realities is through the creation of a coherent world, or at least a fair portion of a world. Such worlds sometimes take the form of a map; sometimes a panorama or terrain reveals the existence of worlds above the ground or worlds below, and frequently both at once.

The conversation of the Worldmaking game may be quite different in tone from that of the Getting Into and Getting Out of Difficulty game. In the Difficulty game, one participant waits while the other either makes a move or counters one. The waiting is essential. In Worldmaking, the drawing by two or more participants usually occurs simultaneously, although it is by no means a matter of everyone for himself. There is a continual consultation about what goes next to what, where things ought to be attached, the form things should take, and what happens and what happens next.

Many of the dialogues we suggest derive from the self-initiated drawings of children. In these drawings we have seen elaborate machines (like those of Andy shown in Chapter 2 in figures 2-15 to 2-17) shown in the process of manufacturing such things as ink, automobiles, and human body parts ready for assembly as bionic people. Whenever possible it is advantageous to begin a dialogue with the ideas commonly used by children in self-initiated fantasy games. A "machine making" dialogue might begin with a short discussion of "what should we make?" and once something is decided upon then "what kind of machine would it take to make it?" It's also possible just to begin with a machine, because machines themselves sometimes "tell" their creators what sorts of things they might make. This is precisely what happened in a dialogue held between six-year-old David and B shown in Figure 8-12.

"The Solar-Powered System"

This drawing conversation had three participants: two ten-year-old boys, Sam and Bobby, and B., an adult. Earlier, Sam's mother had shown us a drawing by Sam and Bobby that appeared to be an X-ray view of the prow of a huge aircraft carrier with compartment upon compartment for sleeping, with tunnels and airshafts. Sam and Bobby corrected us, however, explaining that it was actually the inside of a mountain. And so the contour of a mountain was the starting place for "the solar-powered system." B. started by drawing hilly contours near the top of the page to assure that much of the world would appear underground. Sam's line, continuing on the second half of the paper, described a deep ravine climbing to a steep cliff, assuring for his part that the world would appear above the ground as well.

As with most worlds, the world that developed is far too complex to be described easily. The idea for a world with solar power was Sam's. "You know how there is an energy crisis and all? Let's say this thing is solar powered." But it was Bobby who was responsible for most of the solar power collectors, underground power substations, power lines and transformers, and vehicles whizzing through tunnels. Sam specialized in rocket ships, their elaborately detailed interiors, and cavernous underground warehouses for storing rocket parts. B. was the gadfly, adding elevators to Bobby's substations, helping Sam with some of his rocket-ship components, and spending a lot of time on the distant city seen floating in midair on the left-hand side of the drawing.

The world took on highly realistic characteristics, and an implicit logic controlled its structure. It was Sam who decided that this was to be a working place and that people were to return to the city for sleeping purposes, but since they did need to eat, underground caverns for growing food as well as restaurants were created. An air of seriousness characterized this drawing session, until at the very end, when people began falling down shafts and then had to climb all the way back to the top. (8-9A–L)

What are some of the things we learned from the conversation? There was a considerable amount of sharing of technical drawing information. Sam had already learned from Bobby how to depict things in three-dimensional form. Here, Sam and Bobby both learned that in drawings, tunnels, shafts, and power lines can pass in front of and

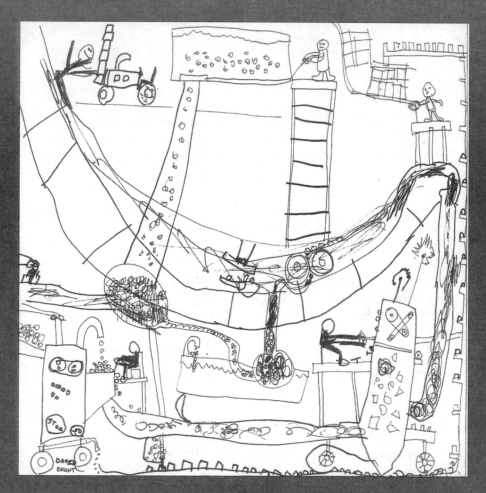

Figure 8-12

David (age 5) and B., an adult
The Peanut Butter Machine (colored
marker)
12″ × 12″

David sat as we talked about machines and described a hay baler we had seen, a machine that picks up cut hay, bales it and ejects the bales through a chute to a trailer in the rear. This was a new game to him but he entered into it with as much enthusiasm and invention as he had the games of pure action which David and B. had drawn together earlier.

B. suggested wheels and David immediately drew a box with wheels and added two flywheels with a pulley to the box (indicating that he understood the nature of machines).

B. drew a pipe from which small pellets dropped into a bin. In response David quickly extended the pipe from beneath the bin and carried it to another box-shaped area and on up the side of the page and back across the middle with a sweep to the upper left-hand corner, just

above his starting point. He then proceeded to add the pellets going through his length of pipe (and might have continued filling the page except that B. decided that he wanted his turn).B.'s controls were drawn on the second box-like part that David had constructed and then more controls cropped up in other spots, while David obligingly added the men to handle the controls.

At this point B. stopped and asked, "What are we making?" David thought (but not for long), picked up on the pellet shapes, and said, "They could be nuts"—and quickly, "We could be making peanut butter."

From there the machine took off almost on its own, David and B. working together to smash the peanuts—B.'s smasher, a wheat-grinding mechanism with grinding wheels, David's a device that resembled

two plates that come together like cymbals. Salt and sugar were added through additional devices. The finished peanut butter was poured into jars that traveled on a conveyor belt across the bottom of the page, up the right-hand side, and across the top to a machine that placed the jars into boxes and finally loaded them onto a truck (David pictured a sort of forklift for this part of the operation).

Dialogues of this sort provide particularly rich opportunities for problem-solving because of the requirement to invent machine parts that could conceivably perform a particular process or that could convey a product from one section of the machine to another. Machine making is also an excellent means for developing ideas about cause and effect and processes.

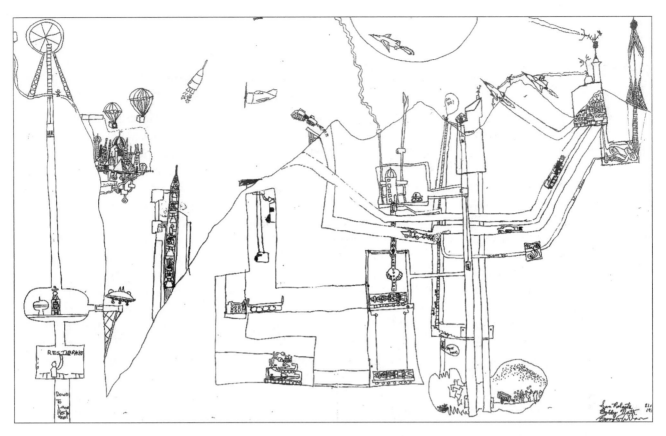

Figure 8-13

Sam (age 10), Bobby N. (age 10), and B., an adult
The Solar-Powered System (colored marker and pen)
17″ × 27″

behind one another. They had previously thought of drawings as one-dimensional and that an object, once encountered, could only be circumvented. So Bobby was disturbed when he discovered an elevator shaft in the path of his power lines. Only when B. reminded him that the lines could go behind the shaft did he happily go back to drawing. B. learned from Bobby how to draw jets in a contemporary way and watched as Sam reproduced almost exactly the World War II planes that B. had drawn when he was Sam's and Bobby's age. "My father used to draw those real kookie planes." When the boys asked B., "Where did you learn to draw that [the city]?" B. explained that he had remembered the illustrations drawn by the Austrian artist Schmögner for a book called *The City*.[3] So Sam and Bobby learned, too, that it is acceptable to borrow ideas.

In the drawing of *Holly's House and the Things That Happened Around It*, we described how Martians and flying saucers flew from one drawing to another; in another session it was fleets of ships and aircraft drawn in a particular way that traversed the two drawings. Just as ideas feed other ideas, drawings feed other drawings, adding layers of richness to one drawing after another. It is these things that make drawing dialogues with children so important to their drawing development. Where do the ideas for graphic dialogues come from? There are as many ideas for dialogues as there are children who draw. It is important only that the participants share ideas and agree on the rules. Remember that whatever can be imagined—the more extreme the better—can serve as the subject for a graphic narrative.

Final Thoughts about Graphic Dialogues and Conversations

We have many more graphic dialogues and conversations we could share. With some children we have drawn stories from before they were in preschool until they graduated from high school. With other children, we have had only a single opportunity to draw. We have drawn with children who spoke only Arabic, Dutch, or Japanese while we spoke only English. Nevertheless, we communicated readily through images. (And with the names of objects being identified as we drew, our knowledge of the children's native language vocabulary increased.) Moreover, there isn't a single child with whom we have drawn from whom we haven't learned something—usually a lot. By drawing with children we have gained a deepened respect for the intricacy, subtlety, and imagination of young minds.

The drawing conversations in this chapter help to illustrate most of what this book has been about:

- Children learn to draw more skillfully through practice.
- Children can learn to draw images that are more varied and exciting and stimulating by adapting and recombining images modeled after those of others.
- Drawings can tell complex stories—what happens and what happens next.
- Drawings can be "real" or fanciful; one's imagination often leads to new and exciting insights and ideas.
- Drawings can deal with major life themes and the four realities: the *common*—the reality that we all share in common; the *archeological*—the reality of the self; the *normative*—the reality of right and wrong; and the *prophetic*—what will be? What may the future reality hold?
- Entire worlds can be envisioned and created on a single sheet of paper.

The Role of the Art Teacher

We wish that virtually every parent would engage in graphic dialogues and conversations with his or her children. Parents, if they wish, can find dozens of opportunities for drawing with their children in the course of a single week. But what about the teacher—especially the art teacher? Can the interactive drawing dialogue be used by an elementary school teacher who may have thirty children in a classroom and teach as many as 600 children a week? Teachers can learn a lot about an individual child and about that child's drawing and narrating abilities through a one-on-one interaction, but we are aware that such activity probably cannot take place in the busy classroom. Before- or after-school sessions with a few highly interested children could prove a worthwhile pursuit, however. And there *is* a place in the classroom for the drawing dialogue between child and child, and it is important to provide the opportunity for this interaction. In fact, our own ideas about the drawing dialogue were reinforced while watching two boys in an art classroom (subsequently joined by an adult and other interested onlookers) as they created a marvelous *Star Wars* battle using straight edges, colored pencils, and numerous sheets of large white drawing paper taped together as the action required.

Once children have seen the possibilities for this type of dialogue, teachers can pair them off in the classroom as part of the ongoing learning experience or encourage them to engage in this activity spontaneously. One art teacher from Orlando, Florida, who learned about drawing dialogues in a workshop we gave, recently told us that her students engaged in drawing dialogues in her art classroom, and they did so with such enthusiasm that they would hurry to pair off for dialogues when their other work was completed. She recently moved to a new school where she immediately introduced the graphic dialogue with the same enthusiastic response.

The drawing dialogue occurs spontaneously, and because it does, it is a natural and easy model for children to follow. With encourage-

ment and stage-setting from adults, it can become a regular part of in-school as well as out-of-school activities for children. As a result of such interaction, children will develop greater drawing skill through practice and what they can teach one another. And, even more impor-tantly, children will create even richer models of reality and of the world, the very purpose for which most of their drawings are made.

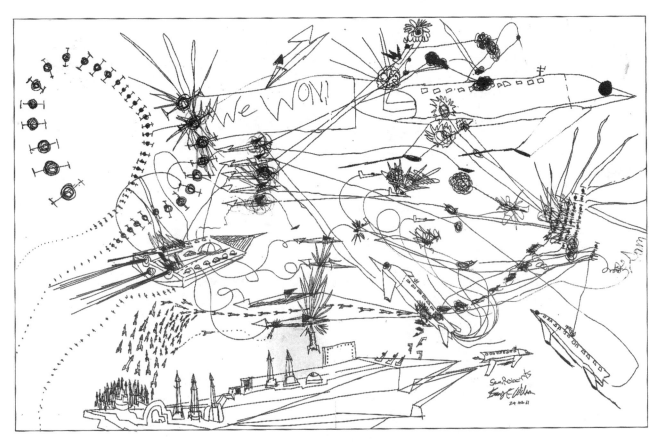

Figure 8-14

Sam (age 10) and B., an adult
Just Space (colored marker and pen)
17" × 27"

We started our discussion of communal drawing with a description of the air battles of World War II recreated on the blackboards of Fairview Grade School. Expanses of space, represented by clean sheets of paper—freeing the young graphic artist from the necessity of anchoring objects to the ground—provide nearly irresistible invitations to create *Star Wars*. "Just Space" shows one of the dozens of space battles in which we have participated.

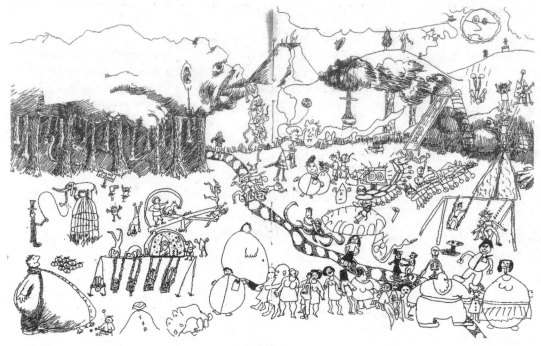

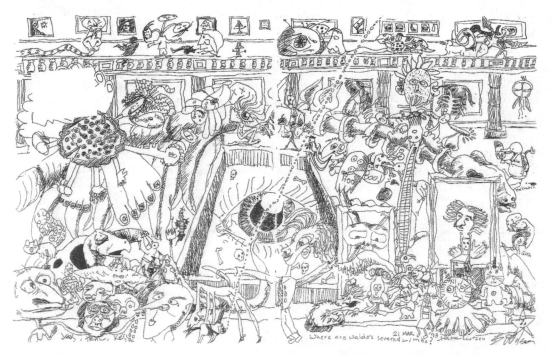

Figure 8-15

Dane (15), Jens (12), Teal (10), Kess (7), and B., an adult
The Playground (various ball-point and fountain pens)
10" x 16"

The playground is filled with characters, many of whom went off their diets years ago. They are joined by a variety of space creatures, circus performers, and insects. More ominous, however, are the huge creatures in the background who lurk in the tops of trees and hide behind slides.

Figure 8-16

Dane (16), Jens (13), Teal (11), Kess (8), and B., an adult
The Natural History Museum (various ball-point and fountain pens)
10" x 16"

Made a year after the "Playground," the "Natural History Museum" drawing has the subtitle "Where are Waldo's Severed Limbs?" The action centers around an excavation pit in which a huge eye has been unearthed, and the rest of the action hangs on the neck and body of a dinosaur. Overgrown human feet and a pizza cover a considerable portion of the dinosaur's body. The balcony hold an exhibit of "modern art."

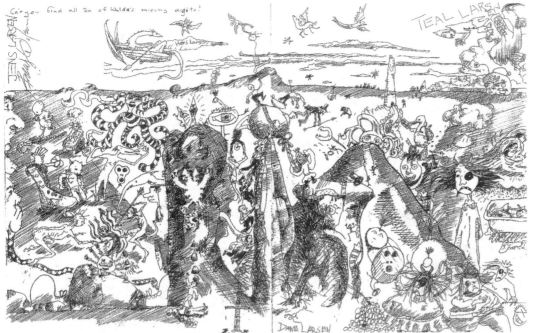

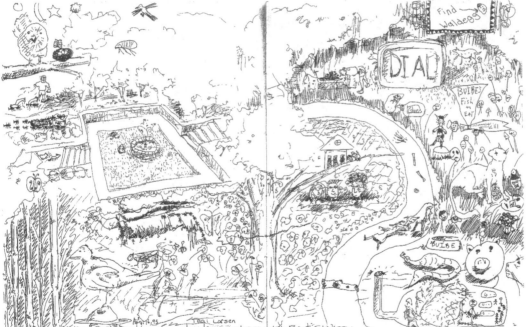

Figure 8-17

Dane (16), Jens (13), Teal (11), Kess (8), and B., an adult
Another Kind of National Park (various ball-point and fountain pens)
10" x 16"

Made just two months after the "Play-ground" (1-14), the National Park has nat-ural rock formations as its central fea-tures. The challenge is "to find all ten of Waldo's missing digits."

Figure 8-18

Dane (18), Jens (116), Teal (14), Kess (11), and B., an adult
The Botanical Garden (various ball-point and fountain pens)
10" x 16"

The Dallas botanical garden, which is located near the artists' home, is the set-ting for this "place" drawing. Much of the terrain was established by Dane before the others began drawing. Kess provided the challenge: "to find 'Waldegg'." There may be more than one—or, perhaps, lots of impostors. One has to look closely to find a Gulliver character asleep just below the fountain court. When are all those ants going to start to bite Gulliver?

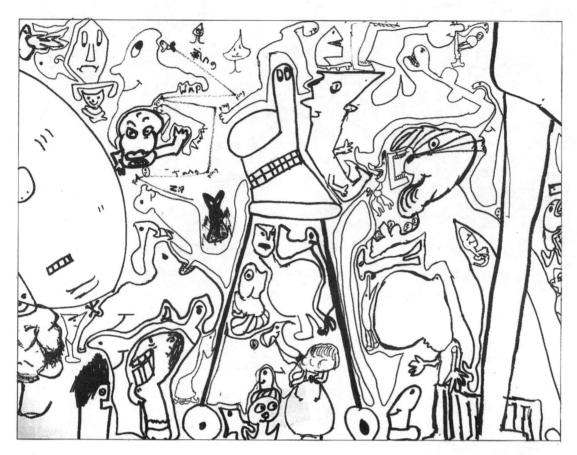

Figure 8-19

Jeff and Chris (grade 5)
Scroll (black marker)
18″ × 25′

This is only one small segment of a 25-foot scroll produced in one evening by two fifth-grade boys working side by side. Their fantastic world of humorous creatures plays with shapes and spaces between shapes as they continuously stretch, compress, and combine both ideas and images. Since both are at the same level of drawing development, growth occurs through the challenges presented through the continual interplay of images.

Notes

Chapter One

1. The "collective monologue" was characterized by Piaget as a monologue during which another person is present but expected neither to attend to nor understand what is being said. Howard Gruber and J. Jacques Voneche, *The Essential Piaget* (New York: Basic Books, 1977), pp. 69, 70.

2. On Picasso's acquisition through drawing, see John Berger, *The Success and Failure of Picasso* (Harmondsworth, Middlesex, Eng.: Penguin Books, 1965), p. 3.

3. We have talked about Kelly and Michael L. in Brent Wilson and Marjorie Wilson, "Visual Narrative and the Artistically Gifted," *The Gifted Child Quarterly* 20, no. 4 (Winter 1976): 432–47; and in "Children's Story Drawings: Reinventing Worlds," *School Arts* 78, no. 8 (April 1979): 6–11. We have also written more about Kelly's drawings in "An Iconoclastic View of the Imagery Sources in the Drawings of Young People," *Art Education* 30, no. 1 (Jan. 1977): 5–12.

4. The Boston reminiscences are those of Marjorie Wilson.

5. C. S. Lewis's descriptions of his early drawing activities are found in C. S. Lewis, *Surprised by Joy* (New York: Harcourt, Brace and World, 1955).

6. On Nadia, see Lorna Selfe, *Nadia: A Case of Extraordinary Drawing Ability in an Autistic Child* (London: Academic Press, 1977).

7. On one such accumulation of a child's prized drawings, see Sylvia Fein, *Heidi's Horse* (Pleasant Hill, Calif.: Exelrod Press, 1976).

8. See Maurice Sendak, *Where the Wild Things Are* (New York: Harper & Row, 1963).

9. Maurice Sendak speaks of his fantasy life in Justin Wintle and Emma Fisher, *The Pied Pipers: Interviews with the Influential Creators of Children's Literature* (London: Paddlington Press, 1974), p. 223.

Chapter Two

1. A description of Dirk's "Mr. And and the Change Bugs" is found in our "Children's Story Drawings."

2. Hans and Shulamith Kreitler fully explore the four realities in Chapter 15, "Cognitive Orientation and Art," in *Psychology of the Arts* (Durham, N.C.: Duke University Press, 1972), pp. 325–58.

3. Piaget's statement is from "Some Aspects of Operations," in Maria W. Piers, ed. *Play and Development* (New York: Norton, 1972), p. 27.

4. Erik Erikson's theories of play are set forth in *Toys and Reasons* (New York: Norton, 1977), p. 44.

5. Erikson speaks of ideal and evil roles in *Toys and Reasons*, p. 101.

6. Robert Ornstein presents this idea about the role of stories in his introduction to Idries Shah's writing on "The Sufis," in *The Nature of Human Consciousness* (San Francisco: W. H. Freeman, 1973), p. 274.

7. The Wilsons have written about Tami in "Reinventing Worlds."

8. Ornstein, *The Nature of Human Consciousness*, p. 274.

9. Mercer Mayer, *There's a Nightmare in My Closet* (New York: Dial, 1968).

Chapter Three

1. An account of Franz Cizek's discovery of child art is given by Wilhelm Viola, *Child Art and Franz Cizek* (Vienna: Austrian Junior Red Cross, 1936).

2. On uninfluenced tadpole figures, see Dale B. Harris, "The Case Method in Art Education," in *Observation*, a report on a preconference education research training program for descriptive research in art education. National Art Education Association (Jan. 1971): 29–49.

3. The tadpole person is discussed by Rudolf Arnheim in *Art and Visual Perception: The New Version* (Berkeley: University of California Press, 1974), ch. 4.

4. The innatist position is perhaps best exemplified by Rhoda Kellogg, *Analyzing Children's Art* (Palo Alto, Calif.: Mayfield Publishing Co., 1970).

5. Viktor Lowenfeld declared, "Never let a child copy anything. . . . Don't impose your own images on a child." *Creative and Mental Growth*, 3rd ed. (New York: Macmillan, 1957), pp. 14–15.

6. Breyne Moskowitz discusses the child's process of language acquisition in "The Acquisition of Language," *Scientific American* 239, no. 5 (Nov. 1978): 92–108.

7. Even in Rhoda Kellogg's samples of cross-cultural drawings in which she purports to be illustrating the universal nature of children's drawings, it is possible to see distinct cultural differences. See the inside front cover of *Analyzing Children's Art*.

8. On what we have chosen to name the *simplicity principle*, see Arnheim, *Art and Visual Perception*, pp. 179–82.

9. Figures 3-1, 3-2, 3-4–3-6, 3-8–3-18, 3-20–3-26, 3-28–3-35, 3-37–3-39, and 3-42 have either been traced or drawn from original drawings of young children.

10. On perpendicularity, see Jean Piaget and Bärbel Inhelder, *The Child's Conception of Space* (London: Routledge & Kegan Paul, 1956), ch. 13. Henry Schaefer-Simmern writers of the greatest contrast of the direction of lines in *The Unfolding of Artistic Activity* (Berkeley: University of California Press, 1948), p. 13.

11. On "To Each Its Own Space," see Jacqueline Goodnow, *Children Drawing* (Cambridge, Mass.: Harvard University Press, 1977), pp. 11, 34.

12. For illustrations and discussion on filling the format, see Fein, *Heidi's Horse*, pp. 25–28. Also, Goodnow, *Children Drawing*, p. 58.

13. Picasso's painting *Three Dancers* is reproduced in H. W. Janson, *History of Art* (Englewood Cliffs, N.J.: Prentice-Hall, 1963), colorplate 75.

14. On conservation and multiple application, see Goodnow, *Children Drawing*, p. 141, and Arnheim, *Art and Visual Perception*, p. 177.

15. On intellectual realism, see G. H. Luquet, *Le Dessin Enfantin* (Paris: Alcan, 1927).

16. For Lowenfeld's views on "disproportion," see *Creative and Mental Growth*, pp. 135–38.

17. On the importance of the interaction between mother and baby in the acquisition of language, see Jerome Bruner, "Learning the Mother Tongue," *Human Nature* 1, no. 9 (Sept. 1978): 42–49.

18. Kellogg has catalogued children's scribbles extensively in *Analyzing Children's Art*. Claire Golomb's work with children's scribble behaviors is more insightful: *Young Children's Sculpture and Drawing* (Cambridge, Mass.: Harvard University Press, 1974).

19. On romancing, see Golomb, *Young Children's Sculpture*, p. 4.

20. Golomb notes that Rhoda Kellogg's own tabulation of preschool incidence of mandala and sun schema reports only 1.6 to 9.6 percent for the mandala "and an even more limited range of 2–4 percent for the sun-schema." In "Representation and Reality: The Origins and Determinants of Young Children's Drawings," paper presented at the Symposium for Research in Art, Representation and Metaphor: University of Illinois, Urbana-Champaign, October 1980.

21. On global man, see Golomb, *Young Children's Sculpture*, pp. 14–24.

22. On Freeman's research, see "How Young Children Try to Plan Drawings," George Butterworth, *The Child's Representation of the World* (New York and London: Plenum Press, 1977), pp. 3–29.

23. On developing a body between the two parallel lines of the legs, see Golomb, *Young Children's Sculpture*, p. 40.

24. On the all-embracing line, see Goodnow, *Children Drawing*, p. 37.

Chapter Four

1. We are indebted to June McFee for first making us aware of the role of culture in children's art. McFee, June King. *Preparation for Art*. San Francisco: Wadsworth, 1961.

2. On the two-eyed profile, see Marjorie Wilson and Brent Wilson, "The Case of the Disappearing Two-Eyed Profile: Or How Little Children Influence the Drawings of Little Children." Proceedings of the National Symposium for Research, University of Illinois, Urbana-Champaign, October 1980.

3. Figures in 4-1, 4-6, and 4-7 have been either traced or redrawn from the original.

4. For an account and reproductions of Picasso's early drawings, see Juan-Eduardo Cirlot, *Picasso: Birth of a Genius* (New York and Washington: Praeger, 1972).

5. On Beardsley's early drawing activity, see Brigid Brophy, *Beardsley and His World* (New York: Harmony Books, 1976), p. 29.

6. On the early art activities of Millais, see Raymond Watkinson, *Pre-Raphaelite Art and Design* (Greenwich, Conn.: New York Graphic Society, 1970), p. 44.

7. Maurice Sendak speaks of his early influences in Jonathan Cott, *Forever Young* (New York: Random House, 1977), p. 195.

8. On the running-person exercise, see *Design and Drawing Skills*, Denver, Col.: National Assessment of Educational Progress (June 1977), ch. 4.

9. On Burne Hogarth's fantastic figure drawings, see Hogarth, *Dynamic Figure Drawing* (New York: Watson-Guptill Publications, 1970).

10. For more about the inventions of John Scott, see Brent Wilson and Marjorie Wilson, "Beyond Marvelous: Conventions and Inventions in John Scott's *Gemini*," *School Arts* 80, no. 2 (Oct. 1980): 20–26.

11. Iona and Peter Opie, editors. *The Lore and Language of Schoolchildren* (Oxford University Press, 1959)

12. Lowenfeld made his declaration in the first edition of *Creative and Mental Growth* (New York: The Macmillan Company, 1947), p. 1.

13. David Sudnow wrote this melodic description of improvisation in *Ways of the Hand: The Organization of Improvised Conduct* (Cambridge, Massachusetts: Harvard University Press, 1978), p. 60.

Chapter Five

1. On Picasso's pigeons and persons, see Cirlot, *Birth of a Genius*, 13: pp. 197–205.

2. On Anthony, see the Wilsons' "Iconoclastic View" and "Artistic Giftedness" and Howard Gardner, *Artful Scribbles* (New York: Basic Books, 1980), pp. 170, 171.

3. On Picasso's sketches for *Guernica*, see Rudolf Arnheim, *Picasso's Guernica: The Genesis of Painting* (Berkeley & Los Angeles: University of California Press, 1962).

4. Claire Golomb found that when scribblers were given a specific task they were able to draw more regular scribbles: "Representation and Reality."

5. David Hockney has illustrated this theme from Rumpelstiltskin in four frames in *Six Fairy Tales from the Brothers Grimm* (Petersburg Press, 1969); (New York: Abrams, 1976).

6. For a comparison of paintings of storms at sea by Winslow Homer and John Marin, see John Canady, *Mainstreams of Modern Art* (New York: Simon and Schuster, 1959), pp. 444, 445.

7. J. M. W. Turner's most dramatic images are of shipwrecks, fires and storms at sea, e.g., *The Fighting Temeraire Tugged to Her Last Berth to Be Broken Up* in the National Gallery, London; *The Burning of the Houses of Lords and Commons* in the collection of the Philadelphia Museum of Art, Philadelphia.

8. Andrew Wyeth's *Christina's World* (1948), is one of the most well-known images in 20th century American art. It is in the collection of the Museum of Modern Art in New York City.

9. On "Fog," see Carl Sandburg, *Chicago Poems* (New York: Holt, 1916).

10. One of Vachel Lindsay's best known poems, "Congo" produces the atmosphere of the jungle through sound:
Whirl ye the deadly voo-doo rattle,
Harry the uplands,
Steal all the cattle,
Rattle-rattle, rattle-rattle,
Bing.
Boomlay, boomlay, boomlay, Boom. . . (lines 21-26)

11. The *Great Wave off Kanagawa* can be seen in Hokusai (Prague: Artia), p. 108.

12. In foot/endnotes 11-16, I don't think it is necessary to have complete citations with full author name and publication information. We need only say that all of these references can be found in any standard art history text.

13. Boccioni's *The City Rises* is seen in Arnason, *History of Modern Art*, colorplate 87.

14. On some animation techniques see, e.g., Yvonne Andersen, *Make Your Own Animated Movies* (Boston: Little, Brown, 1970). See also Eadweard Muybridge, *The Human Figure in Motion* (New York: Dover, 1955) and *Animals in Motion* (New York: Dover, 1957).

15. Wilson, B., Hurwitz, A., & Wilson, M. (1987) *Teaching Drawing from Art.* Worcester, MA: Davis.

Chapter Six

1. Brian Sutton-Smith explains the two-year-old's story as an acquisition of the terminal (beginning and end) markers in "A Sociolinguistic Approach to Ludic Action," *Handlugentheorien Interdisziplinar,* ed. Hans Lenk (Karlsruhe: Universität Karlsruhe, 1977), pp. 239–50.

2. On story takers, see Brian Sutton-Smith, *Folkstories of Children* (Philadelphia: University of Pennsylvania Press, 1980).

3. On visual narrative, see Brent Wilson and Marjorie Wilson, *Reinventing Worlds, School Arts* 78, no. 8 (April 1979): 6–11.

4. On Bruno Bettelheim's view of fairy tales, see *The Uses of Enchantment* (New York: Alfred A. Knopf, 1975).

5. Brian Sutton-Smith's characterization of children's verbal stories appears in *Folkstories.*

6. On the singer of tales, see Albert B. Lord, *Singer of Tales* (New York: Atheneum, 1976).

7. On the mythology of ads, see Pierre Miranda's introduction to *Mythology,* ed. Pierre Miranda (Harmondsworth, Middlesex, Eng.: Penguin Books Ltd., 1972), pp. 7–18.

8. On the dyads of villainy/villainy nullified and lack/lack liquidated, see Vladimir Propp, *The Morphology of the Folktale* (Austin and London: University of Texas Press, 1977).

9. Herman Hesse's story "The City" is found in Hesse, *Stories of Five Decades,* trans. R. Manheim and D. Lindley (Toronto and New York: Bantam, 1974), p. 193.

10. These narrative instructions have been used by the Wilsons to collect stories from children in the United States and countries around the world—Australia, Egypt, Finland, and New Guinea. Stories have also been collected from Japan, Taiwan, Jordan, and Nigeria. The collection is now in the Penn State library.

Chapter Seven

1. On Jerome Singer's fantasy experiences, see *The Inner World of Daydreaming* (New York: Harper & Row, 1975), p. 18.

2. On imaginative as opposed to unimaginative children, see Dorothy Singer and Jerome L. Singer, *Partners in Play: A Step-by-Step Guide to Imaginative Play in Children* (New York: Harper & Row, 1977) also in Brian Sutton-Smith, ed., *Play and Learning* (New York: Gardner, 1979).

3. On children's imagination and imagination games, see Richard de Mille, *Put Your Mother on the Ceiling* (New York: Penguin Books, 1976).

4. On Leonardo's imaginary animal, see Pamela Taylor, *The Notebooks of Leonardo da Vinci* (New York: New American Library of World Literature, 1960), p. 63.

5. On the mythical world called Middle Earth, see J. R. R. Tolkien, *The Lord of the Rings* (New York: Ballantine Books, 1978).

6. On the mythical land of Narnia, see C. S. Lewis, *Chronicles of Narnia* (New York: Collier Books, 1977).

Chapter Eight

1. See Bruner, "Learning the Mother Tongue."
2. The story of the boy who learned to communicate using *Amislan* was related by Moskowitz in "The Acquisition of Language."

3. Brent Wilson's version of the city derived from Walter Schmögner's pictorial version of *Die Stadt* by Herman Hesse (Frankfurt: Insel Verlag, 1977).

Selected Bibliography

The approaches to interacting with children as they draw that we present in this book are based on inquiry we have conducted and pedagogy we have practiced over the course of nearly four decades. Here are some of our publications in which we first presented the ideas found in this new edition of *Teaching Children to Draw*.

Wilson, B. (1974). The superheroes of J. C. Holtz plus an outline of a theory of child art. *Art Education, 16*(1), pp. 2–9.

Wilson, B. (1976). Little Julian's impure drawings. *Studies in Art Education, 17*(2), pp. 45–62.

Wilson, B. (1997). Types of child art and alternative developmental accounts: Interpreting the interpreters. *Human development, 40*(3), pp. 155–168.

Wilson, B. (1999). Becoming Japanese: *Manga*, Children's Drawings, and the Construction of National Character. *Visual Arts Research*, Vol. 25, No. 2 (Issue 50), pp. 48–60.

Wilson, B. (1999). Becoming Japanese: *Manga*, Children's Drawings, and the Construction of National Character. *Visual Arts Research*, Vol. 25, No. 2 (Issue 50), pp. 48–60.

Wilson, B. (2003). Three sites for visual cultural pedagogy: Honoring students' images and imagery. *The International Journal of Arts Education 1*(3), pp. 107–126.

Wilson, B. (2005). More lessons from the superheroes of J. C. Holz: The visual culture of childhood and the third pedagogical site. *Art education: The Journal of the National Art Education Association, 61*(2), pp. 18–24.

Wilson, B. (2007). Art, visual culture, and child/adult collaborative images: Recognizing the other-than. *Visual arts research, 33*(65), pp. 8–20.

Wilson, B. (2000). Empire of signs revisited: Children's *manga* and the changing face of Japan. In L. Lindstrom, (Ed.). *The cultural context: Comparative studies of art education and children's drawings* (pp. 160–178). Stockholm: Stockholm Institute of Education Press.

Wilson. B. (2004). Child art after modernism: Visual culture and new narratives. In E. W. Eisner & M. D. Day (Eds.), *Handbook of research and policy in art education* (pp. 328). Mahwah, New Jersey and London. Lawrence Erlbaum Associates & the National Art Education Association.

Wilson, B. (2008). Some ways children use local visual culture to transform conventional school art topics. In A. Hurwitz & K. L. Carol (Eds.), *Memory & experience: Thematic drawings by Qatari, Taiwanese, Malaysian, and American children* (pp. 249–262). Reston, VA: National Art Education Association.

Wilson, M. & Wilson, B. (1982). *Teaching children to draw: A guide for teachers and parents.* Englewood Cliffs: Prentice-Hall.

Wilson, B., Hurwitz, A., & Wilson, M. (1987). *Teaching drawing from art.* Worcester, MA: Davis.

Wilson, B. & Toku, M. (2004). "Boys' love," *yaoi*, and art education: Issues of power and pedagogy. In D. L. Smith-Shank (Ed.), *Semiotics and visual culture: Sights, signs, and significances* (pp. 94–103). Reston, VA: National Art Education Association.

Wilson, B. & Wilson, M. (1976). Visual narrative and the artistically gifted. *The Gifted Child Quarterly* (4), pp. 432–447.

Wilson, B. & Wilson, M. (1977). An iconoclastic view of the imagery sources in the drawings of young people. *Art Education, 30*(1), pp. 4–12.

Wilson, B. & Wilson, M. (1979). Figure structure, figure action and framing in drawings of American and Egyptian children. *Studies in Art Education 21*(1) pp. 33–43.

Wilson, B. & Wilson, M. (1979). Children's story drawings: Reinventing worlds. *School Arts, 78*(8), pp. 6–11.

Wilson, B. & Wilson, M. (1979). Drawing realities: The themes of children's story drawings. *School Arts, 78*(9), pp. 12–17.

Wilson, B. & Wilson, M. (1979). Of graphic vocabularies and grammar: Teaching drawing skills for worldmaking. *School Arts, 78*(10), pp. 36–41.

Wilson, B. & Wilson, M. (1980). Beyond marvelous: Conventions and inventions in John Scott's Gemini. *School Arts, 80*(2), pp. 20–26.

Wilson, B. & Wilson, M. (1981). I draw, you draw: The graphic dialogue. *Schools Arts, 80*(2), pp. 50–55.

Wilson, B. & Wilson, M. (1981). Of Rubens, rabbits and extra terrestrials: The extended graphic dialogue. *School Arts, 80*(3), pp. 37–41.

Wilson, B. & Wilson, M. (1981). The case of the disappearing two-eyed profile: Or how little children influence the drawings of little children. *Review of Research in Visual Arts Education*, (15), pp. 1–18.

Wilson, B. & Wilson, M. (1983). Themes and structures in the graphic narratives of American, Australian, Egyptian, and Finnish children: Tales from four cultures. *The Journal of Multi-Cultural and Cross-Cultural Research in Art Education, 1*(1), pp. 63–76.

Wilson, B. & Wilson, M. (1984). Children's drawings in Egypt: Cultural style acquisition as graphic development. *Visual Arts Research, 10*(1), pp. 13–26.

Wilson, B. & Wilson, M. (1987). Pictorial composition and narrative structure: Themes and the creation of meaning in the drawings of Egyptian and Japanese children. *Visual Arts Research, X*(1), pp. 10–21.

Wilson, B. & Wilson, M. (1984). A tale of four cultures: The story drawings of American, Australian, Egyptian and Finnish children. In R. Ott & A. Hurwitz (Eds.), *Art and Education: International perspectives* (pp. 31–38). University Park: The Pennsylvania State University Press.

References for the Introduction (page vi)

Vygotsky, L.S. (1978). Mind and society: The development of higher psychological processes. Cambridge, MA: Harvard University Press.

Bruner, J. S. (1975). The ontogenesis of speech acts. *Journal of Child Language*, 2, pp. 1–40.

Wilson, B. (2000). Empire of signs revisited: Children's manga and the changing face of Japan. In L. Lindstrom, (Ed.). *The cultural context: Comparative studies of art education and children's drawings* (pp. 160–178). Stockholm: Stockholm Institute of Education Press.

Wilson, B. (1999). Becoming Japanese: *Manga*, Children's Drawings, and the Construction of National Character. *Visual Arts Research*, Vol. 25, No. 2 (Issue 50), pp. 48–60.

Wilson, B. & Toku, M. (2004). "Boys' love," *yaoi*, and art education: Issues of power and pedagogy. In D. L. Smith-Shank (Ed.), *Semiotics and visual culture: Sights, signs, and significances* (pp. 94-103). Reston, VA: National Art Education Association.

Wilson, B. G. (2008). Contemporary Art, The Best of Art, and Third-site Pedagogy. *Art Education: The Journal of the National Art Education Association*, Vol. 61(2), pp. 6–9.

Wilson, B. (2005). More lessons from the superheroes of J. C. Holz: The visual culture of childhood and the third pedagogical site. *Art Education: The Journal of the National Art Education Association*, Vol. 61(2), pp. 18–24.

Index

common 21, 23–26, 28, 40, 107, 174
normative 22, 23, 25, 30, 33, 35–36, 174
prophetic 21, 23, 36, 40, 87, 121, 174
the special role of drawing in shaping 23
reality (*see also* realities) xv, 23, 25, 28, 30, 36, 52, 76, 87, 91, 93, 110, 134
models of 40, 66, 110, 175
recreating 23–24, 104
romancing 54

S

scaffolding ix
school art vii, xii, xv, 12
science fiction 36, 145
scribbles (*see also* drawing development) 53, 55–56, 66, 91, 110, 115, 151, 169
irregular 53, 157
regular 54, 95
self (*see* realities: archeological)
delineating concept of 6, 28
ideal and evil roles 29, 33, 110
surrogate self 29
self-image
experimenting with, through play 28–29
self-initiated drawings x, xi, xv, 10, 171
Sendak, Maurice 14
Singer, Jerome 134
Singer, Dorothy 134
sound effects (*see* conventions)
space (*see* point of view)
stories (*see* narrative; story drawings)
encouragement of 97, 113
self-initiated 110
themes 120–131
superheroes 29, 33, 66, 70–71, 75–78, 92, 97, 111, 114–116, 118, 120, 131, 134
Sutton-Smith, Brian 110
symbols (*see also* visual symbols) 4, 23–24, 28, 40, 43–44, 68, 109, 125, 127
symbol systems 43, 75–76, 134
symbolic activity
drawing as (*see also* drawing activity; symbolic drawing activity) 4, 22–24, 33, 37, 41, 127, 151
play as (*see also* play) 4, 39
story-telling as (*see also* narrative; story drawing) 39, 121

symmetry 56
child's natural preference for (*see also* innate principles) 56

T

tadpole figure (*see also* drawing development; human figure) xii, 61, 109, 113
television (*see also* media) vi, 4, 5, 23, 52, 66, 70, 76, 77, 79, 87, 97, 100, 110, 120, 131, 145, 150
themes (of story drawings)
cause and effect 121, 163, 172
contest and conflict 120, 124, 129
creation 120, 125–126
crime and punishment 120, 125
daily rhythms 121
death and destruction 120
good and evil 22, 33, 35–36, 110, 120
growth 14, 24, 112, 116, 120–121, 129
odyssey 81, 118, 120, 122, 129
origins 120, 131
quest 83, 120, 122
success and failure 120, 123, 124
transformation 120, 162
trial 120, 123–124, 129
two-eyed profile 67–70

V

verbal interaction (*see* interaction)
video games 70, 79, 97, 120, 131
villainy (*see also* lack) 83
in children's story drawings 110, 116–117, 120
overcoming 111
visual symbols (*see also* symbols) 23
as universal language 44
Vygotsky, Lev ix, x

W

worldmaking (*see also* realities) 171
in fiction 171
World Wide Web (*see* Internet; blog)

Y

Yoshihiro Yonezawa xiii
YouTube vii